IMAGES
of America

SEDRO-WOOLLEY
WASHINGTON

IMAGES
of America
SEDRO-WOOLLEY
WASHINGTON

Sedro-Woolley Historical Museum

ARCADIA
PUBLISHING

Published by Arcadia Publishing
Charleston, South Carolina

Library of Congress Catalog Card Number: 2002116537

For all general information contact Arcadia Publishing at:
Telephone 843-853-2070
Fax 843-853-0044
E-Mail sales@arcadiapublishing.com
For customer service and orders:
Toll-Free 1-888-313-2665

Visit us on the Internet at www.arcadiapublishing.com

CONTENTS

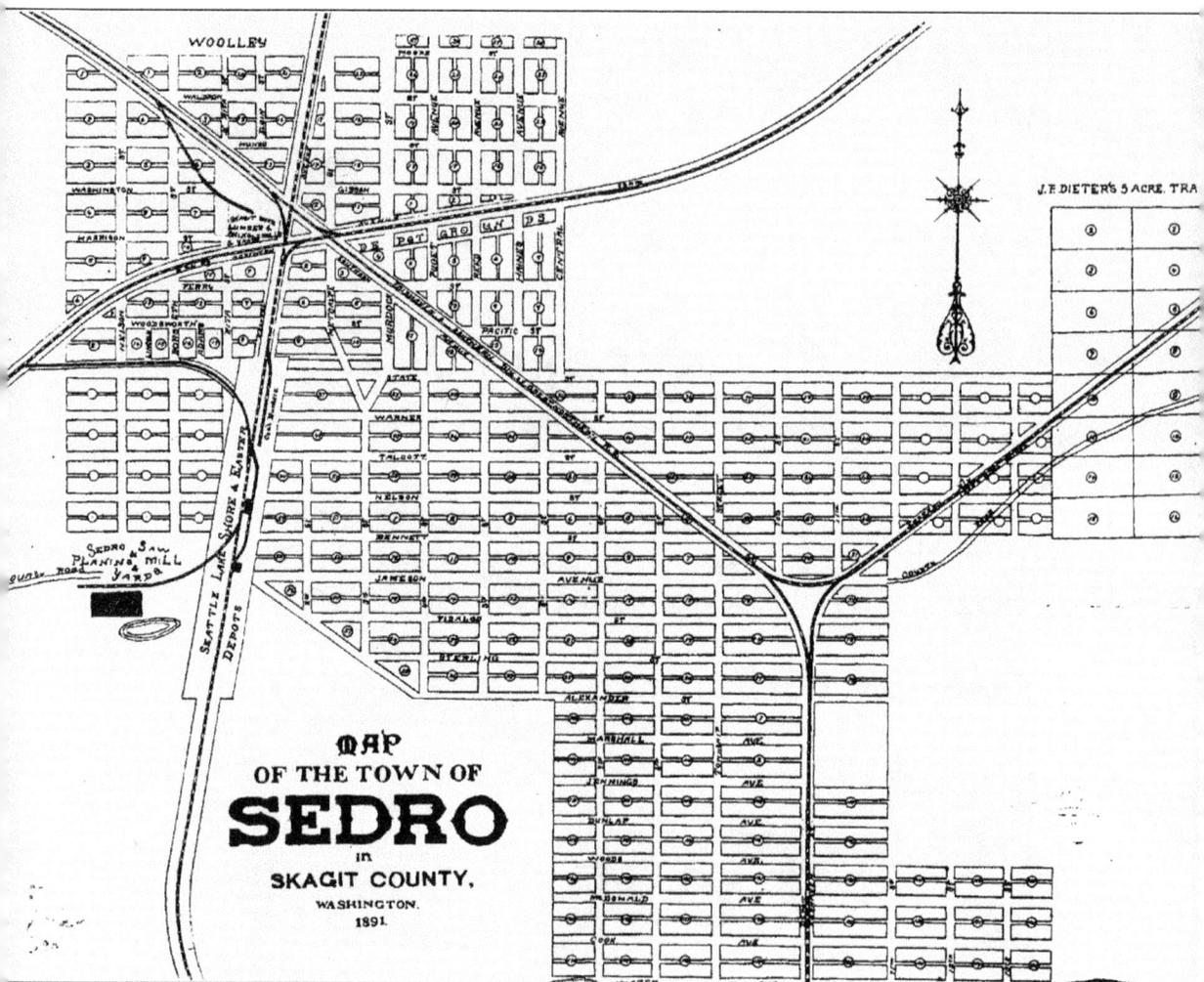

This map of Sedro dates to 1891. This Albert Mosier Plat map shows the early streets of Sedro (some no longer exist). The town of Woolley shows at the top left.

INTRODUCTION

Sedro-Woolley is nestled in the beautiful Skagit Valley in Washington State. This unique town, known as the "Gateway to the North Cascades," is situated at the foothills of the Cascade Mountain Range. To the south is the wild and scenic Skagit River, where the bald eagles winter; to the west are the tulip fields and spectacular San Juan Islands.

The upper Skagit Valley was rich in coal, iron, and vast, dense forests. The soil, when cleared, would yield the finest crops of all kinds. The Native American tribe that lived along the Skagit River in the Sterling-Sedro area, above the logjam, was the Nookachamish, consisting of about 500 members. From all accounts they were friendly and caused the settlers no trouble.

Traveling to this area was made more difficult because of a huge logjam in the Skagit River. The logjam was so large that it had to be portaged. The canoe was the only means of travel. This great logjam was well over a mile long and kept growing. The History of Skagit and Snohomish Counties, 1906 states: "The material of the jam was mainly green timber, but in many places sediment had accumulated to such an extent as to permit the growth upon it of a perfect jungle of brush and even of large trees."

The very first emigrant settlers to venture above the logjam were mainly prospectors looking for gold who found little, but did discover coal. This led to a small migration of settlers who established homesteads along the river in isolated spots.

This is a story told of Wilhelmine Von Pressentin, one of the first pioneer women to settle above the jam: "There was a big logjam in the river where everything including the canoe had to be carried for a distance of a mile and a half around it. Wilhemine carried her baby, Otto, a large bundle of clothing, and the head of her sewing machine around the jam. The other two children were able to walk, but Paul clung to his mother's dress as they clambered over the rough trail."

There were basically ten families that settled in the Sedro area. The first five were Henry Holtcamp, David Batey, Joseph Hart, William Woods, and William Dunlop. Then came the Van Fleet family, the Wickers, Dreyers, Kiens, and Bensons.

The work on removing the jam was hard and dangerous. By the summer of 1879 the drift was sufficiently open to allow ordinary navigation, although it was ten years before the vast accumulation of debris was removed from the river.

Mortimer Cook arrived in 1884 and established the town of Sedro, originally named "Bug," because of the mosquitoes. Due to the objections raised by the women, it was changed to Sedro, from the Spanish word for Cedar (cedra). In 1889 Phillip A. Woolley arrived and settled in an area north of Sedro, where he founded the town of Woolley—named after himself.

Due to the constant flooding of the river, Sedro kept moving north to higher ground, and Woolley expanded to the south and eventually the two towns grew together. Sedro-Woolley was incorporated December 19, 1898, and yes, it is hyphenated.

P.A. Woolley was responsible for bringing the three trains a day that came into Woolley. This, along with the clearing of the logjam, was very important to the area because it brought prosperity and people to the region.

Logging, mining, and agriculture were the first industries. The Skagit Steel and Iron Works brought improvements to the logging industry and employed many people. The Northern State Hospital, a state mental hospital, also employed many of the local people.

It did not take long after the communities were established for clubs and organizations to form. This was a great source of entertainment on weekends: remember, there were no radios or televisions.

In the greater Sedro-Woolley area each pocket of settlers formed their own communities. Each of these communities started their own school and church. Education was very important to these early settlers. Eventually there were at least 26 little schools that were incorporated into the Sedro-Woolley school district. The early churches were either held in people's homes or in their small community centers.

Sedro-Woolley is proud to claim Darius Kinsey, a world-renowned photographer, at the turn-of-the-century. He photographed the logging industry and surrounding area and we have featured several of his photographs in this book.

Sedro-Woolley grew over the years, with its many lumber and sawmills, the iron works company that was developed by the McIntyre family, a coke mine, and the state mental hospital.

Today, the iron works company is closed down, and its many buildings leased to various companies. The coke mine has long since been closed down, and the mental hospital has been converted to many different organizations, but is slowly being shut down completely. The timber industry is slowly declining, but despite this, Sedro-Woolley continues to grow and prosper. The North Cross-State highway brings a flow of tourists who delight in their discovery of this unique little town.

The compiler of this historical work can do nothing more than to collect, collate, and arrange accounts of things already recorded. A careful effort has been made to make the best use of all available materials. It is hoped that in some measure, at least, we have succeeded. The source we relied on for the early history and some early pioneer pictures was the *History of Skagit and Snohomish County, 1906*.

Mrs. W.T. Odlin wrote a poem that was published in the 1906 book, and we find the last verse of this poem applicable today: "And I sing of a glorious future, Well worthy the deeds of the past: Here is three cheers for our own Sedro-Woolley—Long may its prosperity last!"

One

EARLY SETTLERS
AND OUR
FOUNDING FATHERS

"What is in a name?" Shakespeare asked. What is in a name indeed? Sedro began on the banks of the Skagit River, founded by Mortimer Cook in 1884. Its unique name came from the corrupted spelling of the Spanish word for cedar. Woolley, in turn, was named after its founder P.A. Woolley in 1890. Neither town would give up its name, for doing so would mean oblivion. So when the two towns merged in 1898 they had several meetings on this very subject: "What to name this new incorporated town?" They decided on combining them into a hyphenated word, Sedro-Woolley. The only Sedro-Woolley on earth.

This chapter covers the formation of each of these towns, their founders, and the very early settlers.

Drawn to this area for its abundance of natural resources and availability of land, the five bachelors that settled on the land that we now call Sedro are covered in this chapter. The friendly Indians had long made this their home and reverenced its bounty. Giant Douglas fir, Cedar, Hemlock, Spruce, and Maple covered the landscape with beauty and wealth. The deep and nourishing Skagit River teemed with five species of salmon and their cousin the steelhead. Game of all kinds abounded in the forests and streams. The very early pioneers used potatoes as currency because money was scarce.

We hope that this visual account can in someway depict the hardship, the isolation, and loneliness that these early settlers encountered in the dense forest.

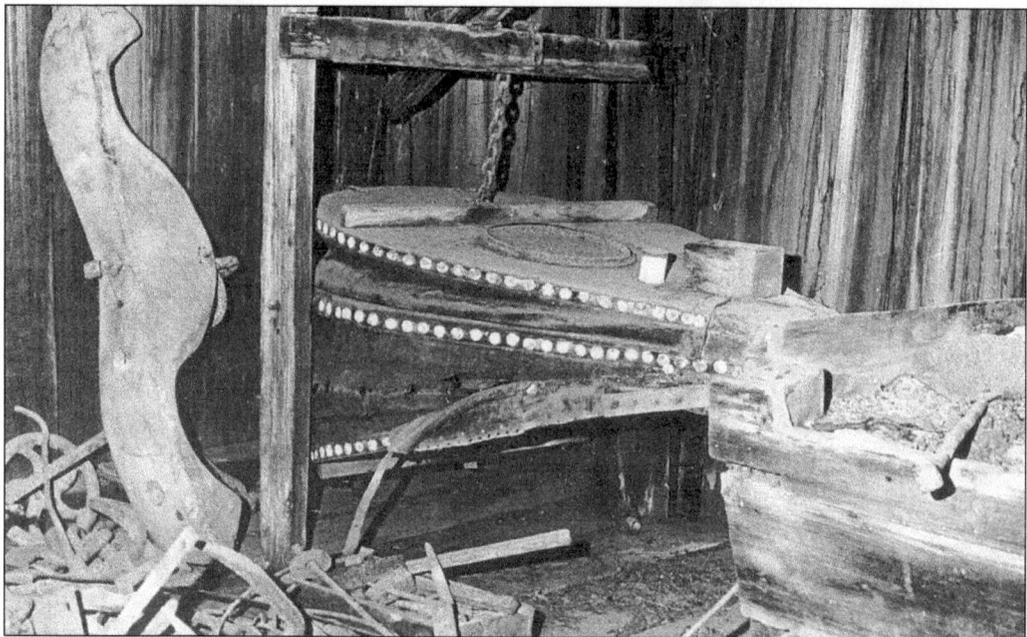

The bellows in the blacksmith shop of Henry Holtcamp's homestead was used during logging operations in the 1880s. Note the walls of split cedar boards and the oxen yoke made out of one piece of wood.

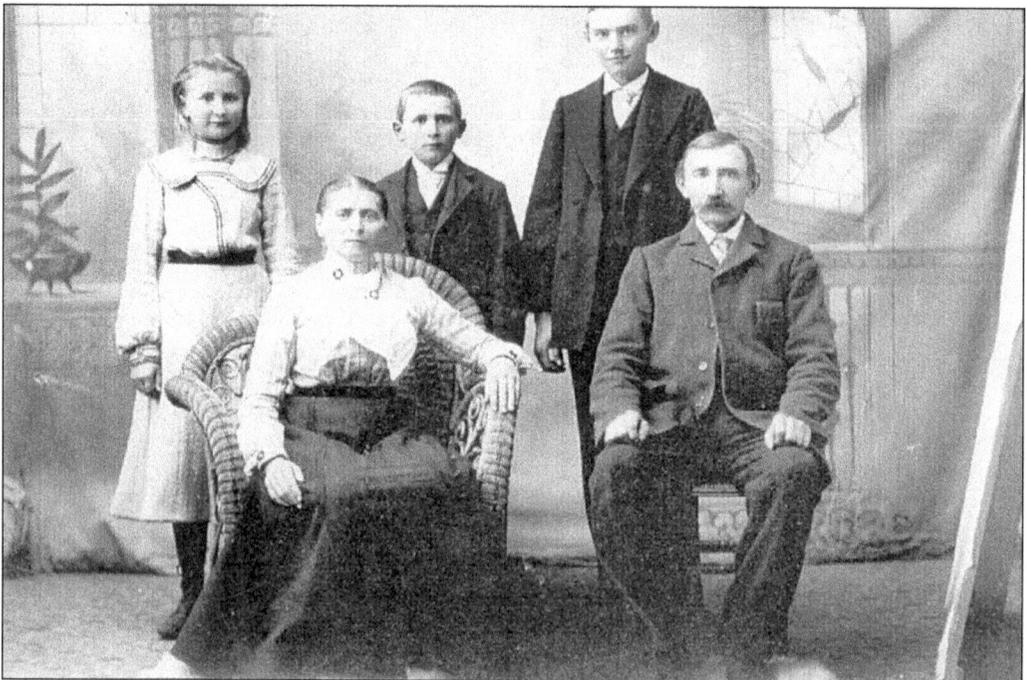

Henry Holtcamp was born in Hopston, Germany, in 1847. He came to Skagit Valley and found a homestead in the Sterling area in 1880 and met and married Anna Reichel on March 21, 1889. The family, from left to right, are: (front row) Anna and Henry Holtcamp; (back row) Anna, William, and George.

Joseph Hart was born in Durham, England, on July 4, 1852. He and David Batey came to the Skagit area in 1878 and homesteaded in the area later known as Sedro. Joseph married Emma Anderson and with David Batey started the Sedro and Lumber Shingle Co., which burned in 1896. He died in 1933.

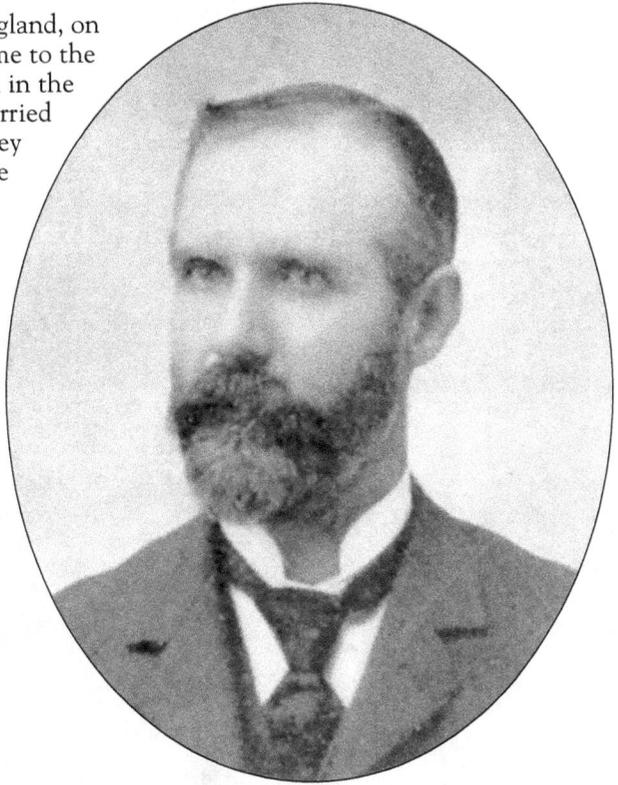

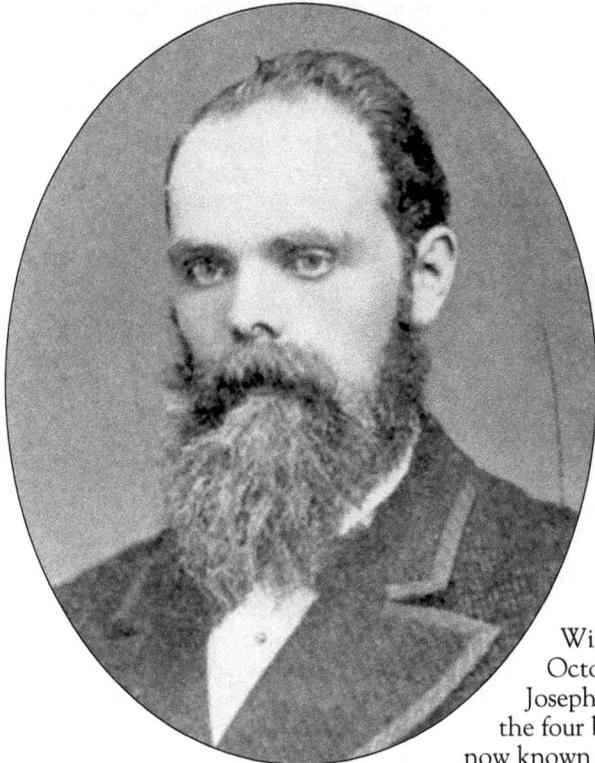

William Dunlop was born in England, on October 25, 1848. He was friends with both Joseph Hart and David Batey. He was one of the four bachelors who homesteaded the area now known as Sedro in 1878. He died in 1921.

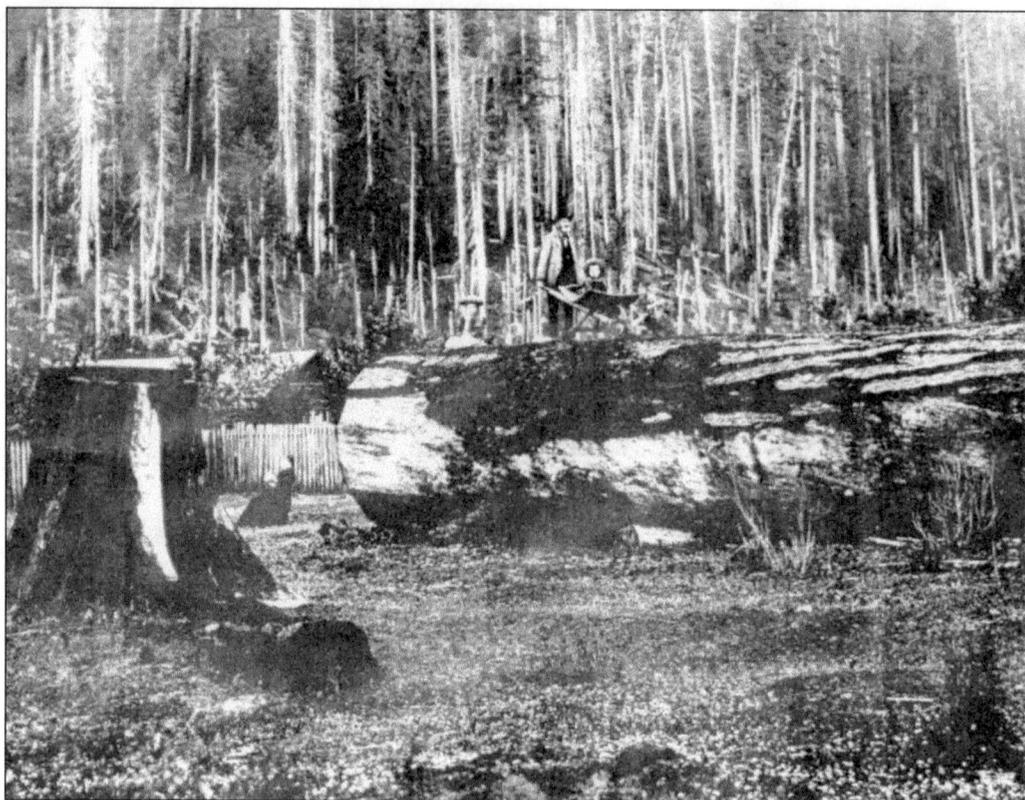

This scene takes place at Prairie, Washington, Skagit County, on the Bruce Patey Place in 1892. Mr. and Mrs. Patey are shown in the picture; he on the log, she on the ground. The cut fir log was sent to the Chicago Worlds Fair in 1893.

William Woods, born in Ireland, was the oldest of the four bachelors who came to the Skagit area in November of 1878. He liked the area and the companionship of the other three bachelors who were homesteading. He stayed and became the second mayor of Sedro. He died in 1924.

David Batey, born in Carlisle, England, on May 21, 1849, came to the Sedro area in 1878 with Joseph Hart, whom he had known as a boy in England. He built Mortimer Cook's store and the first Cook family home. Two years later he went to San Francisco and married Dr. Georgiana Ferron. He died in 1930. He and Georgiana had the first white child born in the Sedro community, Susan Batey.

Dr. Georgiana Batey, born in Wisconsin on October 2, 1838, studied medicine at Hughes and Sanford's Medical College in Iowa. Georgiana married David Batey in 1880 and accompanied him to the Sedro area. She was the only physician in the area and traveled day and night by horseback and by boat to render aid whenever called. She was instrumental in securing the first clergyman for Sedro, the Reverend McMillan. Georgiana died in 1927 at the age of 89.

Mortimer Cook founded the town of Sedro in 1884. He originally named the town Bug, but because of the ladies' objections settled on Sedro, from the Spanish word for Cedar (cedra), which they misspelled. He started a general store, post office, and shingle mill. Born in Mansfield, Ohio, on September 15, 1826, he died at the U.S. Brigade Hospital in the Philippines on November 21, 1899, at the age of 73. He also started towns in British Columbia, Canada, and California.

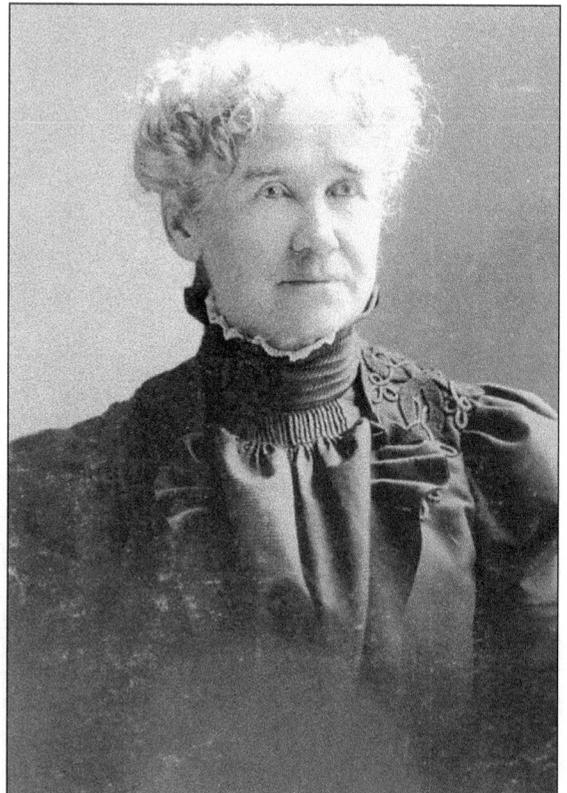

Nancy Frances (Pollock) Cook was born in Ohio in 1834. She married Mortimer Cook on January 14, 1863, at her parents' home in Mansfield, Ohio. She, along with their two daughters, Farrie (age 20), and Nina (age 15), came to the new town of Sedro. They arrived aboard the sternwheeler Glide, on June 25, 1885. She died November 25, 1920, at the age of 86. At the time of her death she was residing with her youngest daughter, Mrs. Standish Budlong, in Rockford, Illinois.

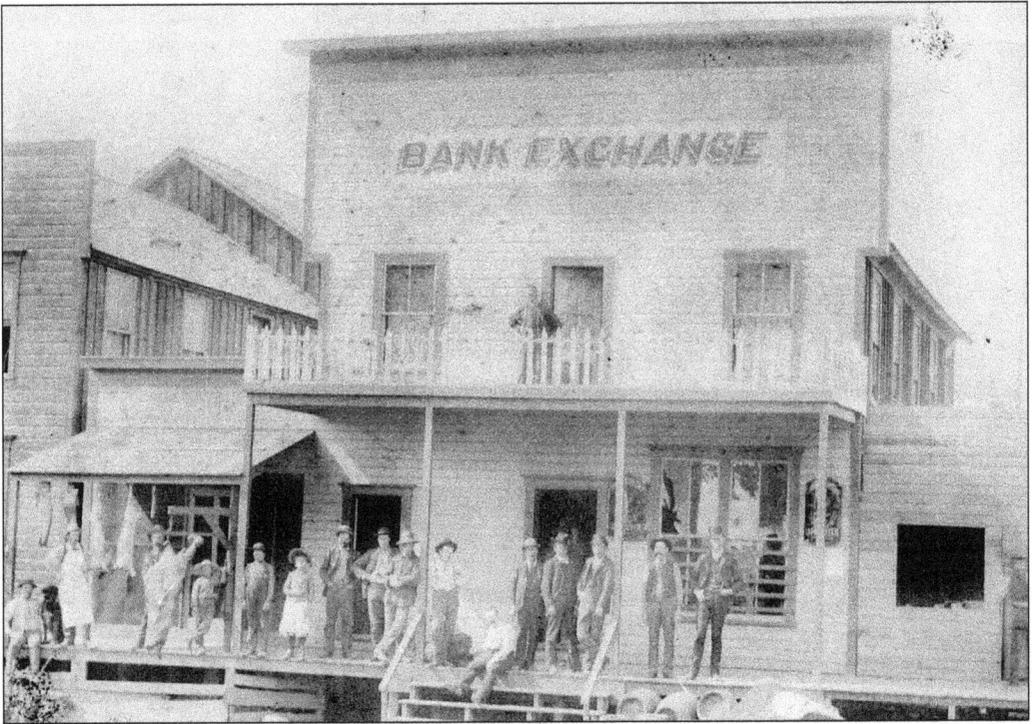

The hotel in old Sedro belonging to Mr. and Mrs. J.A. Fredricks. This picture was taken before the Sedro fire. George Millar is on the balcony with Mrs. Bovey at the extreme left. The little boy at the right of the beef is Ed Adams, next to him is Ed Layden and the little girl is Kate Bovey (Shrewsbury). This is one of the few pictures we have of old Sedro on the banks of the Skagit River.

Mortimer Cook's General Store faced the Skagit River. The river was the only mode of transportation into the area and even though the general store was on one floor, he wanted the town to look prosperous from the river; so when he had David Batey build his store, he had him add a second story facade because investors coming up the river would be more likely to stop in a town with a two-story building.

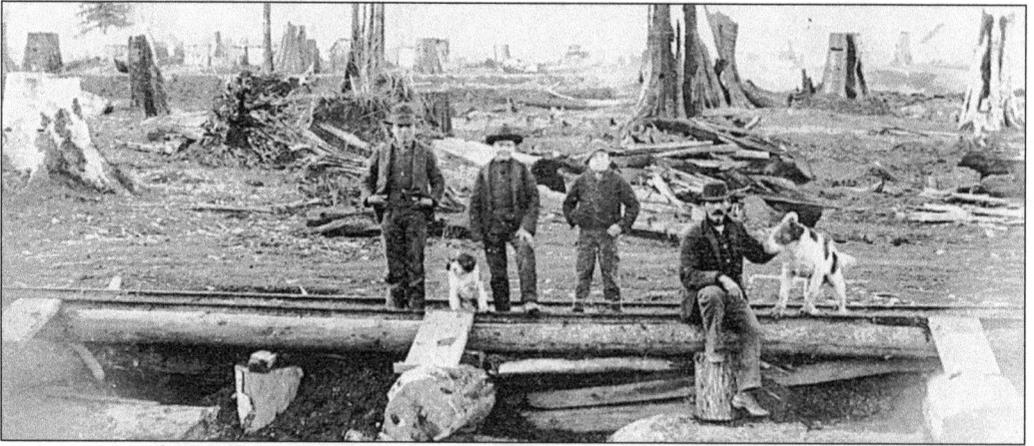

Kelley Town was platted between Sedro and Woolley. This picture shows the clearing of the town's site in 1890 or 1891. Seated is Mr. Fredricks; standing on the rail, from left to right, are Joe Fredericks, Ed Layden, and Alex McDonald.

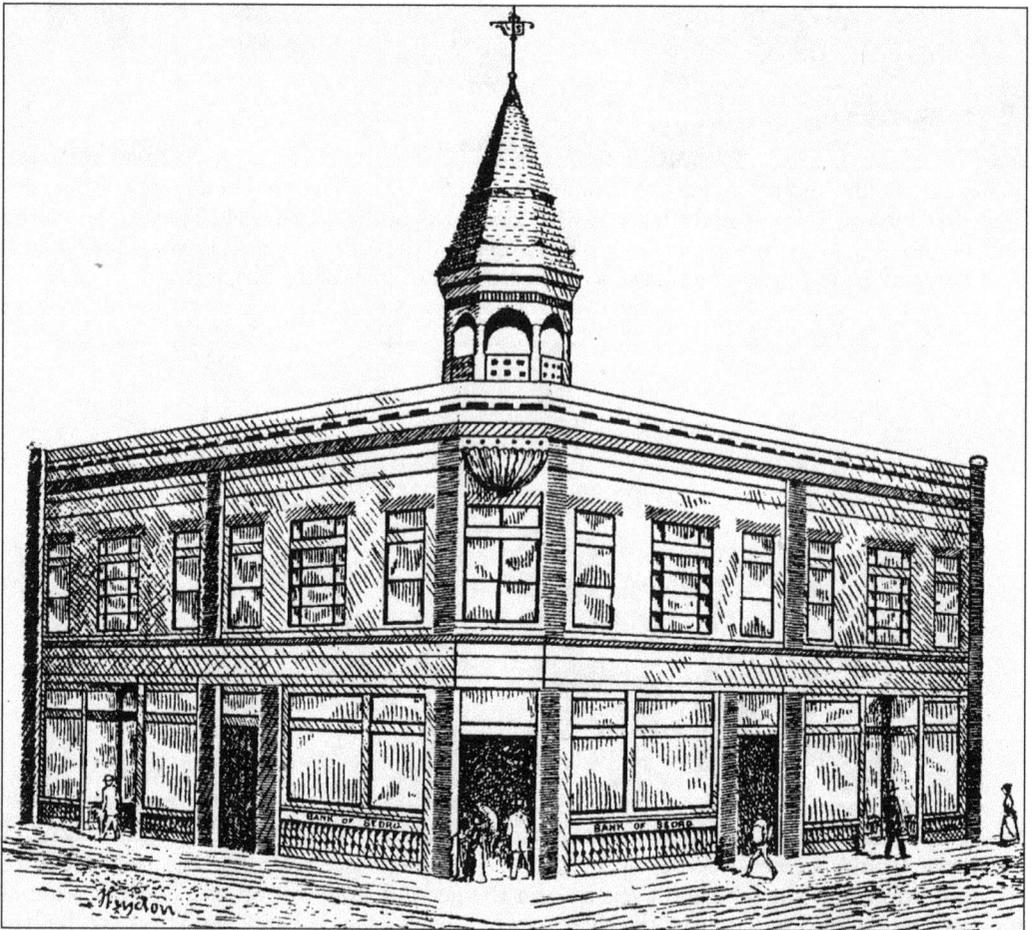

This drawing is of the Bingham and Holbrook private bank that was built as part of Kelley Town. The bank was located at 3rd and Bennett and included the Holland Drug Store. It burned in 1895.

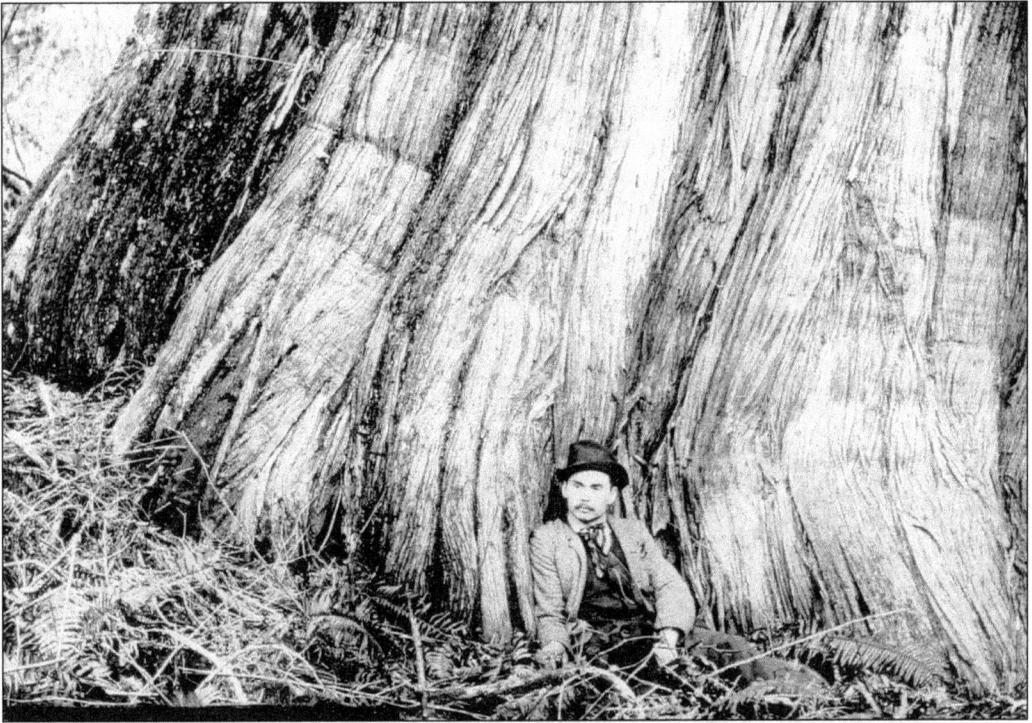

Darius Kinsey is sitting at the foot of a large cedar tree. The photograph was taken by Darius Kinsey, a Sedro-Woolley photographer.

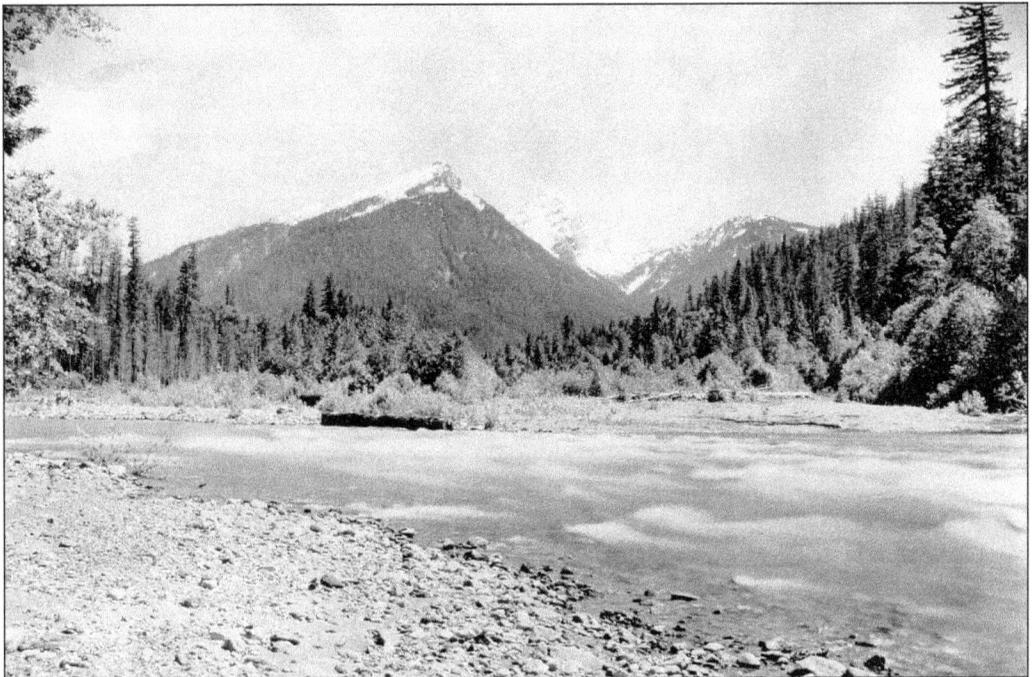

Sedro-Woolley is nestled in the foothills of the Cascade Mountain Range. This view is of Bedal Peak, 6,500 feet, and Sloan Peak, 7,790 feet, taken from the banks of the Sauk River.

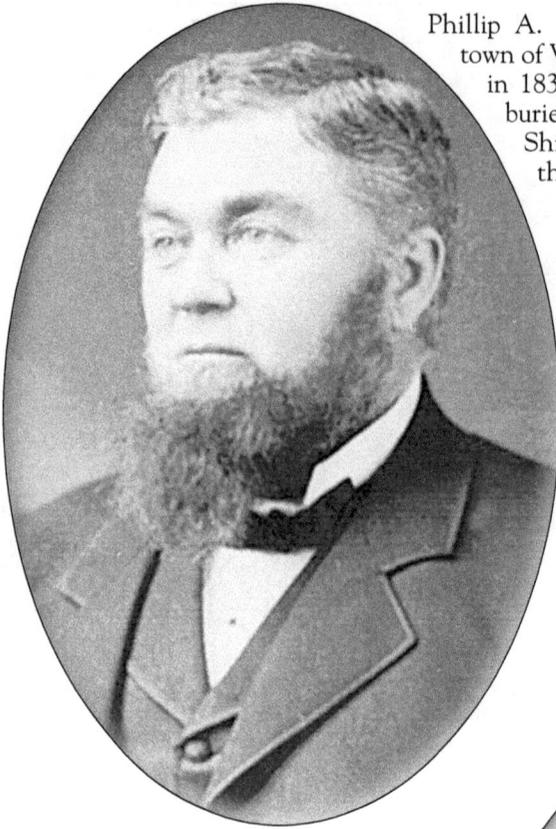

Phillip A. Woolley was the founding father of the town of Woolley in 1890. He was born in New York in 1831, died in Sedro-Woolley in 1912, and is buried here. He started the Skagit Lumber and Shingle Company Mill and was responsible for the three trains a day that ran through town.

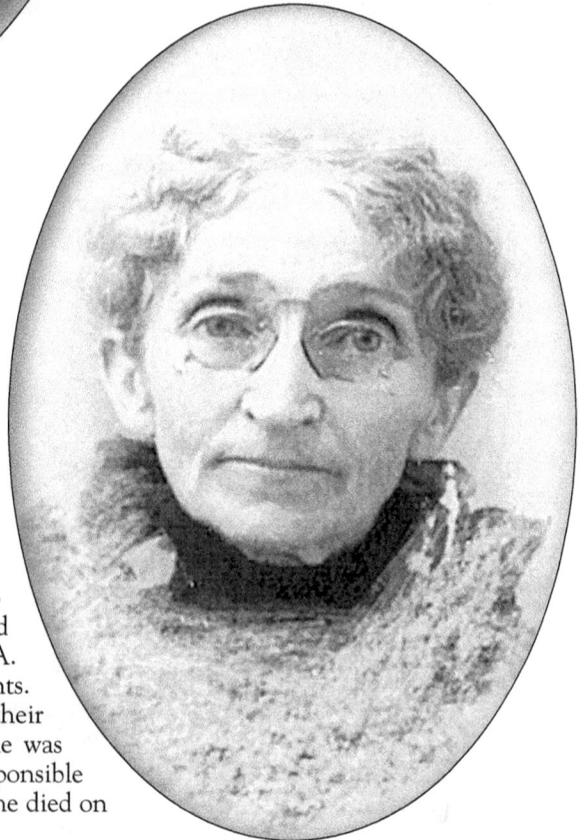

Catherine Woolley was born in Ontario on August 28, 1842, to Honorary and Mrs. William Loucks. She married P.A. Woolley in 1856 at the home of her parents. Catherine and her husband celebrated their golden wedding anniversary in 1906. She was very active in the community and was responsible for starting the first school in Woolley. She died on March 28, 1924, at the age of 81.

18

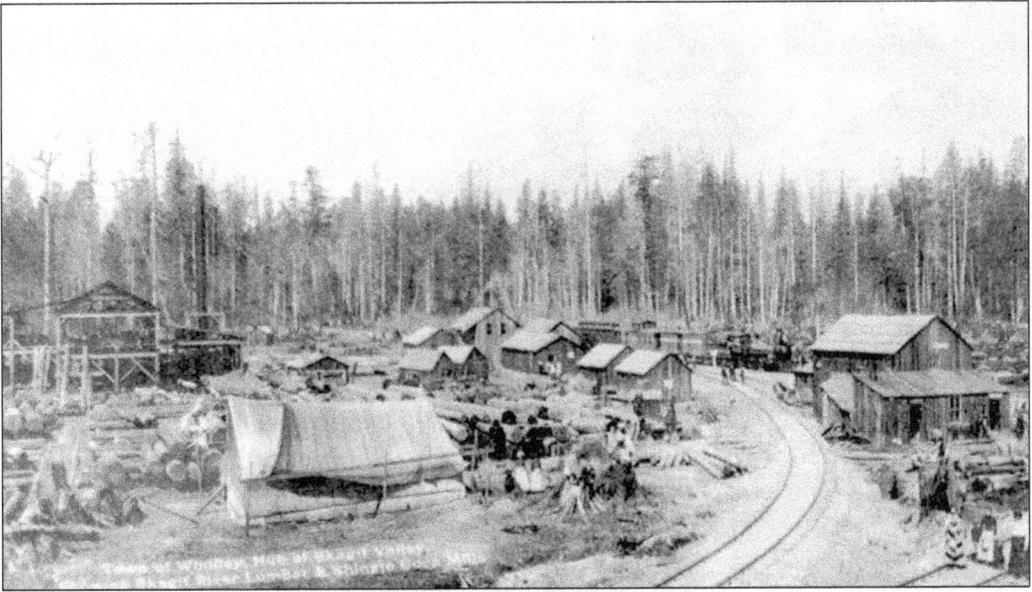

The town of Woolley is the hub of Skagit Valley. This view shows the Skagit River Lumber and Shingle Company's Mill in 1895. The two story building in the center of the picture was the original school of Woolley. The school was located on the upper floor and Mrs. Woolley was the first teacher. The two railroad tracks are the Lakeshore and Eastern, and the Fairhaven and Southern. The tracks were located about where Gibson and Metcalf Streets are now.

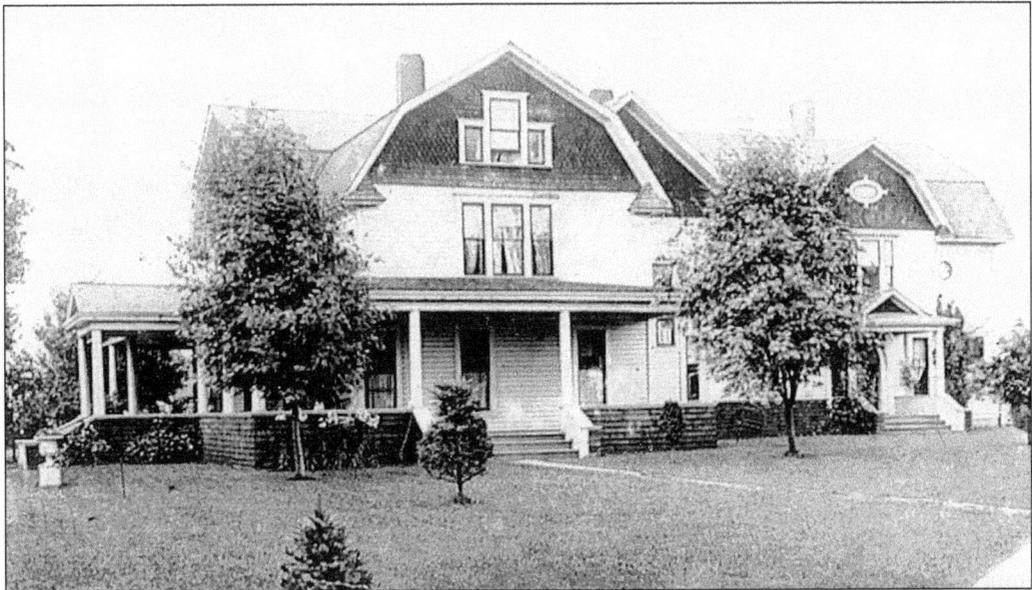

The Woolley mansion was located on Woodworth between Murdock and Metcalf Streets. The upper story burned on June 13, 1926. The mansion was also used as Dr. Harbough's office. Dr. Harbough was Woolley's son-in-law.

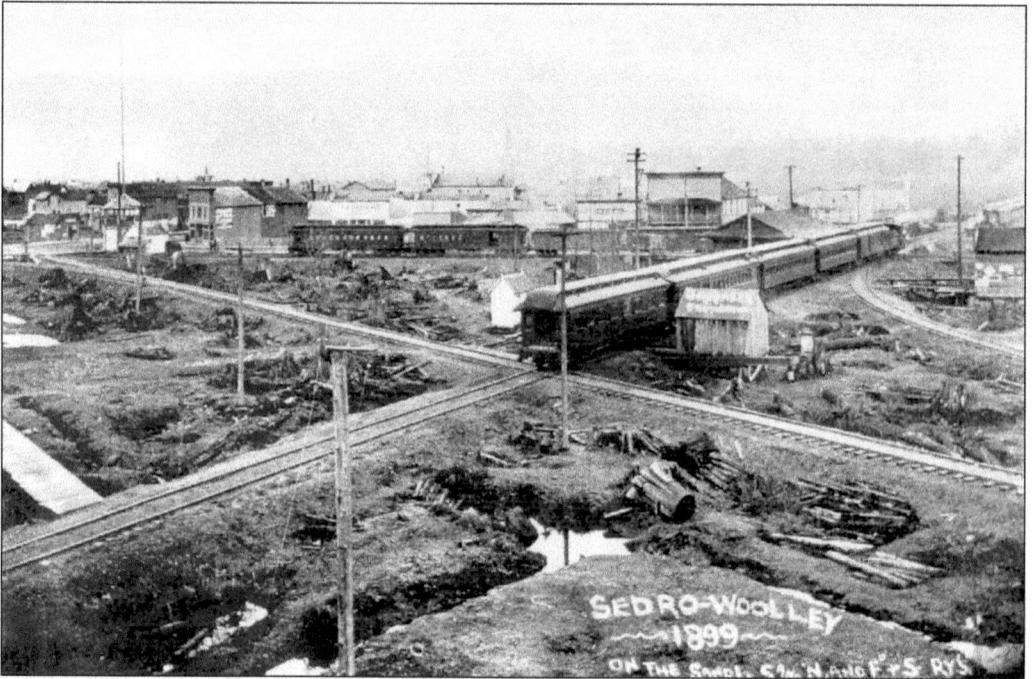

This view of Sedro-Woolley was taken in 1899 and looks southeast at the crossroads of the three railroads, the Southern and Northern, Fairhaven and Southern, and the Seattle and International. This photograph was taken by Darius Kinsey.

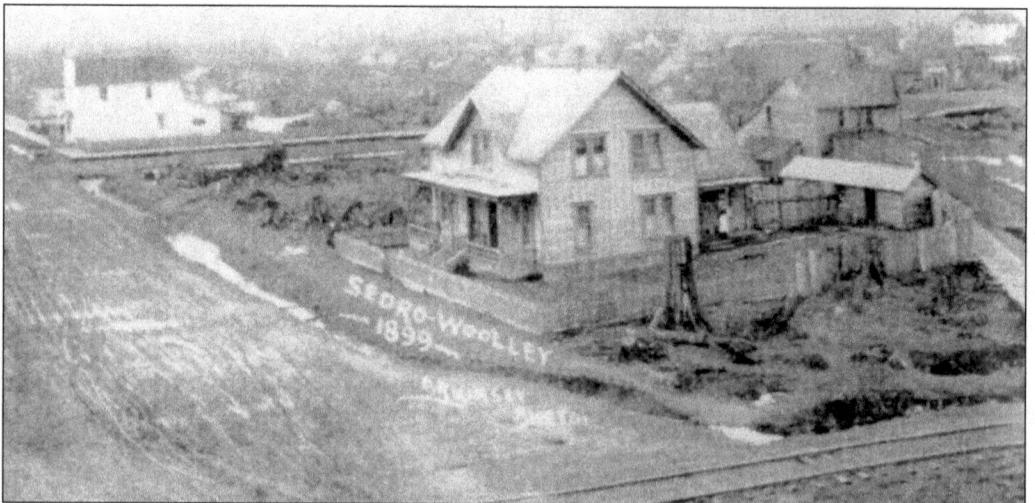

Another view of Sedro-Woolley in 1899, looking east on Gibson Street. Note all the tree stumps. This is also a Darius Kinsey photograph.

Two

PIONEERS AND
FIRST RESIDENTS

President James Garfield once said: "Territory is but the body of a nation—the people who inhabit its hills and valley are its soul, its spirit, its life." This is nowhere more true than with the pioneers that settled in the Sedro area.

After the logjam was partially removed the entire region opened to settlement; it was heavily timbered and the work of clearing land, difficult at times, began. In order to succeed in establishing themselves and their families in this remote area, shelter was often the first priority.

Many of the early pioneers discovered that if they hollowed out a huge cedar stump, they could make an adequate shelter that would sustain them through the winter months. Included in the first part of this chapter is an example of a stump house.

The first real homes that were built were usually not very large and were made out of split cedar. It took at least a year to raise a garden, but when the garden did come in it was usually very good because of the rich soil.

Eliza Van Fleet, one of the very first pioneer women to settle, wrote in her diary: "That Sundays were long and dreary days, nothing to do but to wander in the forest listening to the singing birds and chattering squirrels." She also recounted that the Indians would often walk right in her home and stare at her while she worked, then leave as unceremoniously as they arrived.

We hope that in someway we have captured these early settler's life and spirit.

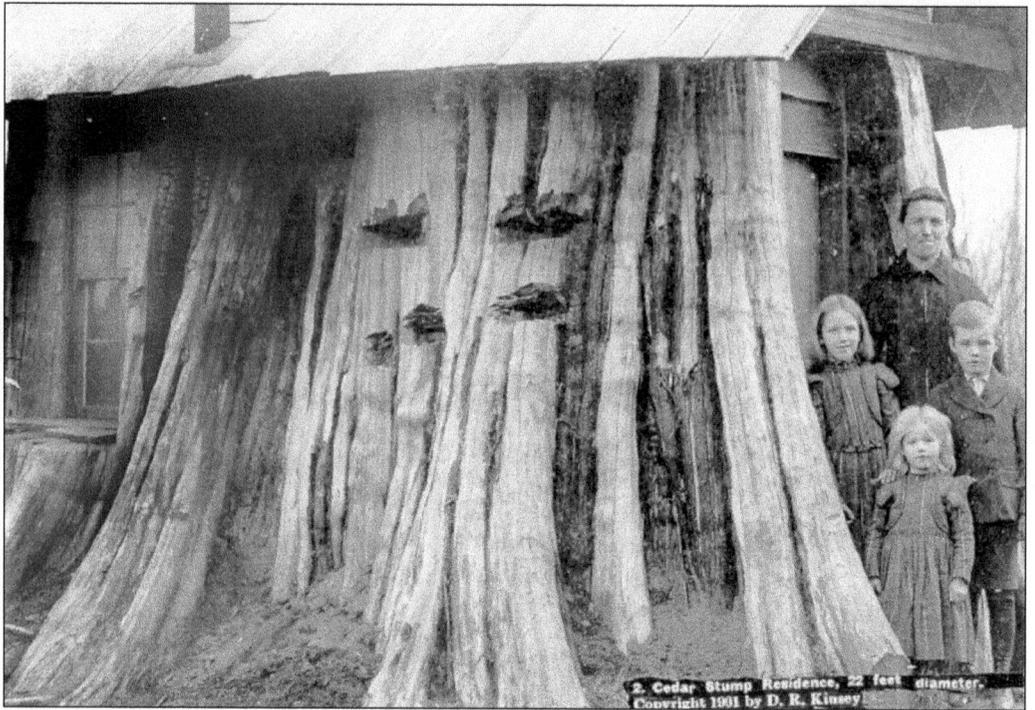

2. Cedar Stump Residence, 22 feet diameter.
Copyright 1901 by D. R. Kinsey.

Pioneers burned out the inside of huge stumps, like this house, which was 22 feet in diameter, to make their living quarters. They constructed a roof and put in a stove and windows. Notice the springboard notches on the side. Springboards allowed the loggers to get up high enough to cut down the tree.

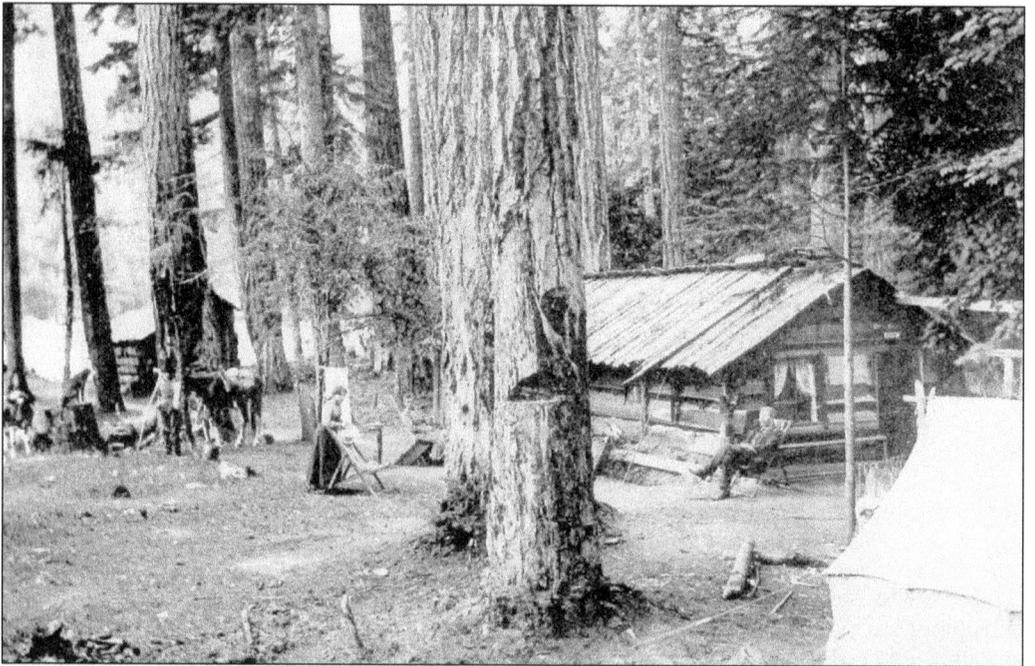

This Kinsey photo shows the Glee Davis family roadhouse on the upper Skagit River.

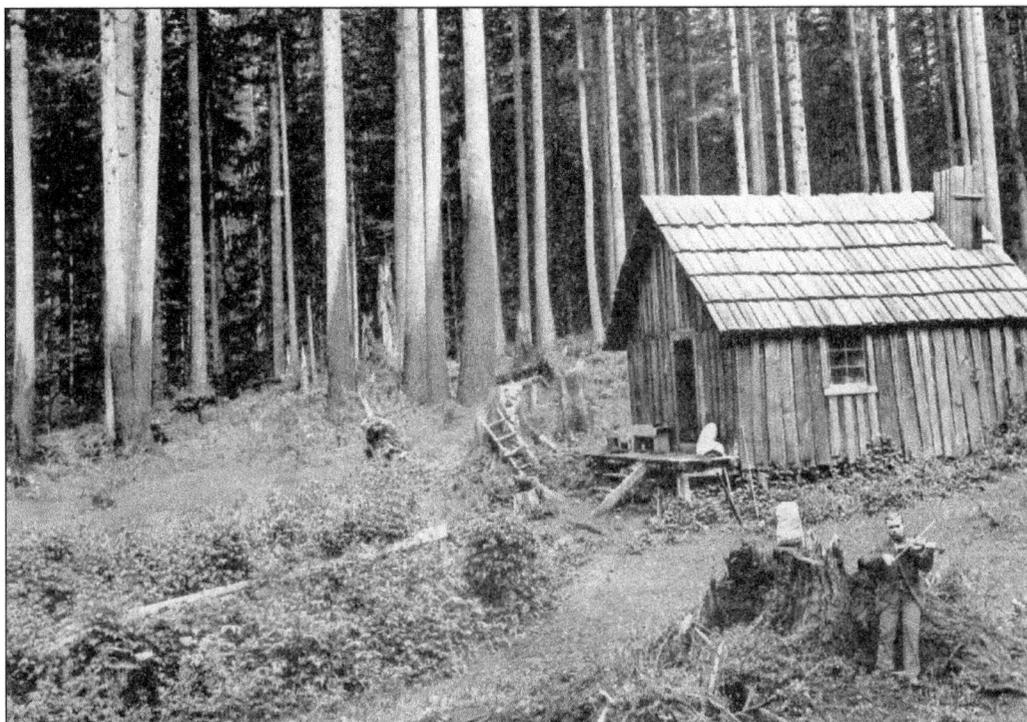

This photo of a cedar homestead with a fiddler is a good example of the type of homestead cabin required to obtain a homestead title. Also known as a "shake shanty," this was called "proving up your homestead" in order to get a title to the land. This is a Kinsey photo.

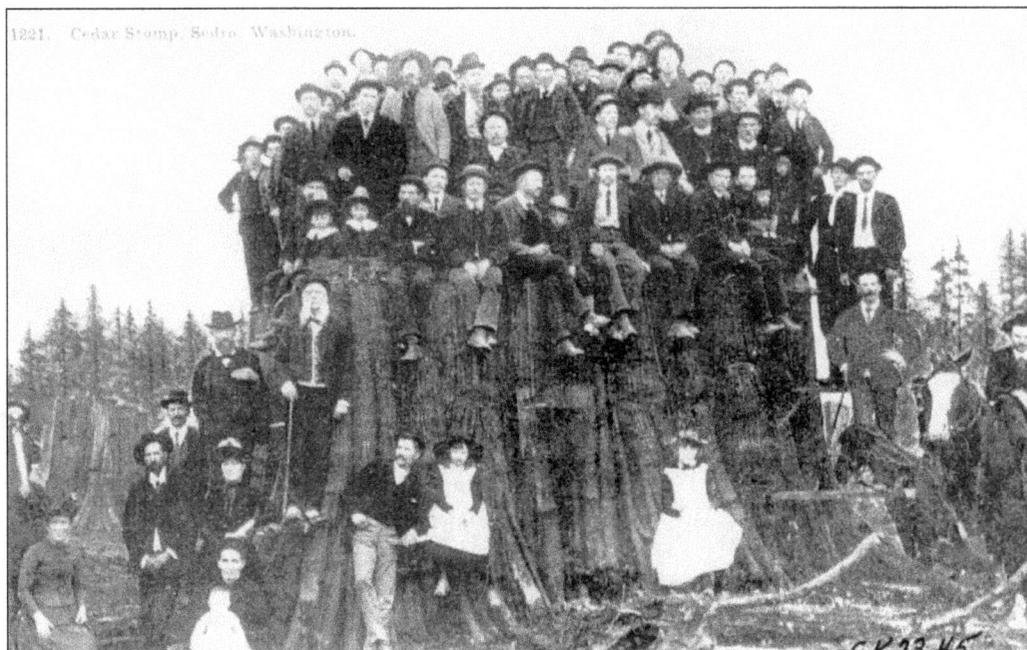

This photo, taken before 1898, of 72 people on a big stump, shows the enormity of the stumps in the early days of the Skagit Valley. The stump was located on the Van Fleet property.

The four generations of Van Fleets pictured here, from left to right, are Eliza Van Fleet, Eva Holm Parker Beebe, Chester Earl Holm (in back), and the baby is Chester Leroy Holm. This picture was taken in 1927.

This is a picture of the Van Fleet homestead. Emmett and Eliza Van Fleet, with their baby daughter Eva, were one of the earliest pioneer families. They arrived in 1880 and knew no neighbors; there were no roads and few trails. They built this house and barn on a knoll overlooking their land and Hanson Creek (formerly Benson Creek).

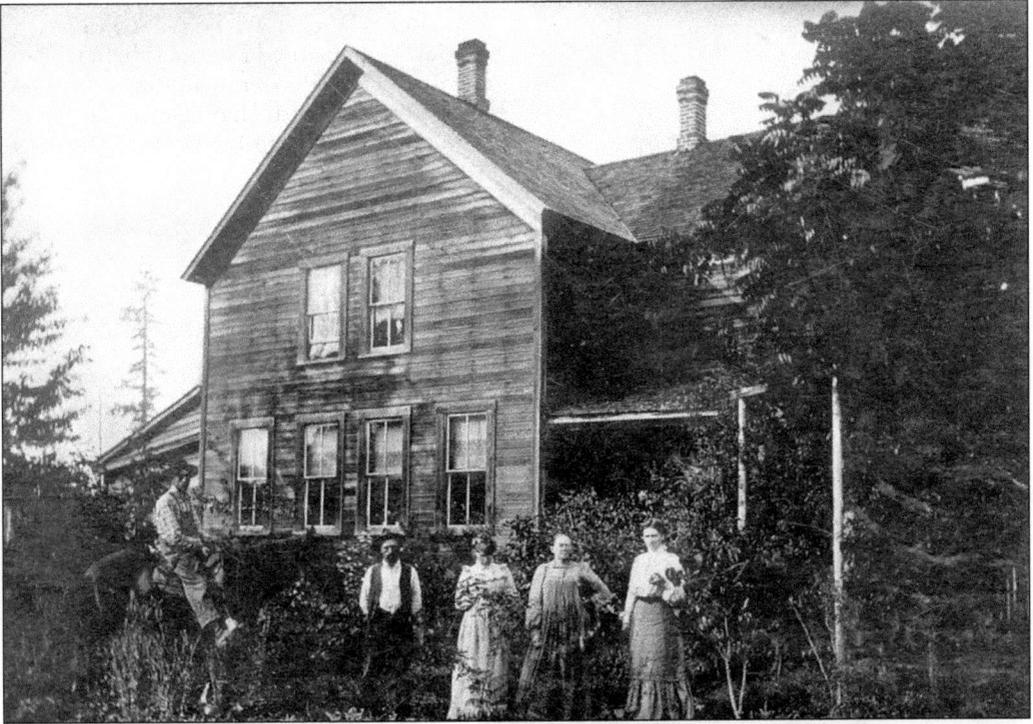

The Henry Dreyer homestead was located on Cook Road in 1906. Pictured from left to right are Whetzel (on the horse), Henry, Lizzie, Alma, and Maud. The Dreyers left for Oregon for one year then returned here and homesteaded. Mrs. Dreyer jokingly said: "Mosquitoes drove us from Skagit County and Willamette flies drove us back."

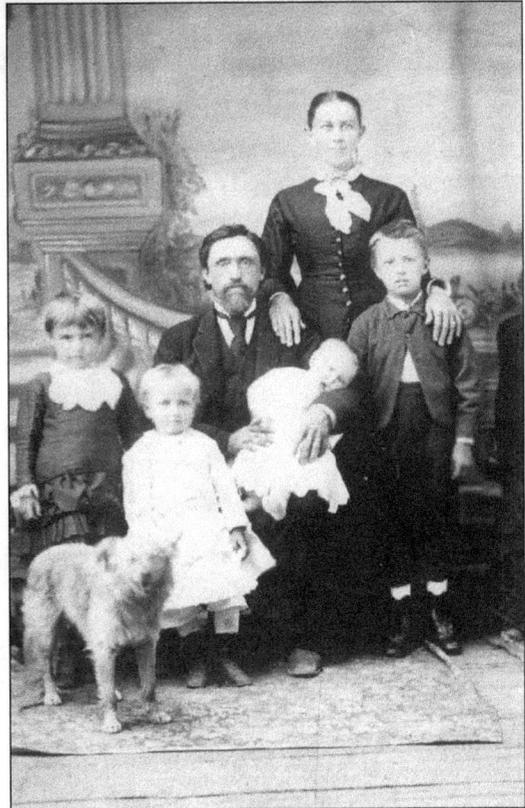

Pictured is the Dreyer family, c. 1882. The children, from left to right, are Waneta, born 1879 in California; Maude, born 1881 in Skagit County; Elizabeth, born in 1883 in Skagit County; and Ernest, born in 1876 in California. The parents are Henry and Alma (Nash) Dreyer.

Charles Wicker was born 1863 in Iowa and married Martha (Hight) in 1895. A pioneer realtor in partnership with Harry Devan, he established Skagit Reality in 1901.

The Wicker children are pictured here, c. 1907. From left to right are Jessie, born in 1904; Charles (Chuck), born in 1906; Gertrude, born in 1902; and Agnes, born in 1899.

Fred Kien's daughters are pictured here in 1934. From left to right are Babe (Mary), Anna, Elizabeth, and Dena.

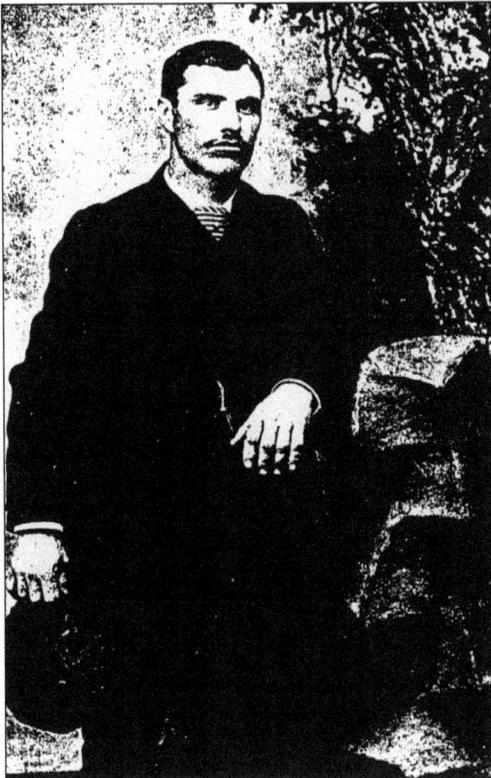

Fred Kiens, born in 1859, came to the Woolley area with his brother John Kiens, from Germany. They established adjoining homesteads one mile north of Sedro-Woolley in 1884. Fred married Mary Thiele in 1885 and they had 7 children. Fred established the Kiens gold mine. The gravel was used for the foundation of the Catholic Church, Northern State Hospital, and to gravel Murdock Street among other downtown streets.

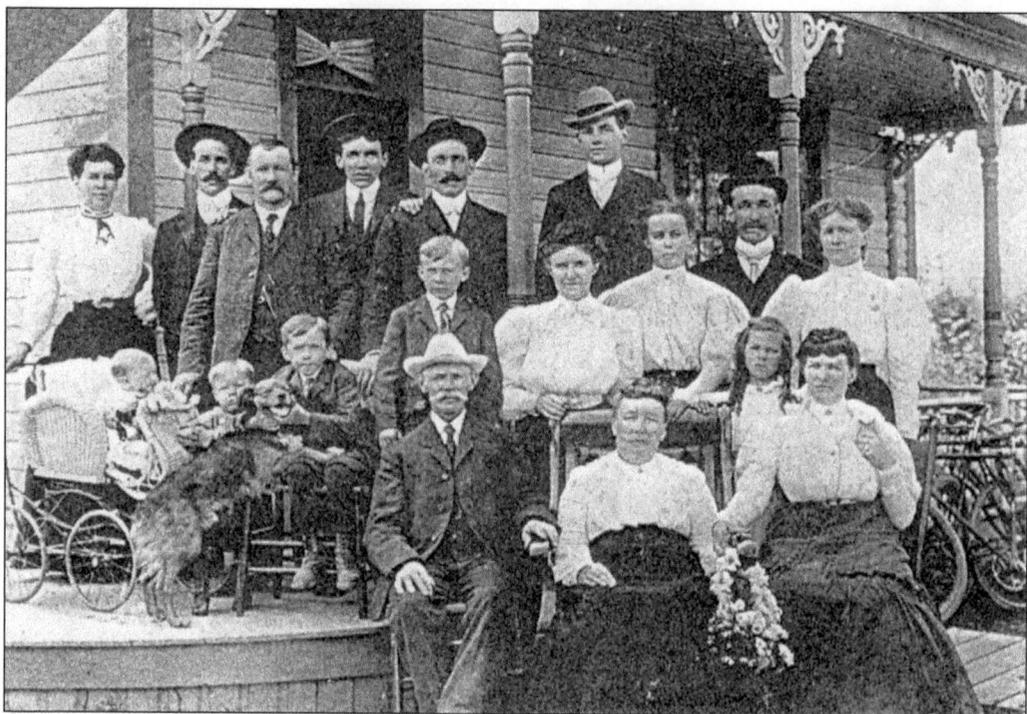

This is the Bergman family home on Marshall Street, 1905. Mr. Bergman started the Star Grocery store in Sedro-Woolley.

The Renfro home on Warner Street was built in 1905. Seen from left to right are Flora, Sarah, Gussie, Harold, and James. Plans for this home were purchased from Sears and Roebuck Catalog.

The Bingham Mansion on Talcott Street was a Dutch colonial style home. Built initially as a five-room house in 1892, the house grew to its present size as the Bingham State Bank prospered. Added were the ballroom, billiard room, maid's quarters, five fireplaces, and seven bedrooms.

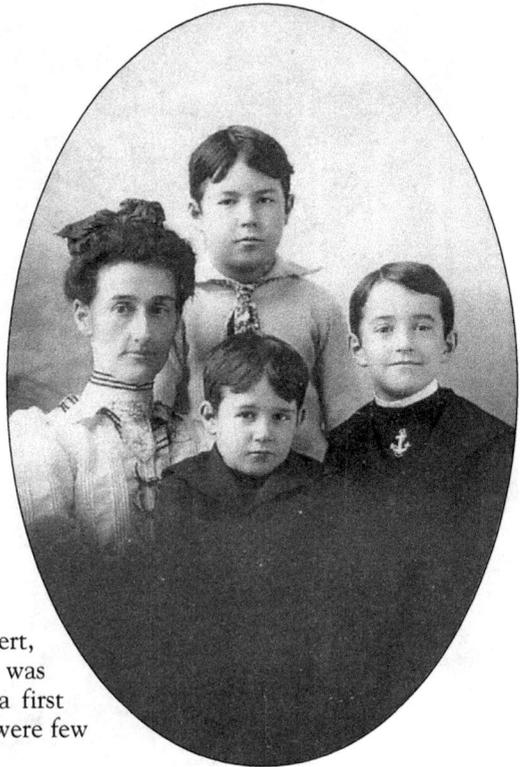

Julia Bingham is pictured with her boys Albert, Quinby, and Charles (standing in back). Julia was responsible for bringing her two sisters and a first cousin to Sedro to marry eligible men. There were few eligible ladies residing in town.

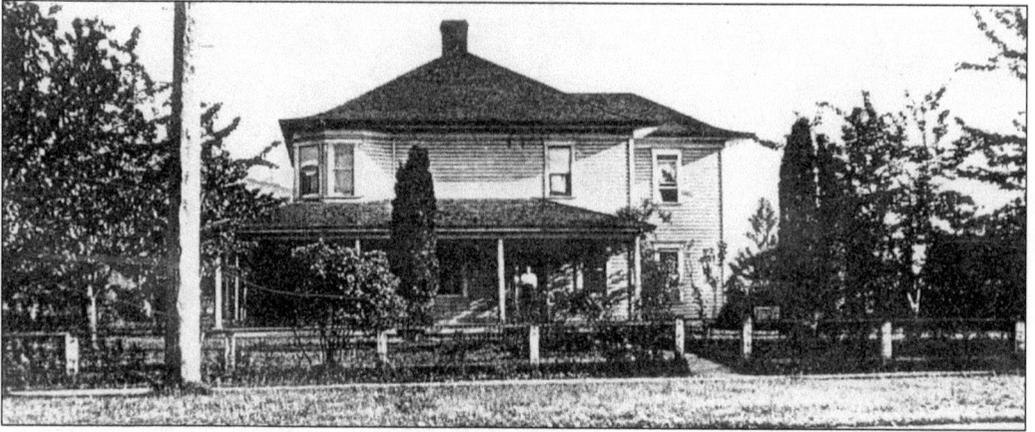

The Douglass Family home was located on Ferry Street. Frank A. Douglass was the pioneer druggist in Woolley.

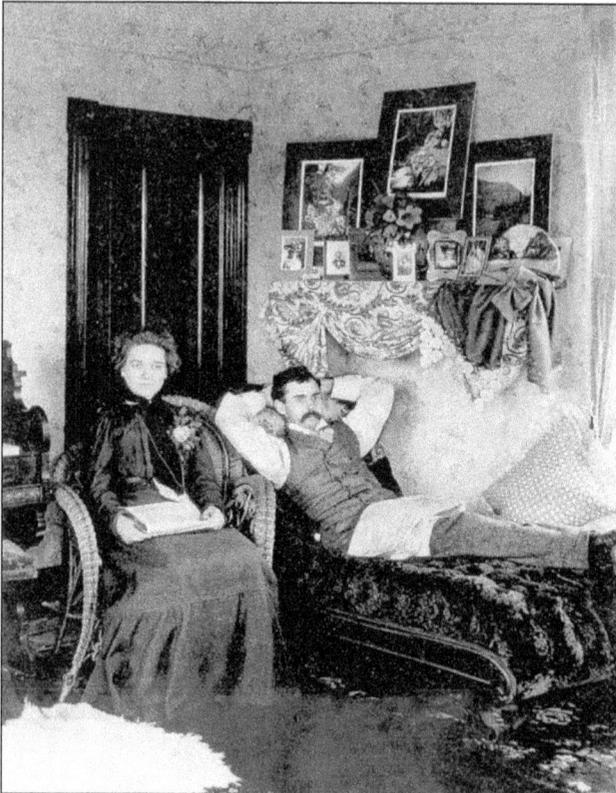

Darius and Tabitha Kinsey lived in a home on Sedro-Woolley's Talcott Street in 1900. The furnishings were purchased from Fredrick and Nelson's, a Seattle department store.

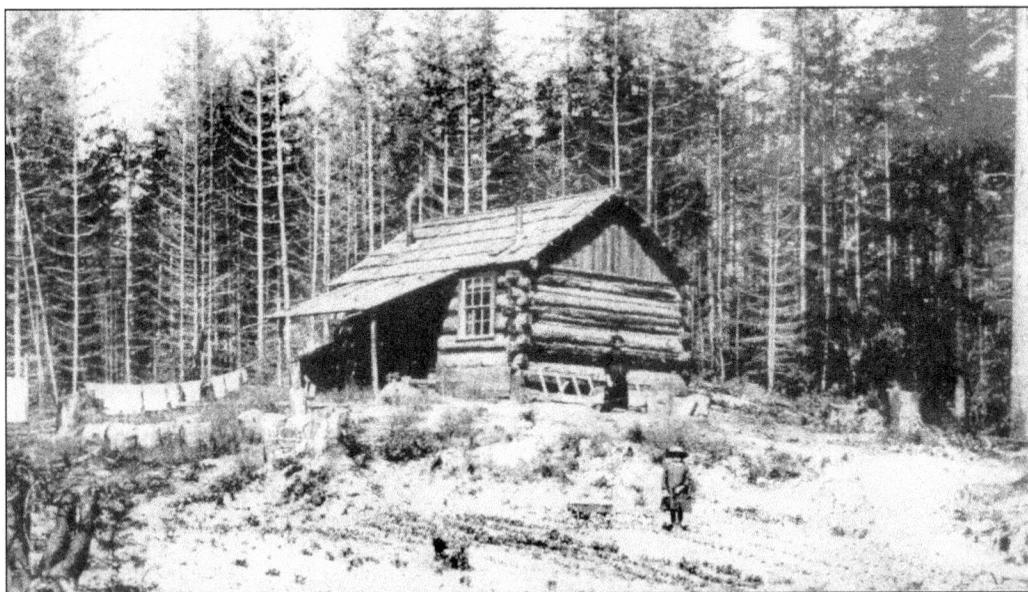

This is an example of an early log home with a garden and a cold frame next to the house.

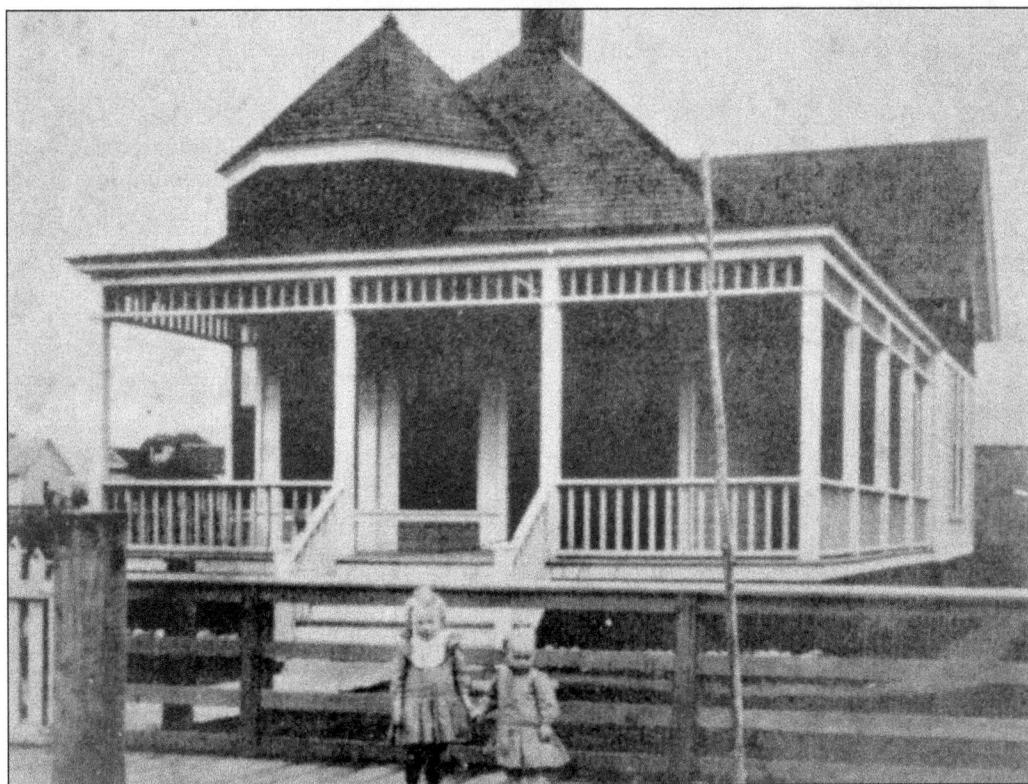

The LaPlant home was built in 1892 by J.B. Alexander. He lived there until 1897 when it was sold to W.T. Odlin. In 1900, J.C. LaPlant bought the home. It was then nicknamed "The Honeymoon Cottage," because both the Odlins and LaPlants moved in as newlyweds. The two boys are Lawrence and Porter LaPlant.

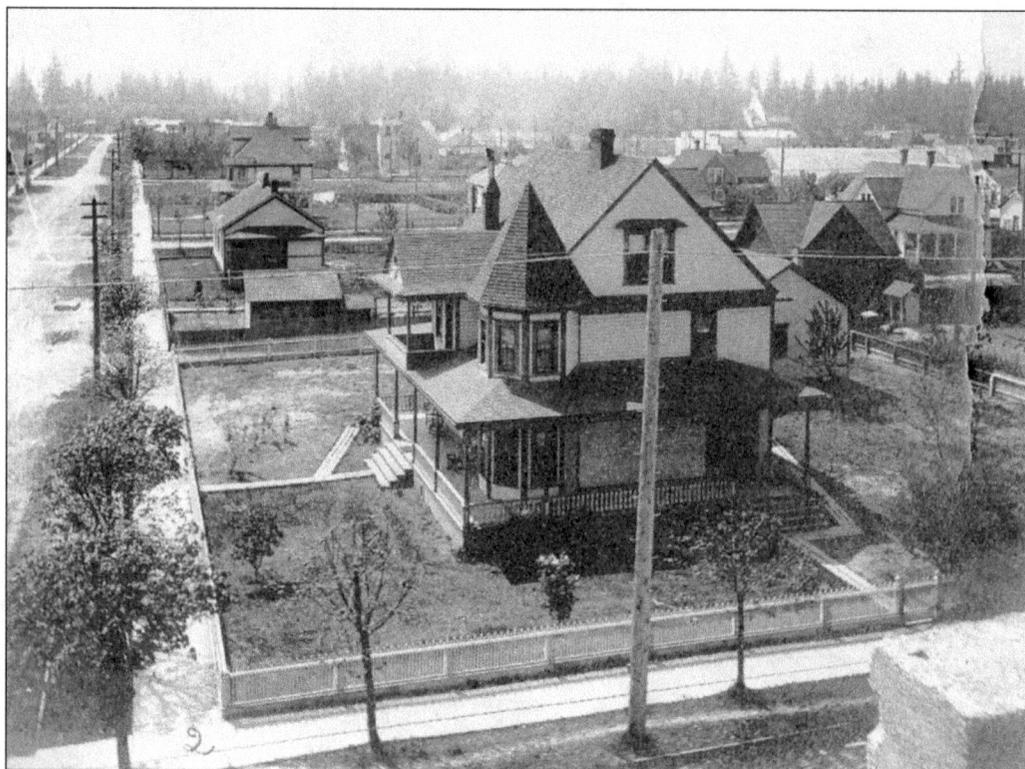

This photo of State Senator Emerson Hammer's home was taken from the roof of the Episcopal Church. This photo was part of a panorama taken in 1910 by Sedro-Woolley photographer LaRoche. Notice the wooden sidewalks.

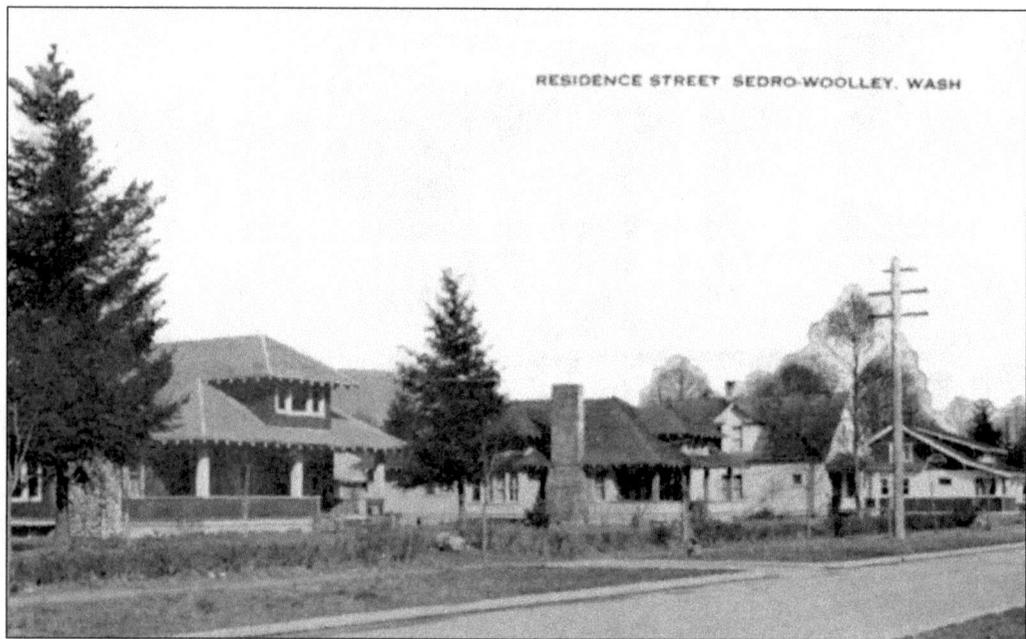

RESIDENCE STREET SEDRO-WOOLLEY, WASH

These stately homes are on Ferry Street in Sedro-Woolley.

Three

TRANSPORTATION

There is an old Eastern proverb that states: "The acts of this life are the destiny of the next." This proverb pertains to the progression of transportation in the Sedro area.

For when the early settlers arrived the only means of travel into our part of the county was by canoe. This method was difficult at times. They had to pole the canoe upriver, going against the current.

Once the men removed the logjam, sternwheelers, which were steam powered, arrived. They brought supplies to the settlers and hauled the settler's products out. Sternwheelers were used because of the shallow draft and rear paddles. They did not need a dock; they could nose into shore, leaving the paddles in deep water.

The pioneers built cable ferries across the river and developed dirt trails into roads. Phillip Woolley worked to bring three different railway lines to the area. This one act brought prosperity to the towns known as Sedro and Woolley.

This chapter is devoted to showing the reader the different modes of transportation that developed through the years. We hope that we have depicted how the actions taken by the early pioneers impacted the lives of the future generations.

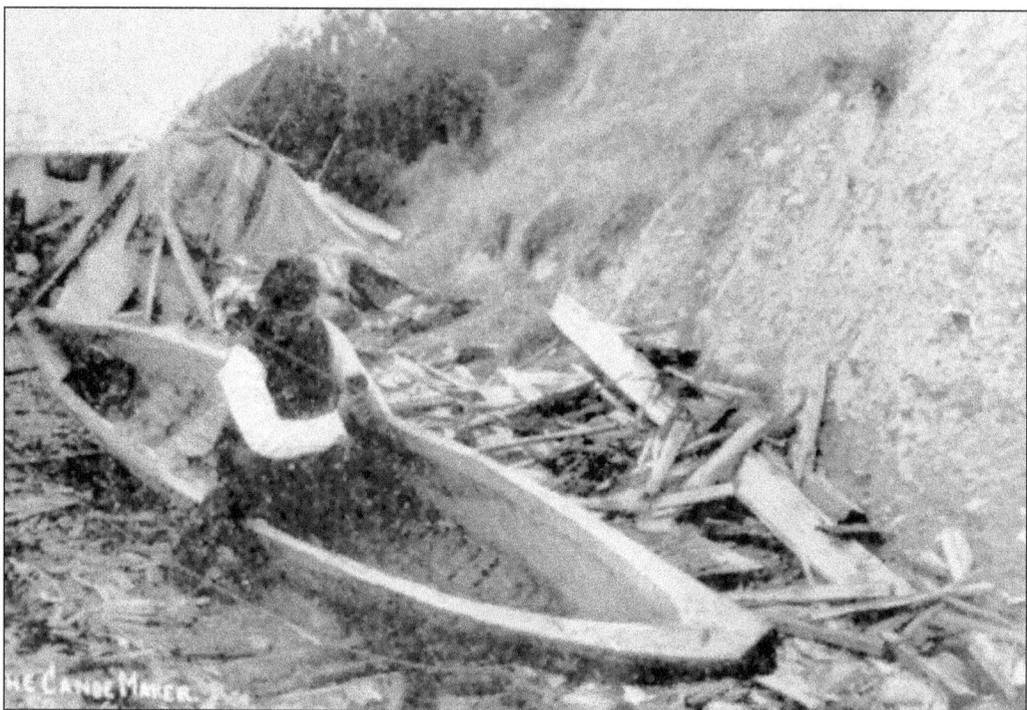

This picture of an Indian dug out canoe construction is taken from the *History of Skagit and Snohomish County, 1906*. Canoes ranged in size from the two-man to one that would hold eight to ten people or more.

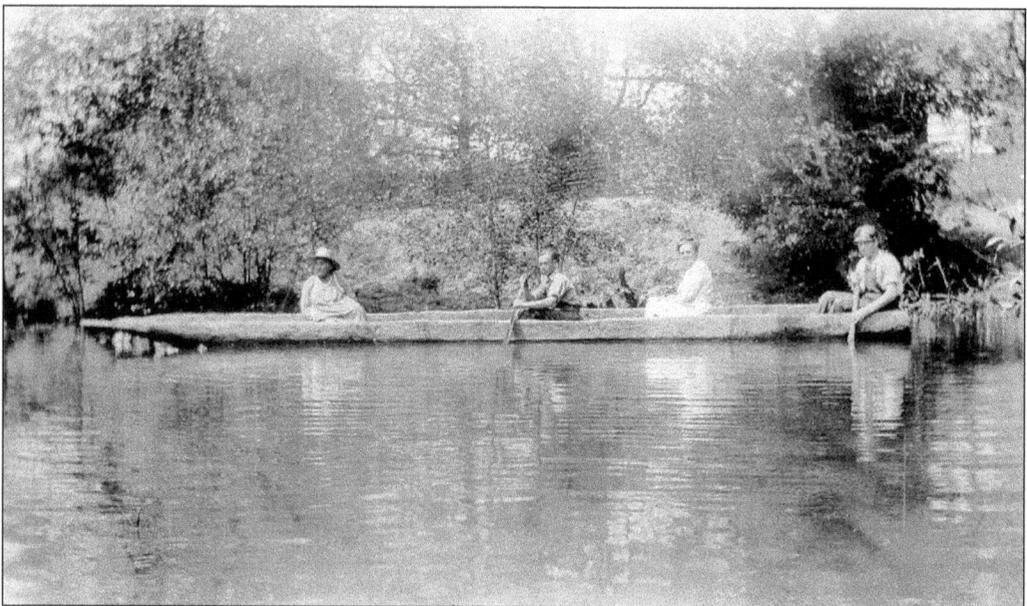

Here is an outing on the Skagit River in a dug out canoe, May 19, 1925.

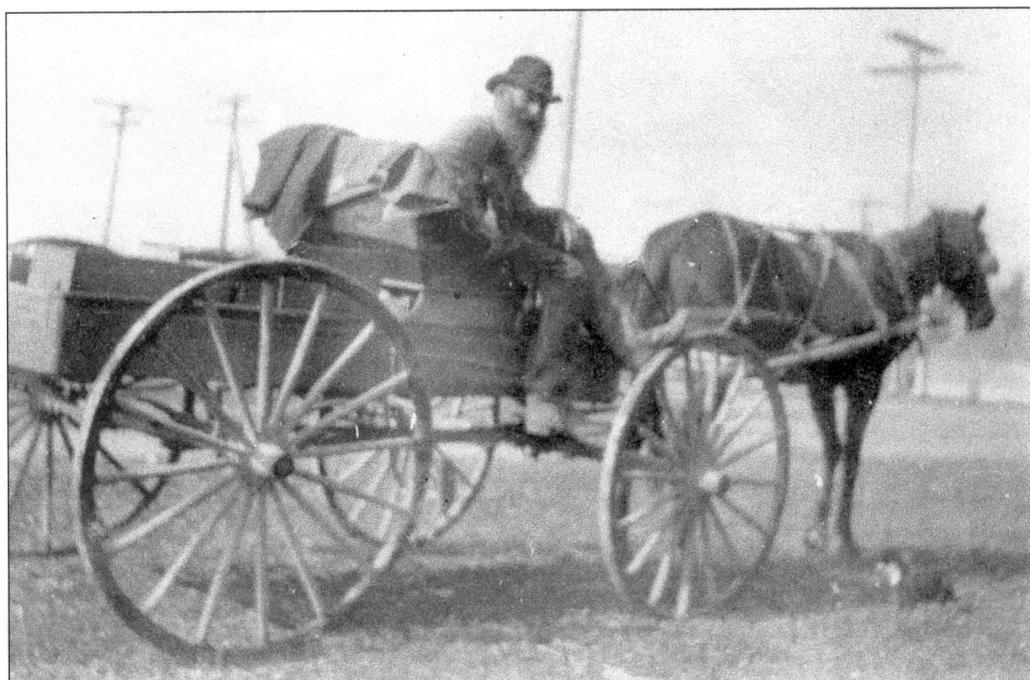

Emmett Van Fleet in his buckboard is shown here, *c*. 1910.

Hoehn's Livery Stable is the building on the right; Ratchford's Blacksmith's shop is on the left on Murdock and Ferry Street, *c*. 1912. They relocated after being burned out in the 1911 fire.

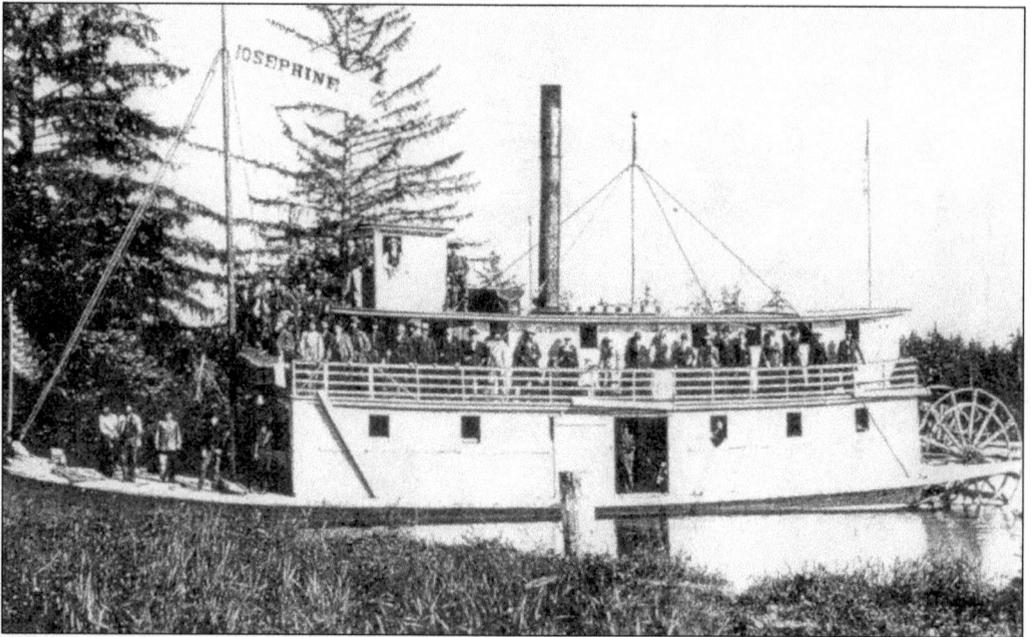

This is a picture of the *Josephine* nosed into shore on the Skagit River. Newton Hartman was captain of the sternwheeler when her boiler exploded in 1883. Eight people were killed, including Sam Kavanaugh, the Native American son of Indian Princess Tol Stola.

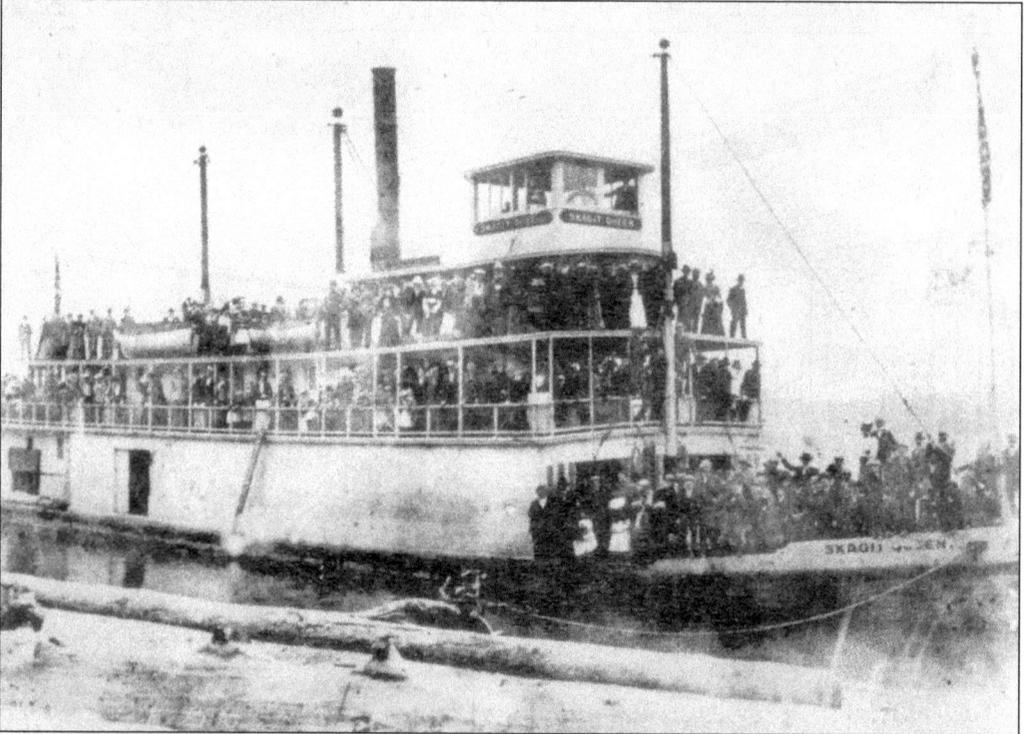

This photo of the maiden voyage of the sternwheeler *Skagit Queen* was taken in 1901. The *Skagit Queen* was used both as an excursion boat and to haul products to Seattle.

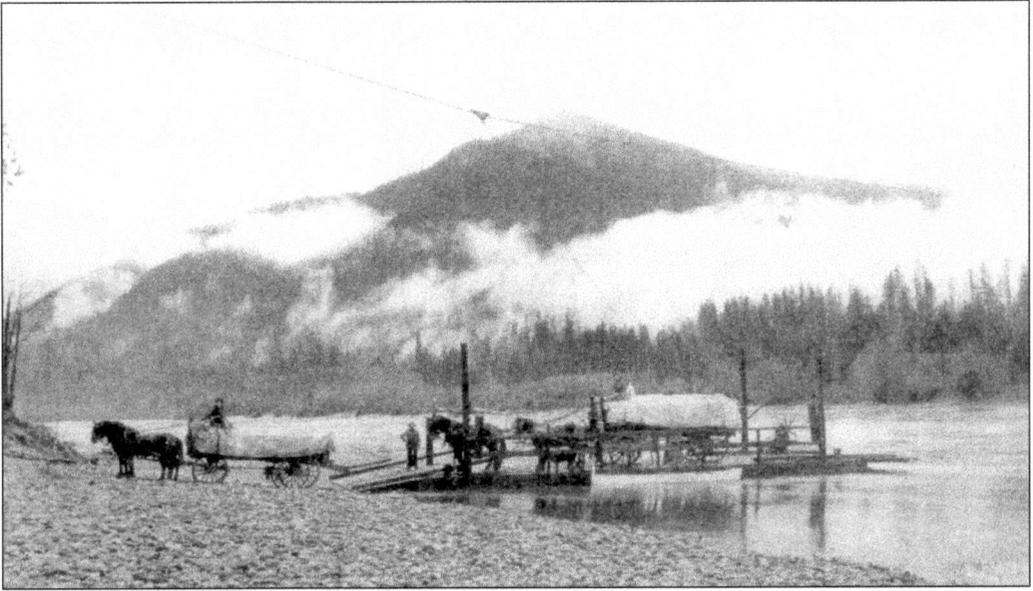

This cable ferry traveling across the Skagit River is a good example of the kinds of loads they hauled across the river. Notice the cable line overhead and Coal Mountain in the background. This was probably the Lyman to Day Creek ferry.

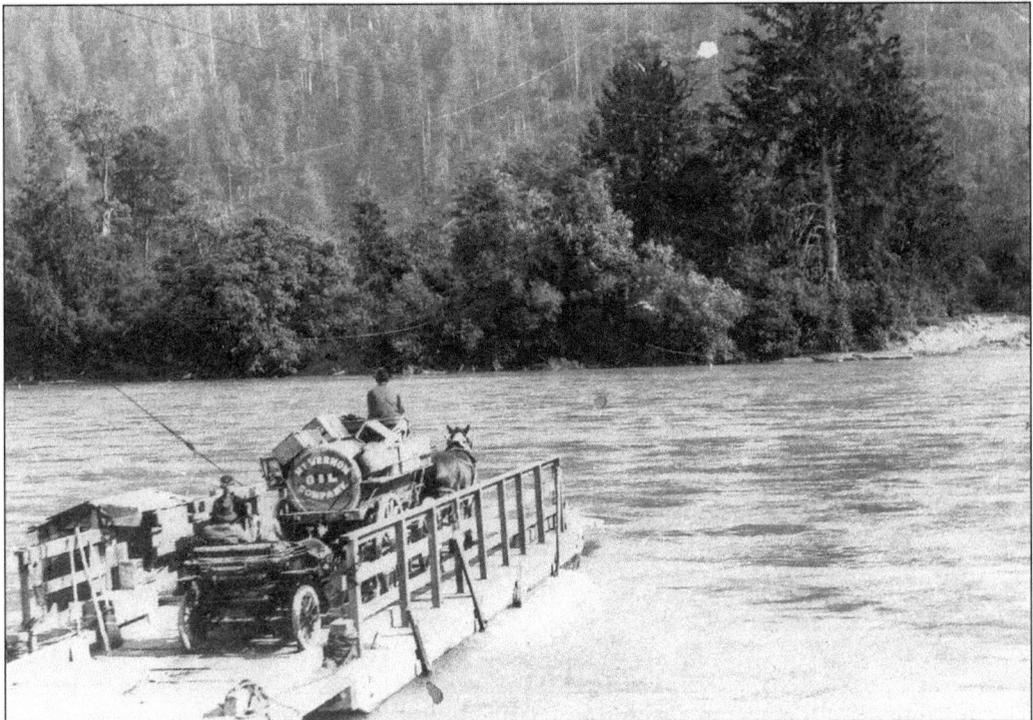

This cable ferry is traveling across the Skagit River in Sedro-Woolley.

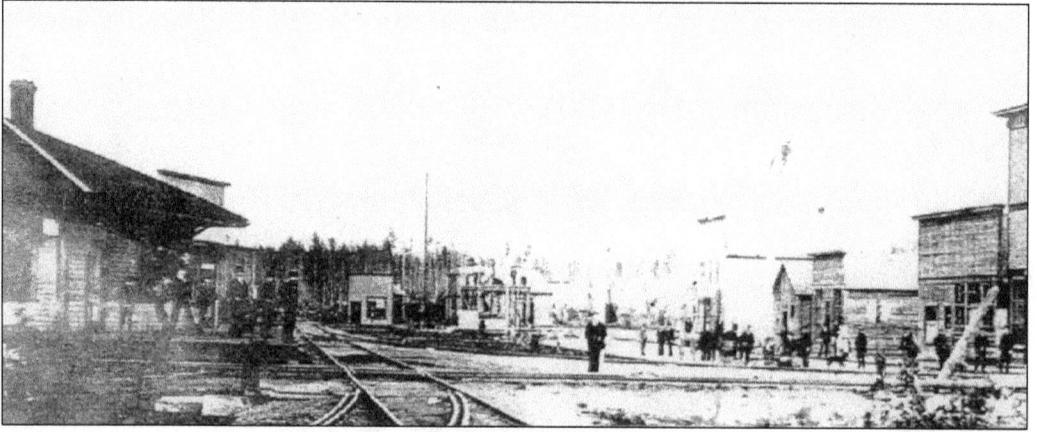

The Seattle and International depot in Sedro-Woolley, pictured here in 1898, was moved August 1, 1901. It eventually became the Northern Pacific Depot.

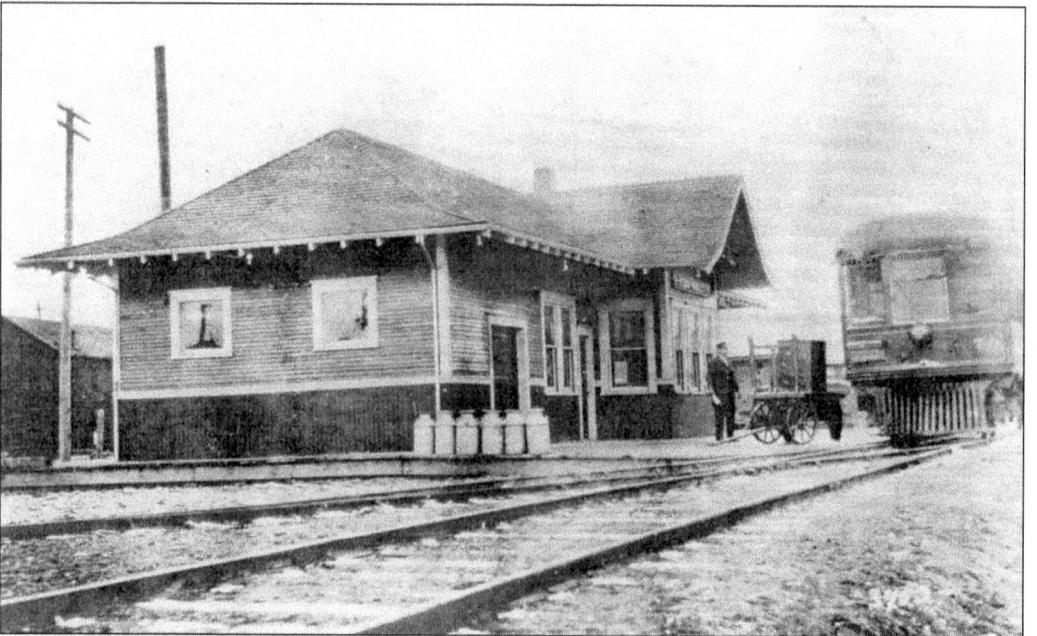

This interurban station, pictured with the electric Interurban passenger train at the depot, was located on Ferry St, west of the railroad tracks, on the southwest corner of Ferry Street.

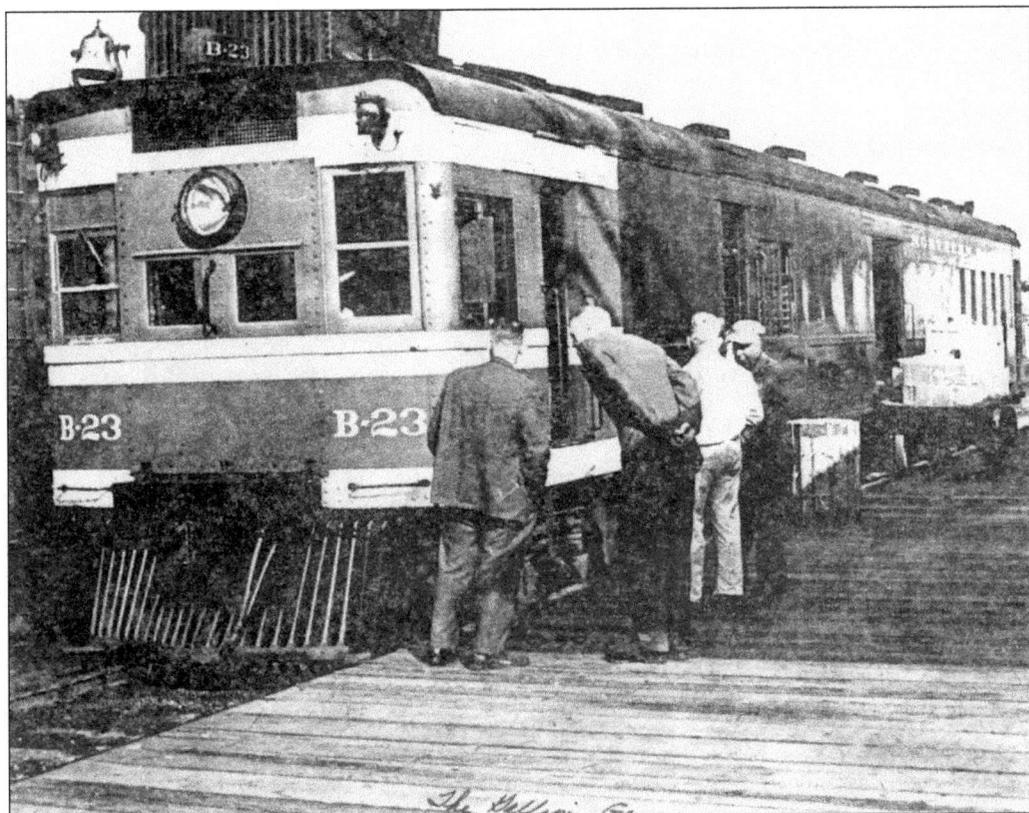

The *Galloping Goose*, a gas-powered passenger train, had a single car that ran over the mainline.

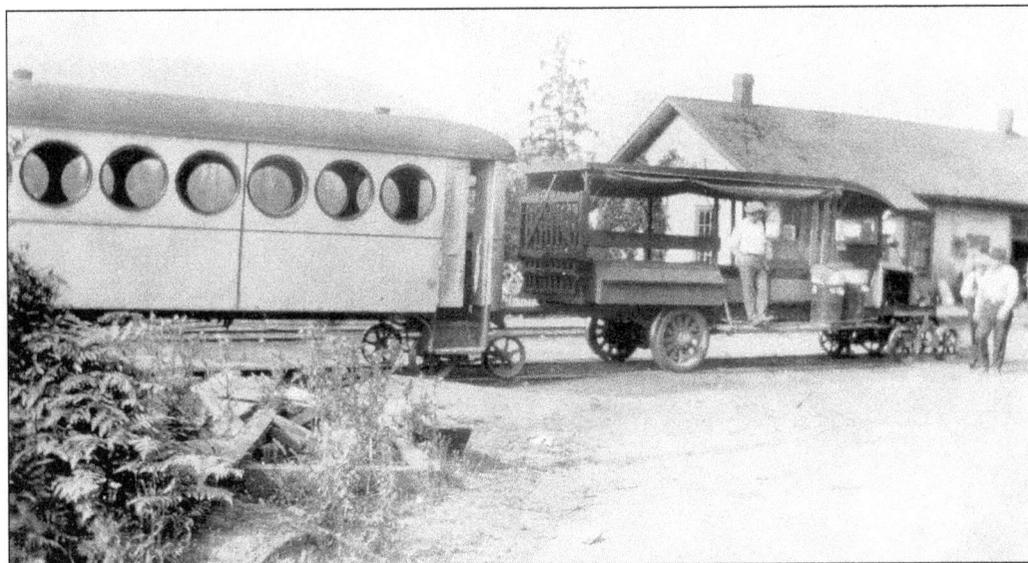

The *Tunnerville Trolley*, pictured on August 13, 1923, ran between Sedro-Woolley and Concrete.

This typical rural scene shows Carl Freeman standing in front of the old car.

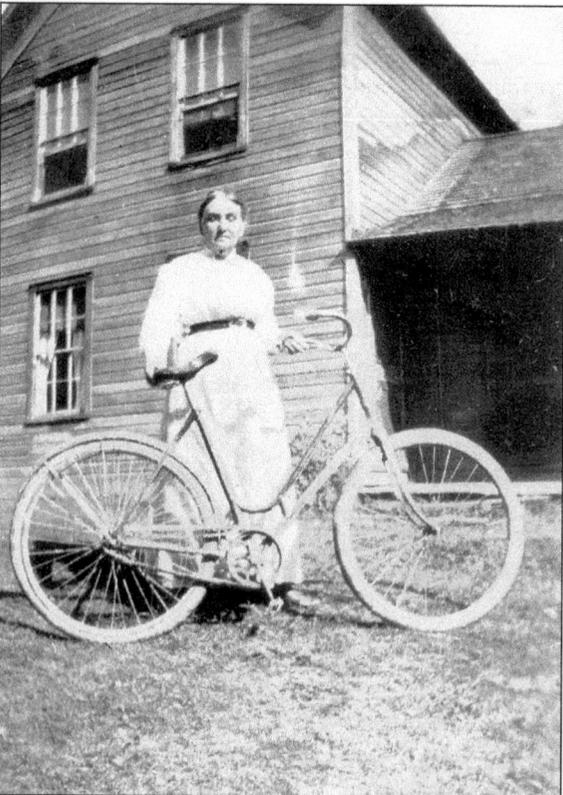

Eliza Van Fleet stands next to another form of transportation widely used—the bicycle.

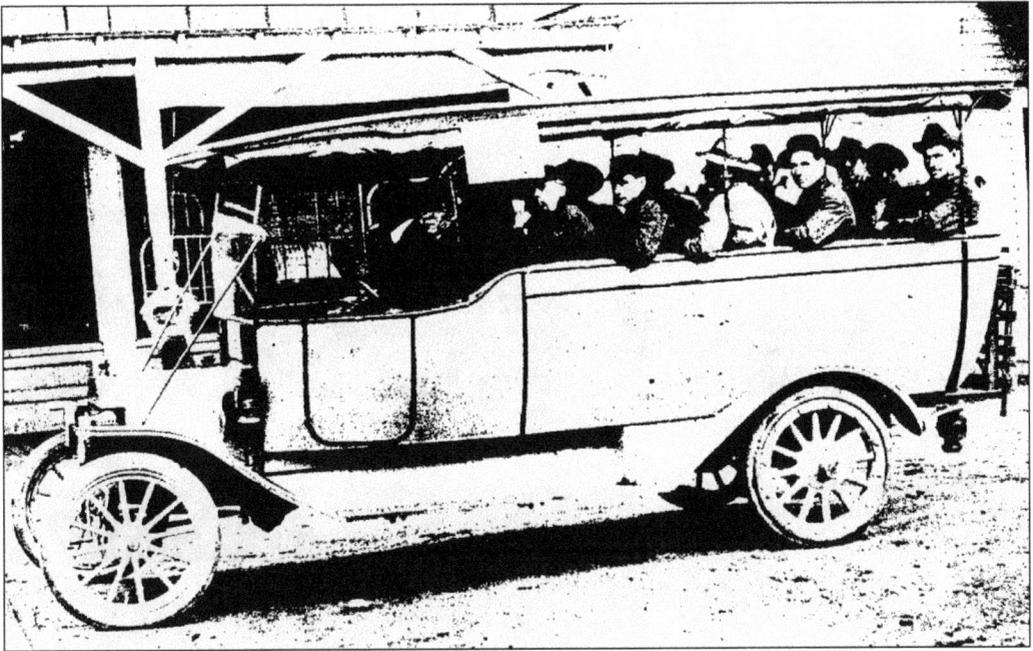

This taxi ran from Sedro-Woolley through Clear Lake to Mount Vernon, Washington.

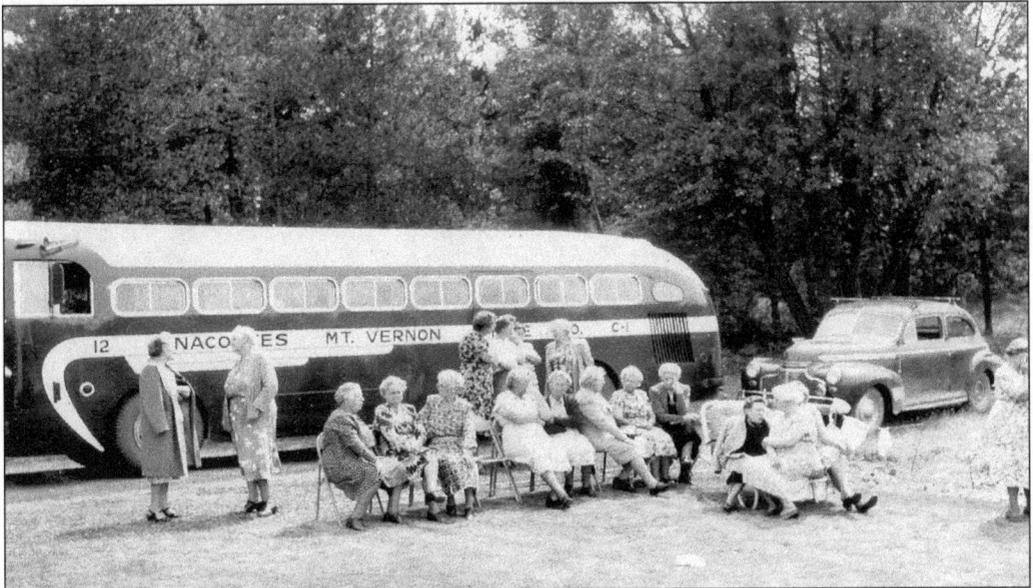

The Anacortes-Mount Vernon stage, the ever faithful green and white bus, operated in the county until the mid 1960s, stopped regularly at the Gateway Hotel in Sedro-Woolley. The stage line was operated by David A. Affleck of Sedro-Woolley and his brother William Affleck of Anacortes.

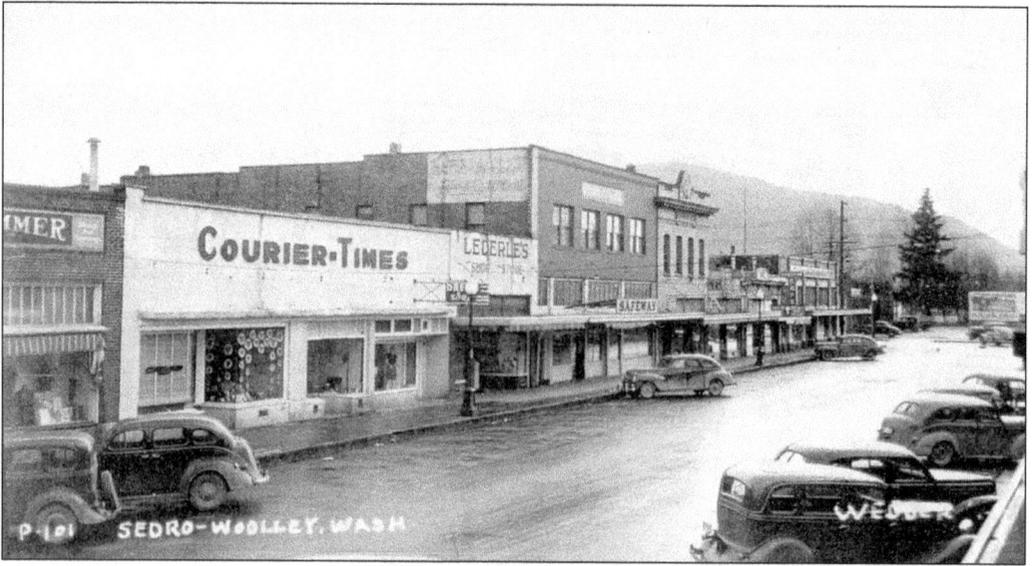

Downtown Sedro-Woolley is shown here in the early 1920s.

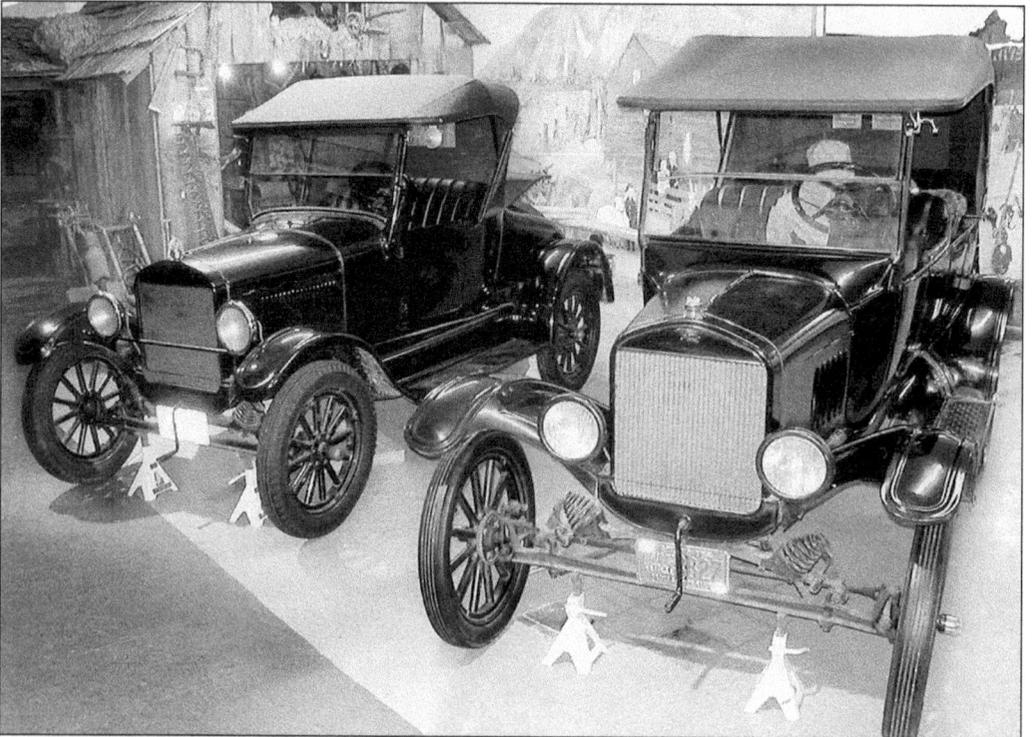

The Sedro-Woolley Museum's Model Ts are on display; on the left is the 1926 Ford coup, which cost $260 when it was new. On the right is a 1924 Ford touring car, priced at $295 when it was new.

Four

LOGGING AND MINING

"We who would really benefit mankind must reach them through their work," so said Henry Ford. The loggers and miners worked hard and the benefit of their efforts reached and enhanced not only their small communities, but all parts of the county.

This chapter will briefly cover the mining that brought prospectors to the area. The Ruby Creek gold discovered in 1877 was short-lived. The gold was hard to get; it was encased in hard rock and high up in the mountains. Coal and iron that was discovered was of low quality.

The Cokedale mine that is now part of rural Sedro-Woolley prospered for several years. A community of Cokedale sprang up but the mine did not survive much past World War I, closing in 1920.

The main focus of this chapter will be on the logging industry. Sedro-Woolley has become known as "The Town that Logging Built." Logging actually began when the pioneers cleared their land. Once the land was cleared there were still dense forests which attracted loggers. Logging in the northwest presented its own set of problems and special equipment was developed to cut down the giant Douglas firs. Mortimer Cook was the one that discovered that drying the shakes made them easier and cheaper to ship. Darius Kinsey chronicled the logging industry and many of his photos are reproduced in this chapter.

In the glory days of logging there were logging companies, shake and shingle mills, saw mills, and millponds. This chapter will cover the progression of logging from the early use of oxen and horses to the modern logging equipment developed by Sedro-Woolley's Skagit Steel, Inc.

This photograph of the mill of the Mammoth Gold Mining Company on Slate Creek was taken in 1927. Slate Creek is not far from the Ruby Creek Mine.

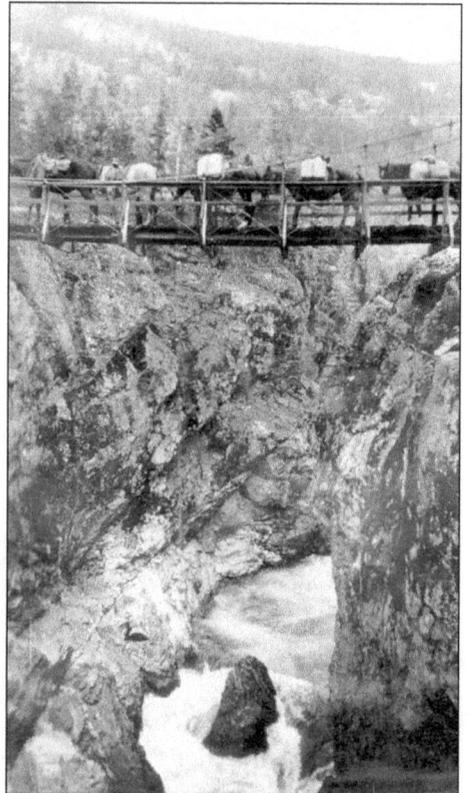

Ruby Creek bridge over the upper Skagit River is being crossed with packhorses.

The Devil's Elbow trail on the way to Ruby Creek began at Goodell's landing and was clear at first but it got worse as you went. The Devil's Elbow, or corner, was a sheer bluff overhanging the trail.

Here a typical miner pans for gold.

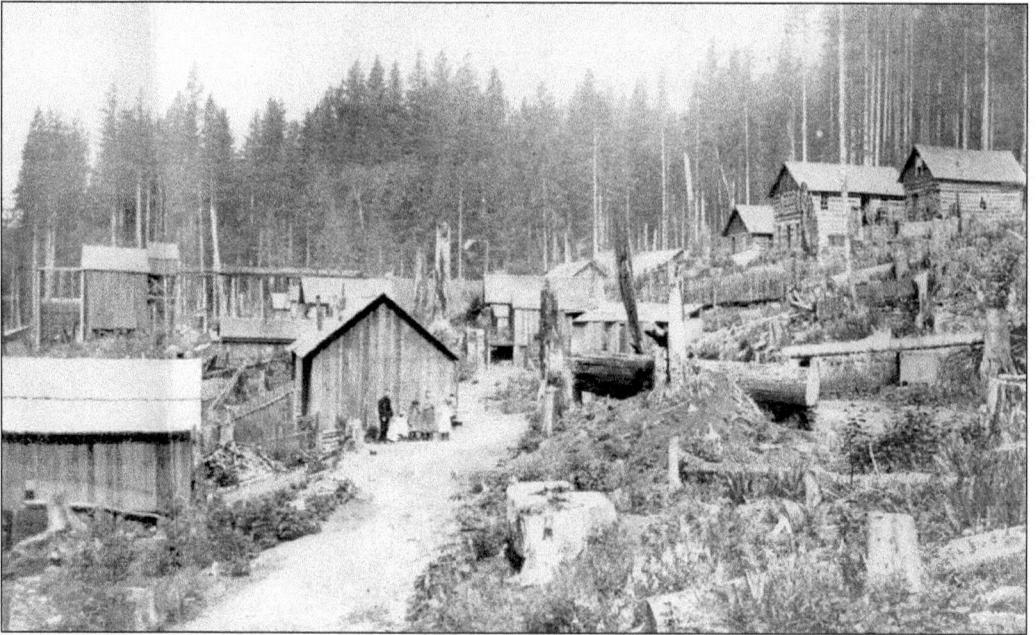

The community of Cokedale sprang up around the Cokedale mine, pictured here *c.* 1902. This was the first phase of the community. The second opening of the mine began in 1917; it finally closed for good in 1920.

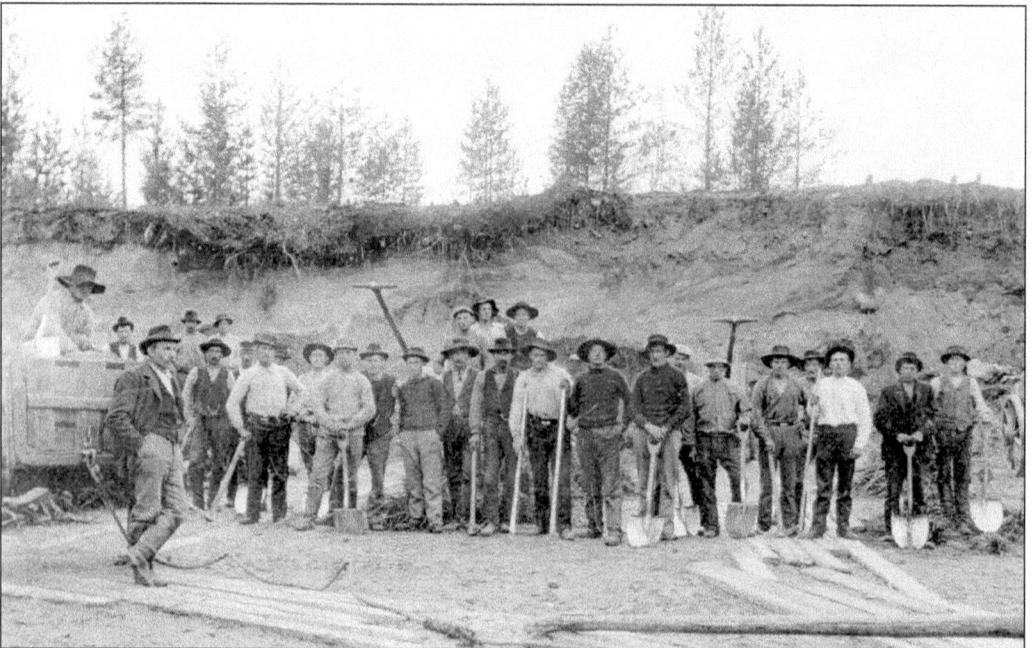

The clay that this crew is mining was used for brick-making in Sedro-Woolley.

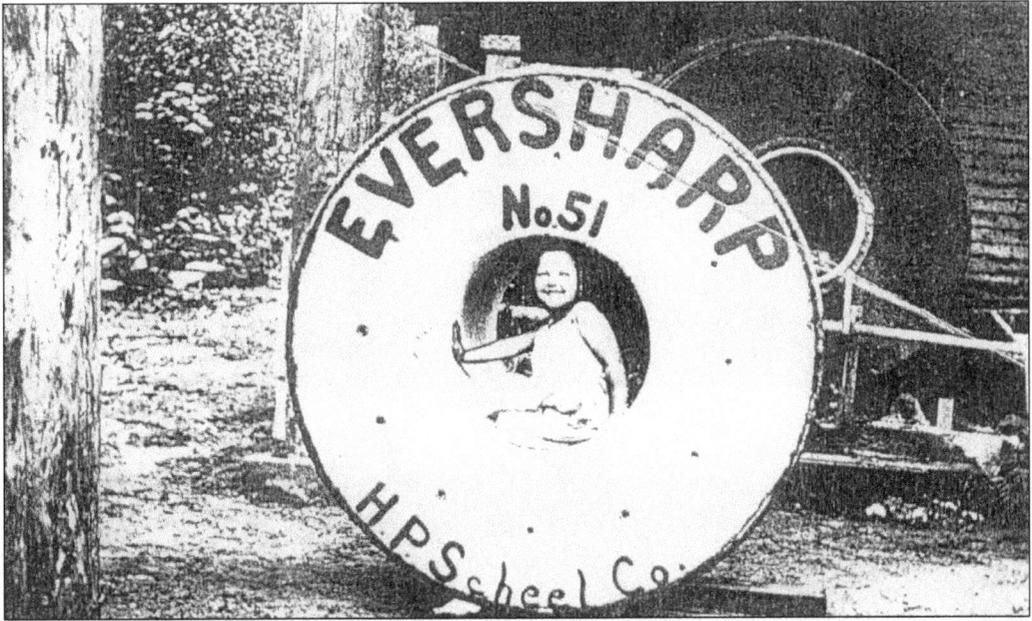

This finished pulp stone was made by the Eversharp Pulp Burr Co. in 1928. The child is Rosalie Scheel Schanzenbach.

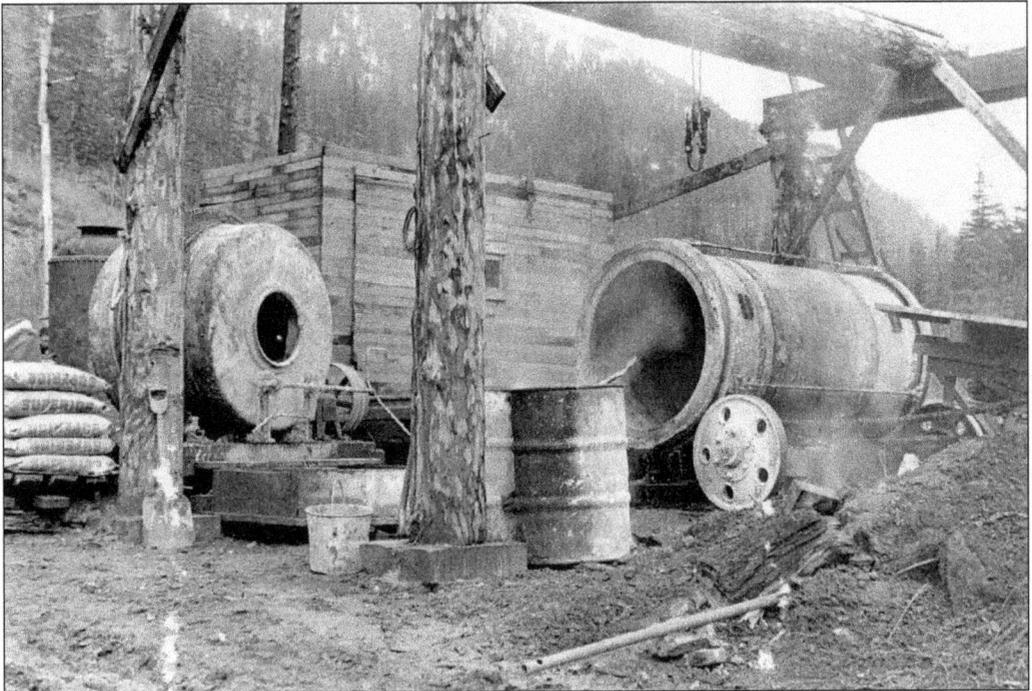

These molds made pulp stones used in paper production. Silica mixed with concrete was used as the abrasive.

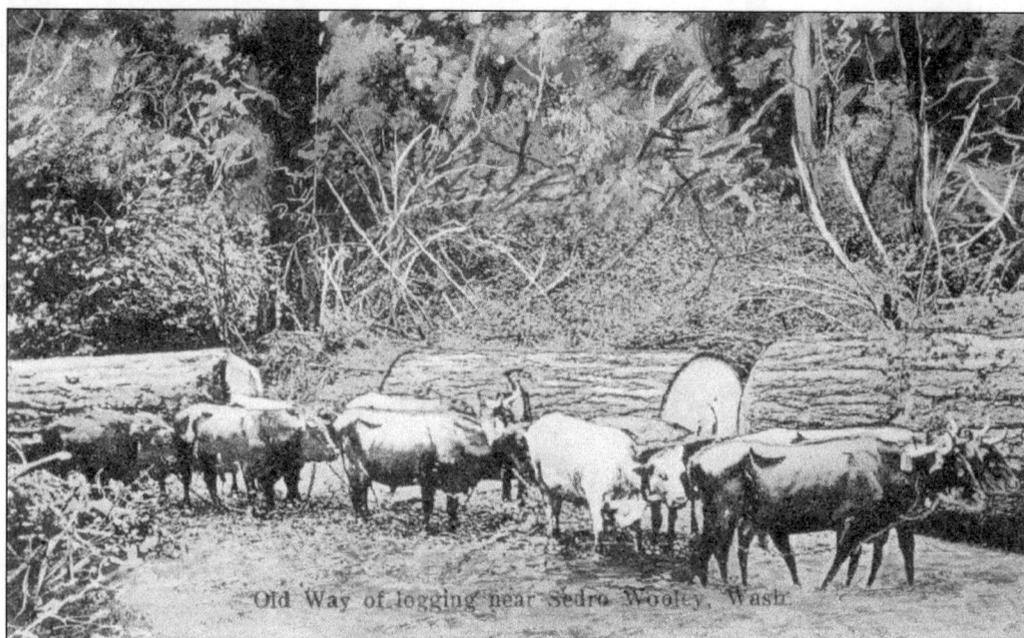

This is the old method of oxen logging near Sedro-Woolley.

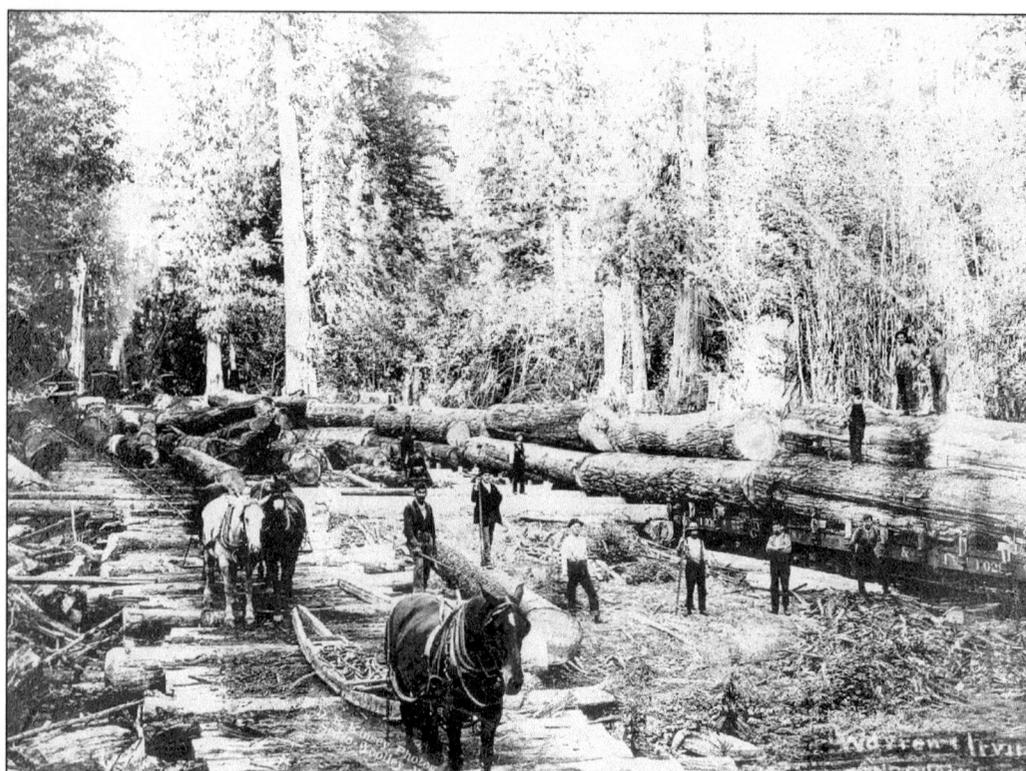

The logs the horses are working on are called a skid row. The skid row was made of skinned logs placed as a road out of the woods. This method made it easy to drag the downed trees out of the forest. Bull punchers stand ready with sticks to prod the team forward.

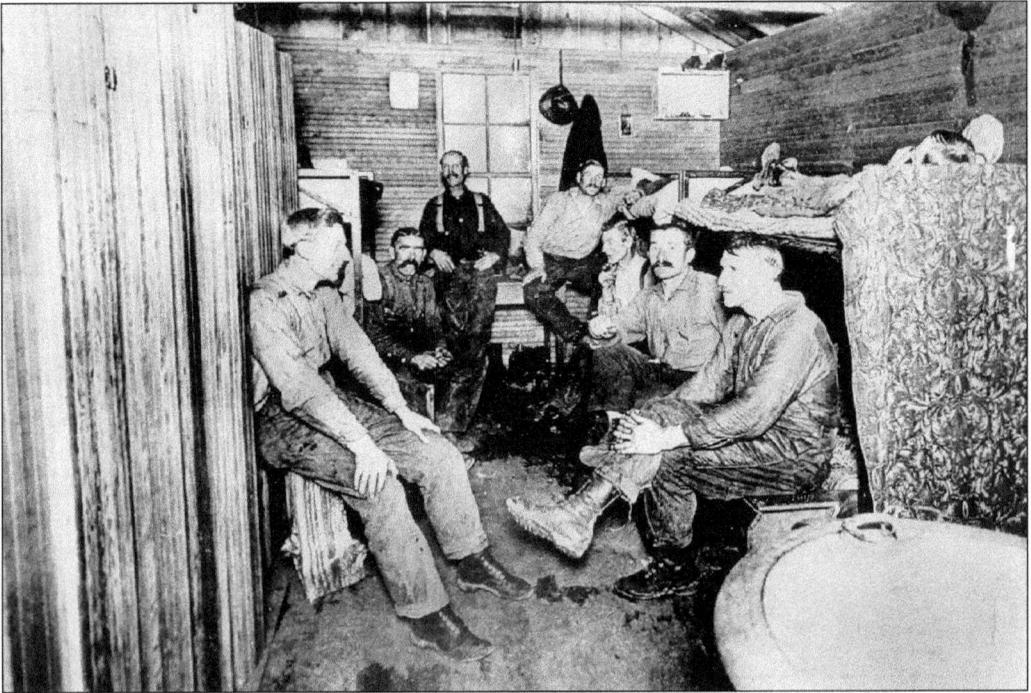

Loggers worked six days a week and lived at the camp. They slept in a one-room bunkhouse, such as the one shown above, with a stove, which they used to dry their clothes overnight.

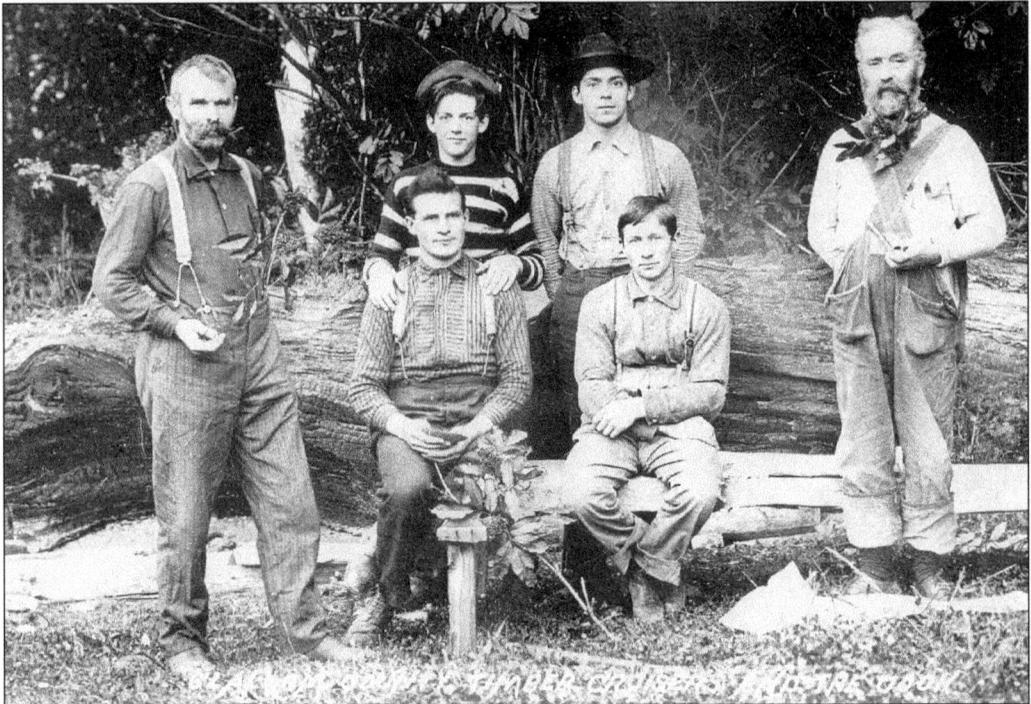

Timber cruisers were scouts sent into the woods to find the best trees and location in which to set up a lumber camp.

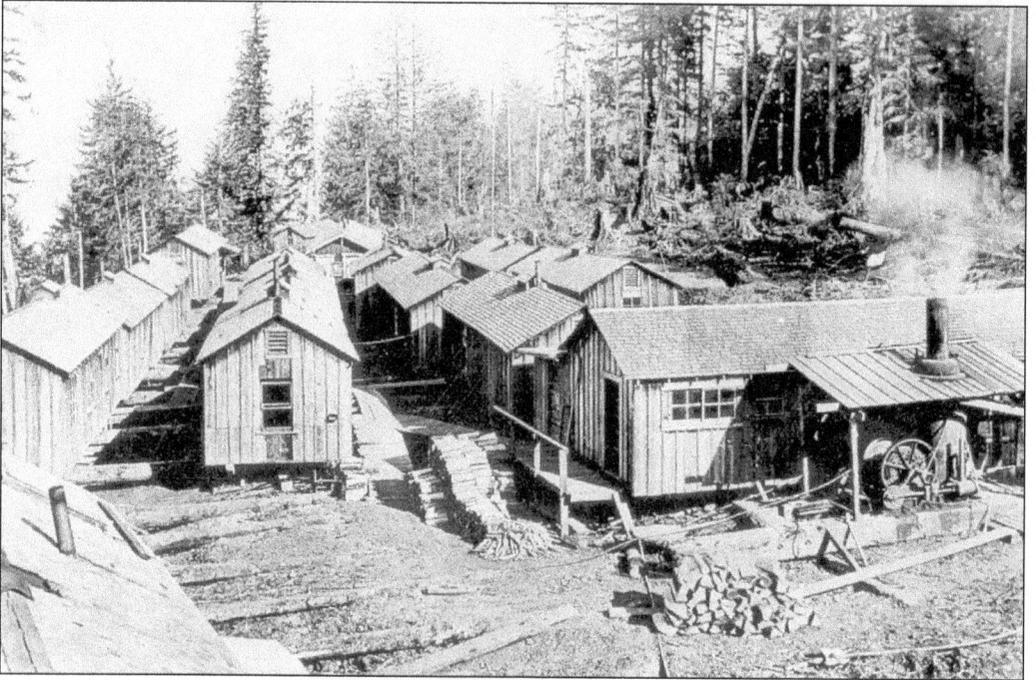

In this typical logging camp with rows of bunkhouses and a cook's cabin, a small yarder next to the one cabin was used for dragging logs into camp to cut for firewood.

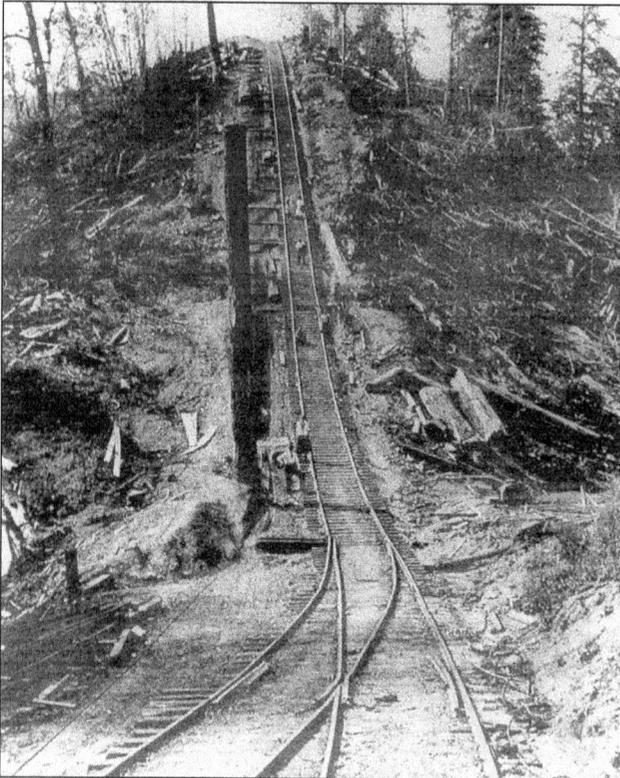

This incline was where flat cars of logs were slowly eased down the steep hill with controlling cables.

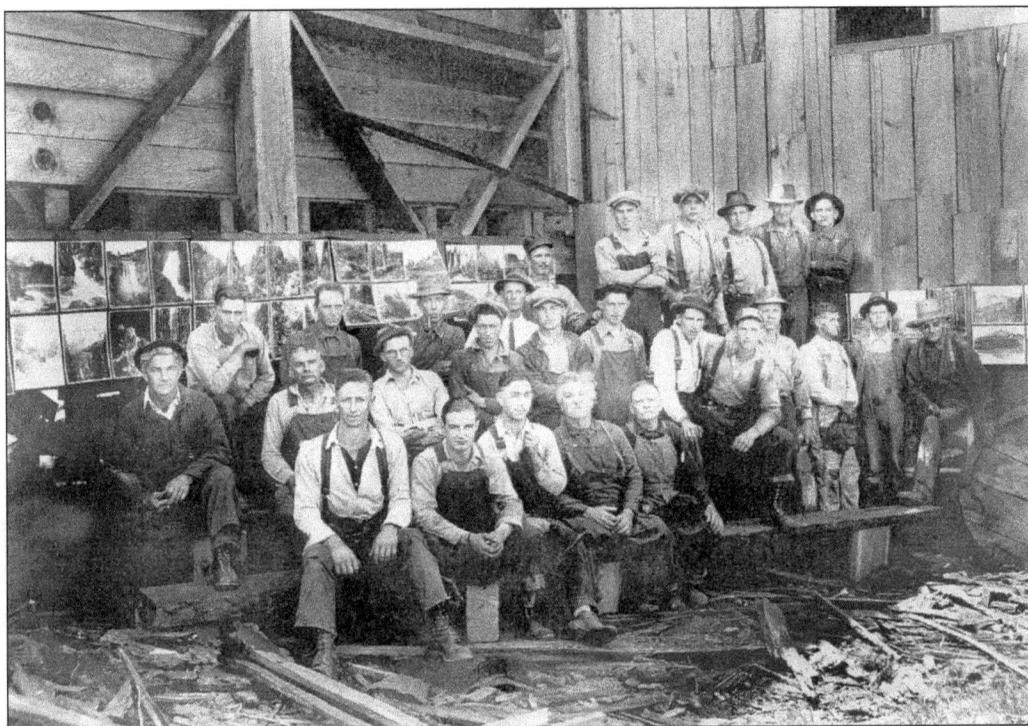

This is a logging camp reload crew. Darius Kinsey took many photographs of mills, logging camps, and their crews. Notice the pictures on the back wall. Kinsey would display many of his previous photos so the crews could purchase them.

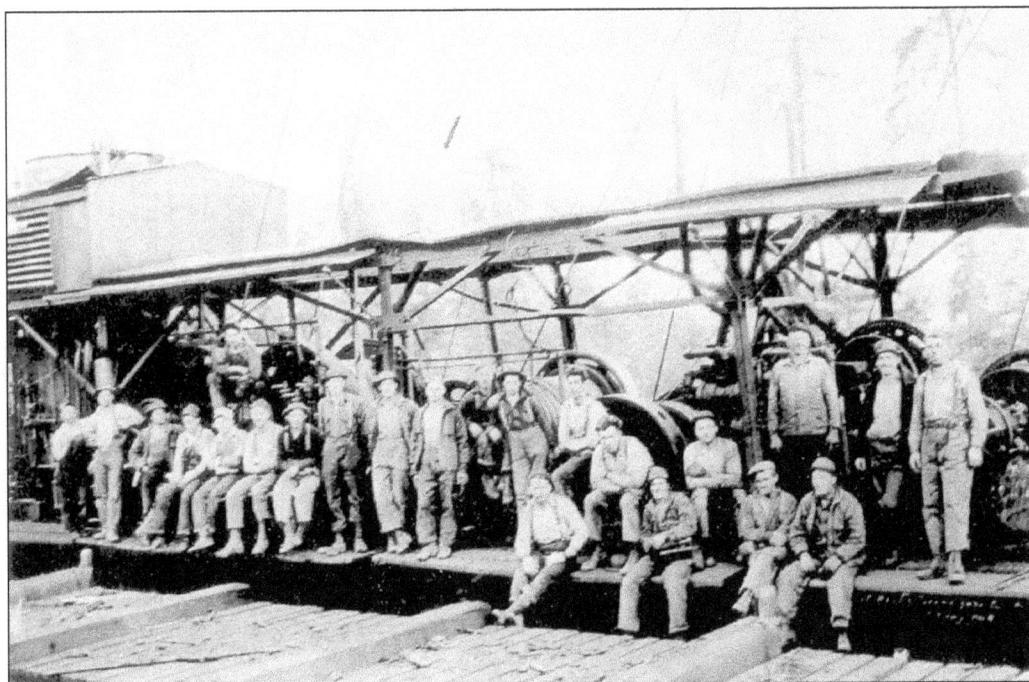

A steam donkey crew poses for a Darius Kinsey photo.

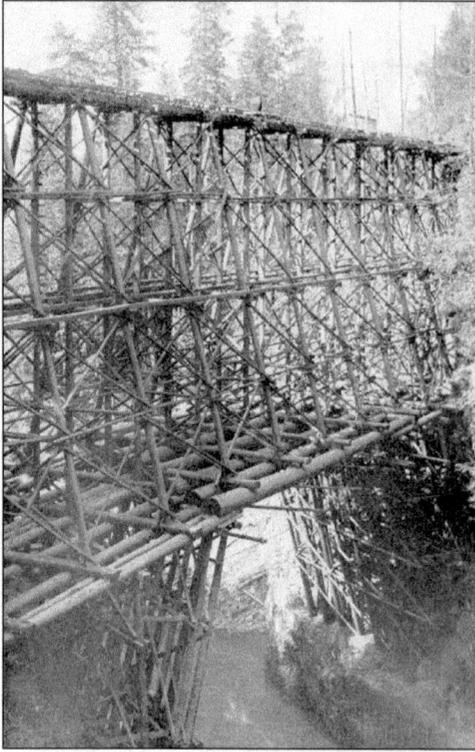

Also a Kinsey photo, this is the highest single pole trestle or bridge in the world. This is a good example of how the trestles were built.

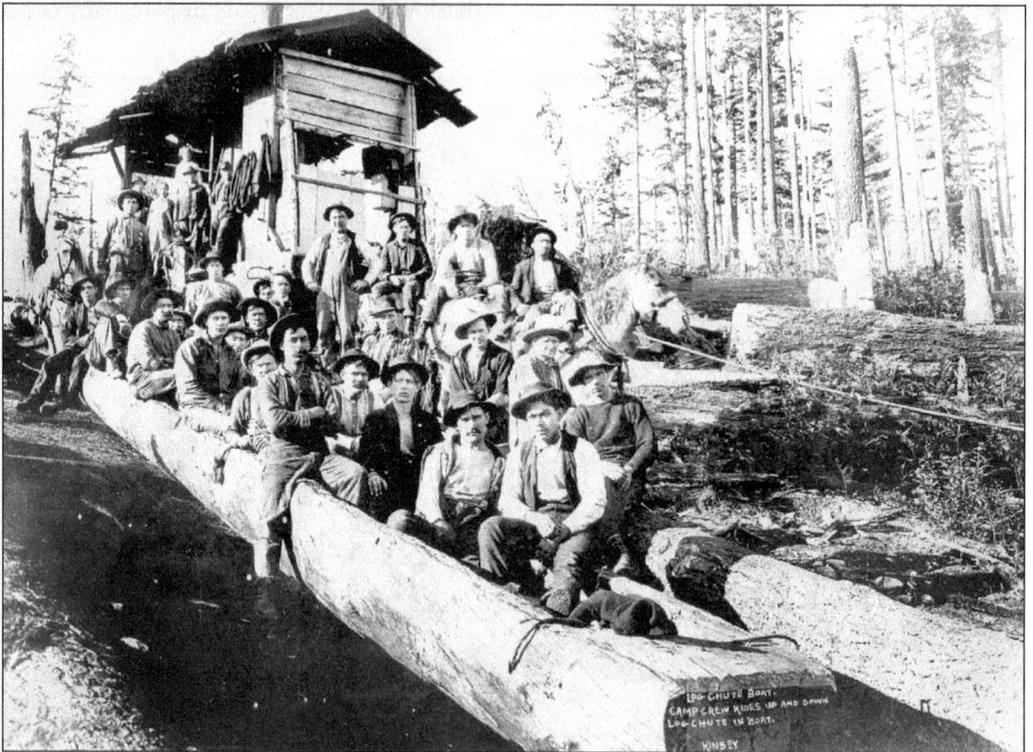

This Kinsey photo shows a log chute boat used by camp crews to ride up and down the hills.

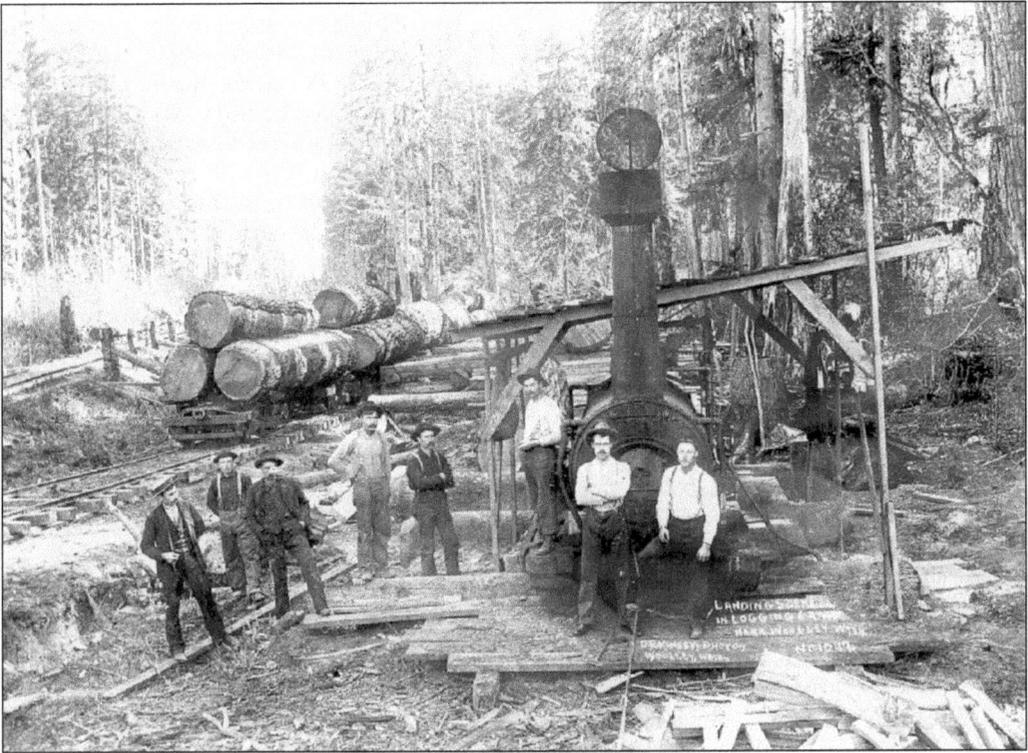

In this landing scene in a logging camp near Woolley, Washington, Darius Kinsey is the man at the far left with the straw hat, *c.* 1897.

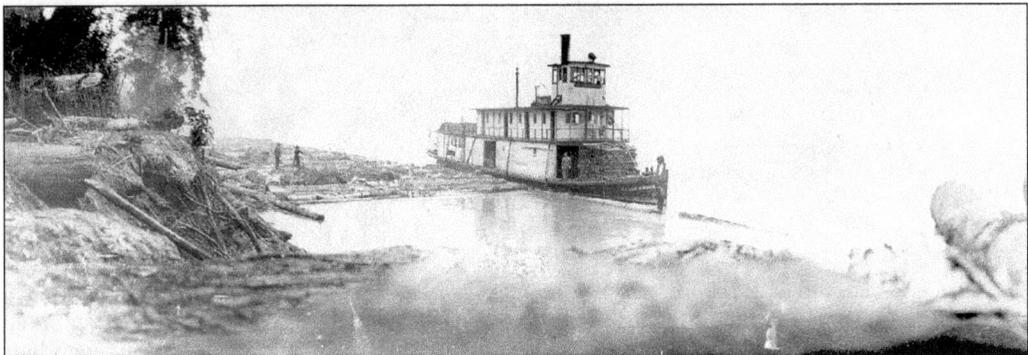

The *Black Prince* boom boat, which guided the log booms down the river to the sawmills.

This labor-saving device operated by one man and a horse was the Pacific Stump Puller, the first product developed by Sedro-Woolley Iron Works, the predecessor Skagit Steel and Iron Works. It revolutionized land clearing in this area. This ad was produced *c.* 1914.

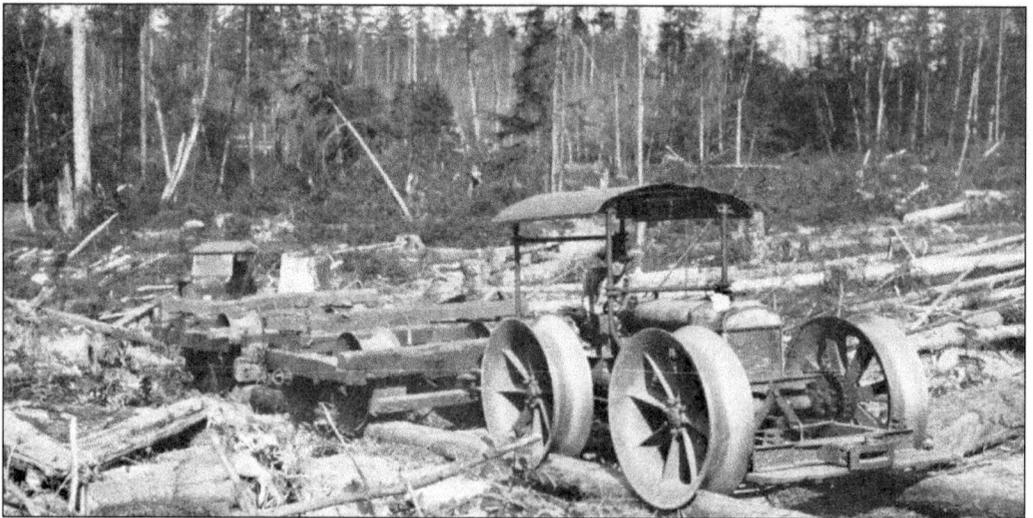

The Mac Tugger was a unique adaptation of the versatile "Little Tugger," the famous Skagit pole road system which enabled the capability of heavy hauling in the logging industry, independent of roads and rail lines, *c.* 1925.

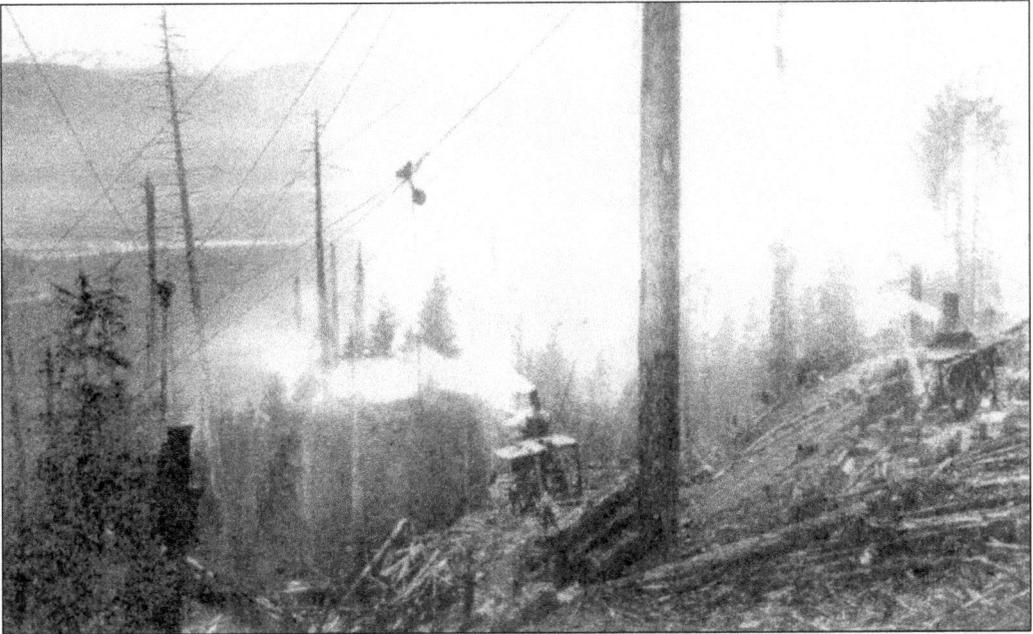

This spar pole is in the middle of a logging scene. Originally the spar pole was a tall tree striped of its limbs. The rigging lines were attached to the tree for yarding the logs.

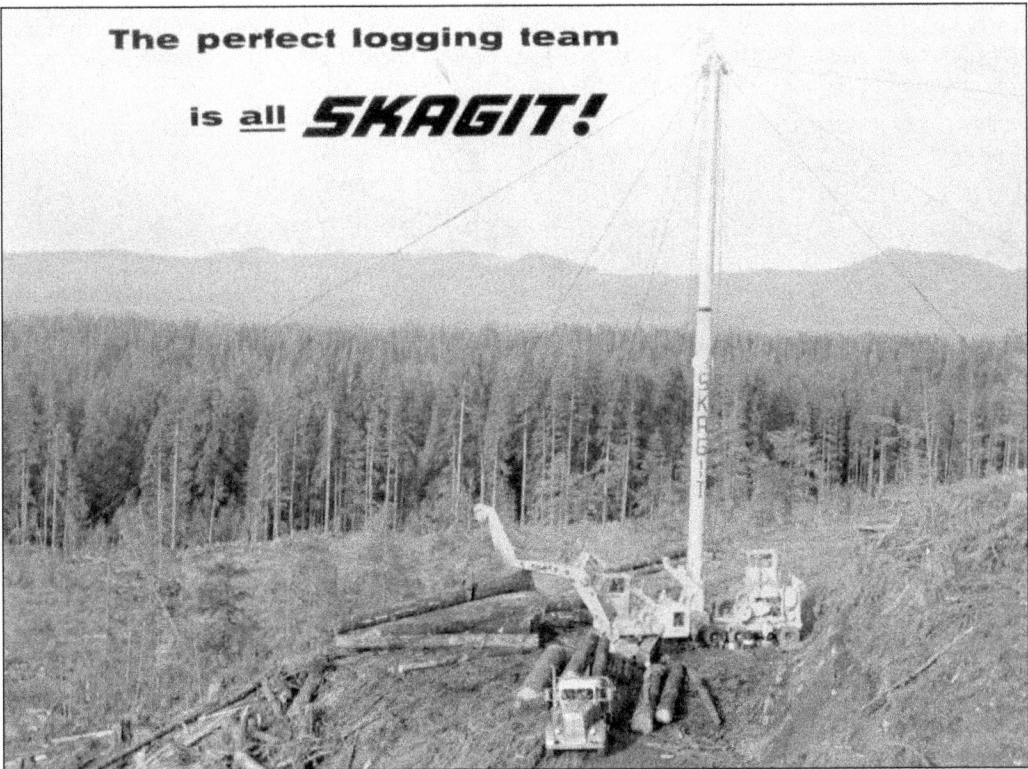

The Skagit Corporation developed a portable spar pole, which could be moved from logging site to logging site. This is the T-100 pre-rigged self-propelled telescoping tower.

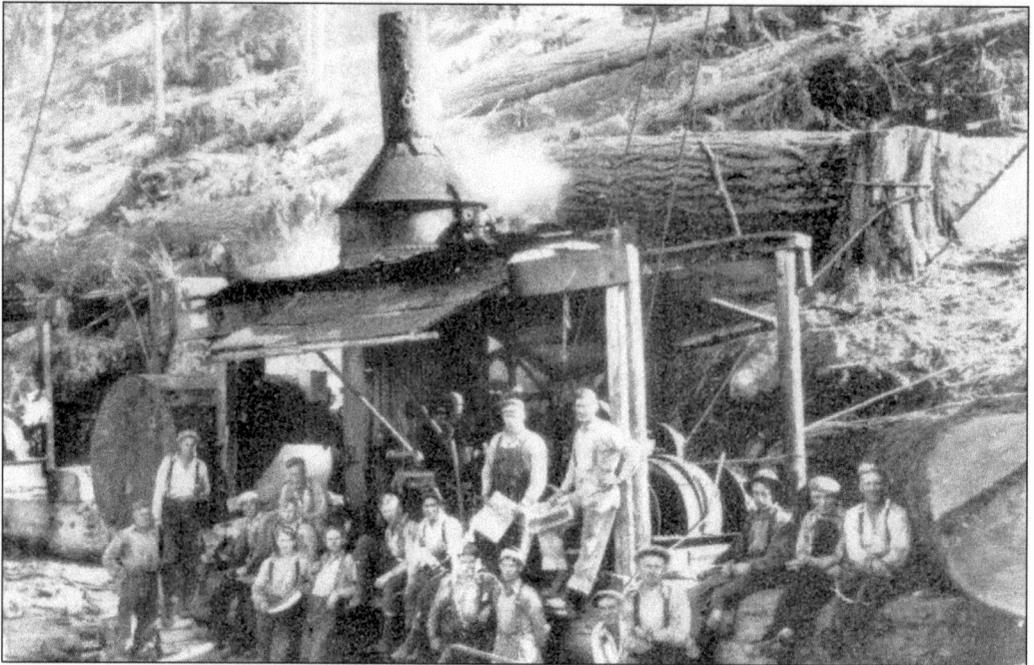

With this steam powered duplex loader, one engine is set for handling high lead line and one is for main or haul back drums. The duplex loader is in the center, and the rigging engine is in front. Logs drag along the ground until an obstacle is met; the fall block can be raised by holding the haul back line tight, thereby lifting the turn-of-logs upward until the obstacle is cleared. It was operated by a donkey doctor and a fireman.

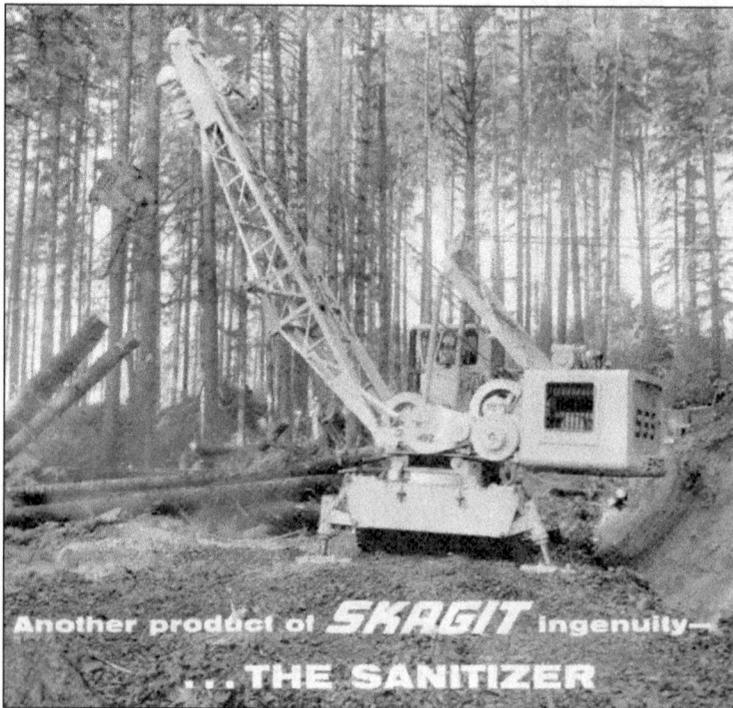

Another product of *SKAGIT* ingenuity—

...THE SANITIZER

Skagit's Skiddo operation combines a 555 mobile loader and Skagit Shamley carriage for fast thinning and dragging of the logs.

The shake these men are holding is a vertical grain, made from an 800-year old red cedar. It is $54^1/_2$ feet wide and was made by the Janicki Cedar Crest Shake Mill in Sedro-Woolley, May 1946.

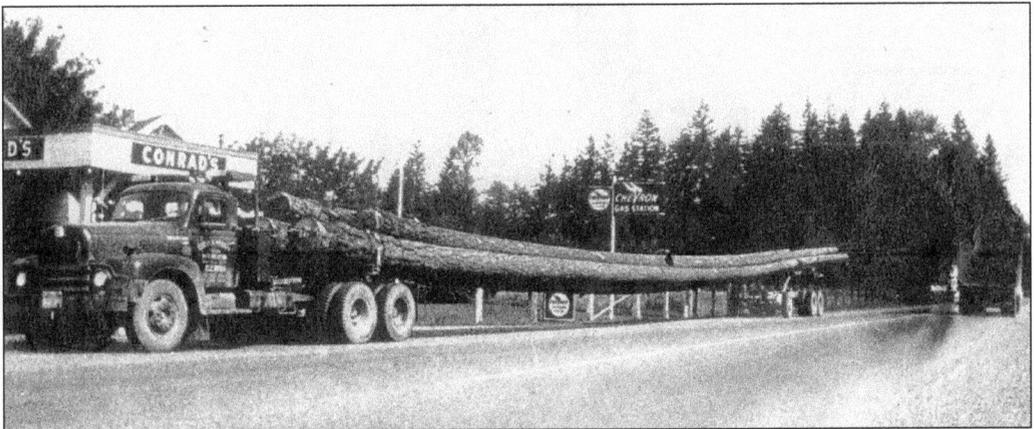

This log truck with a very long log stopped at Conrad's Service Station on the corner of Highway 20 and Collins Road, c. 1950.

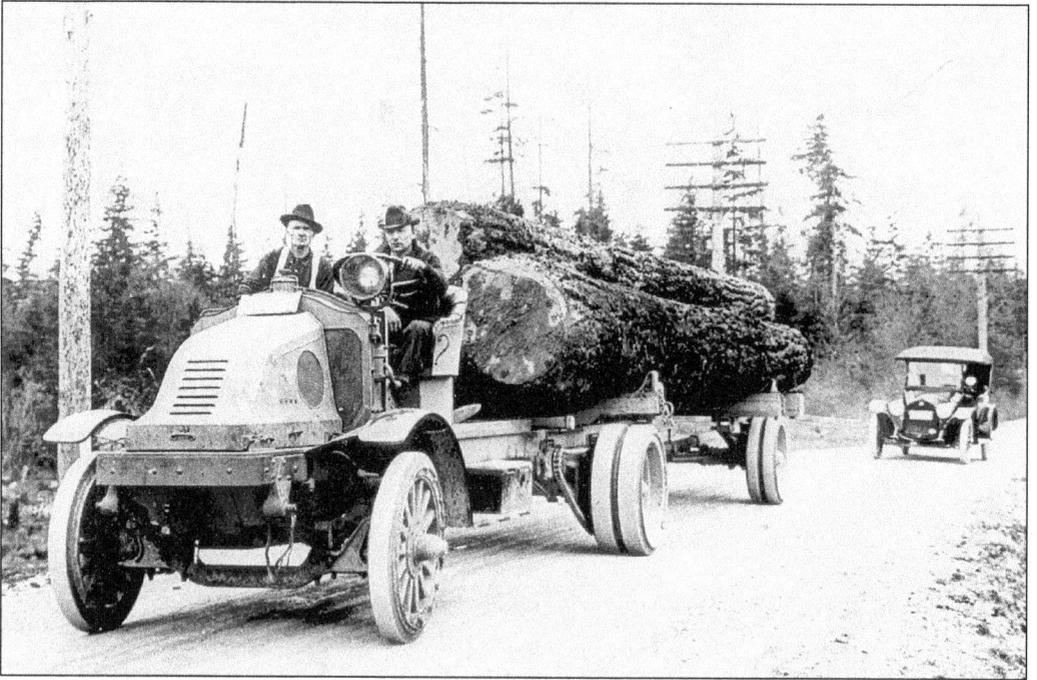

This was one of the first log trucks used in the Sedro-Woolley area.

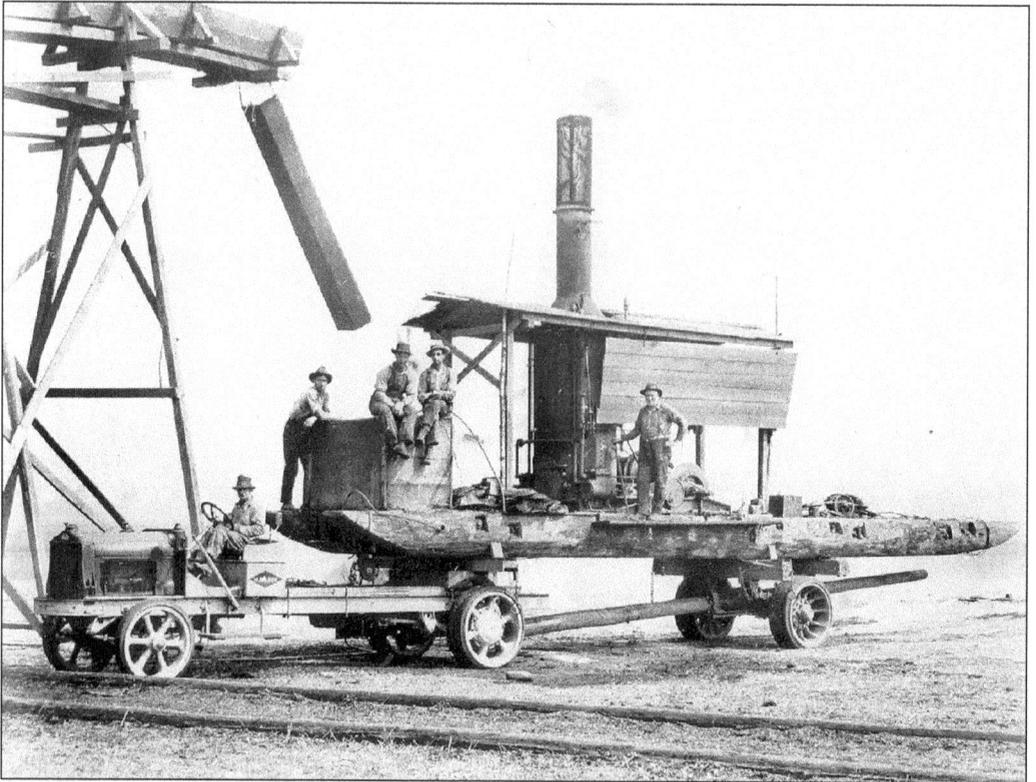

This skid loader is on the back of an old truck and that has an adjustable rear wood axle.

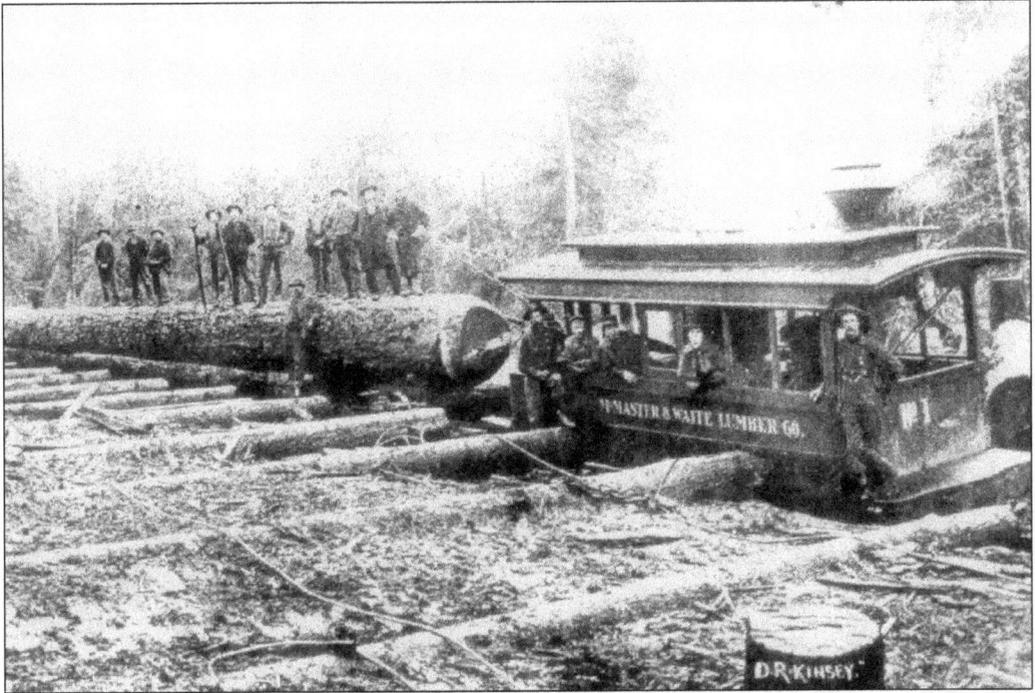

The McMasters & Waite Lumber Company steam dummy No. 1 is at the log railway where the cars are loaded, c. 1899. Notice the skid row alongside.

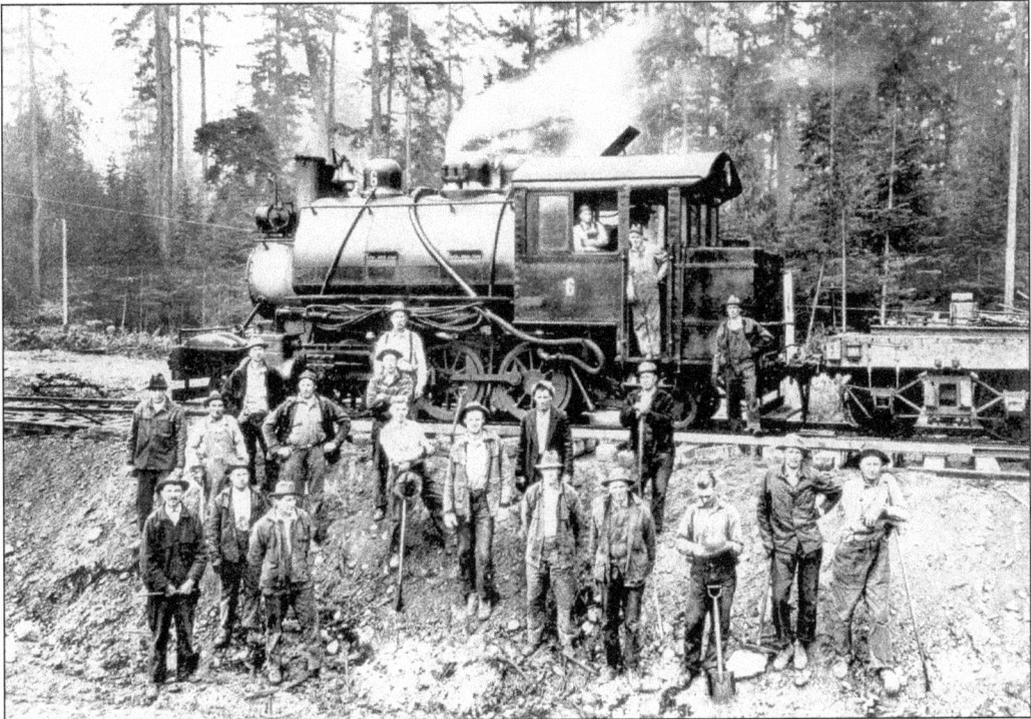

This Saddle tank rod engine and crew are on a railroad spur.

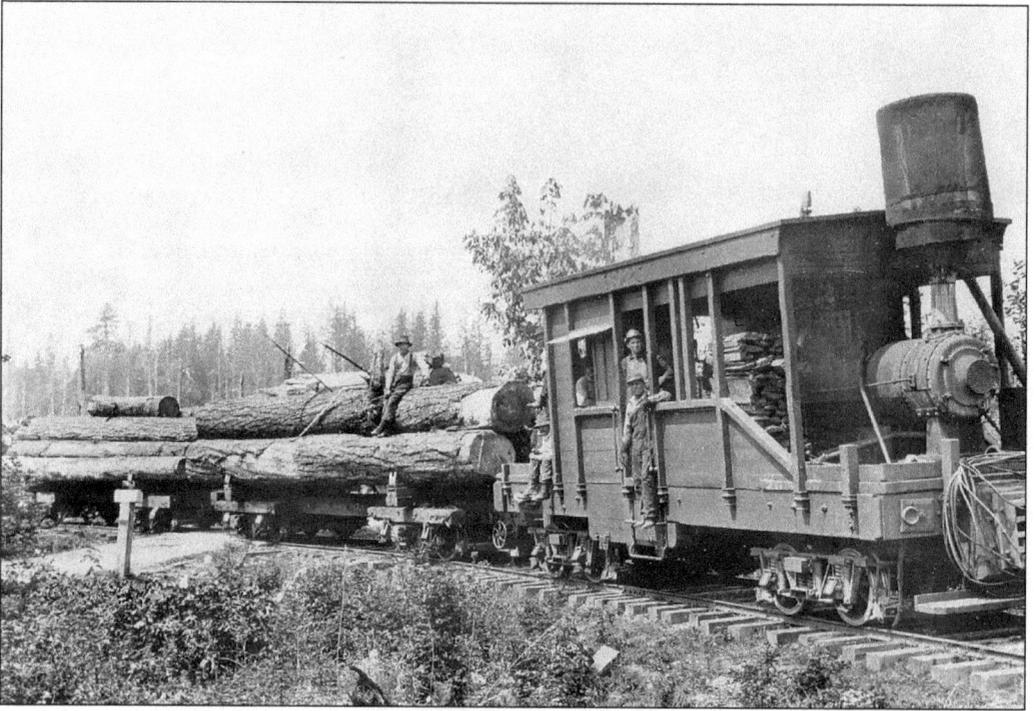

Note the water tank on top of this early Climax engine.

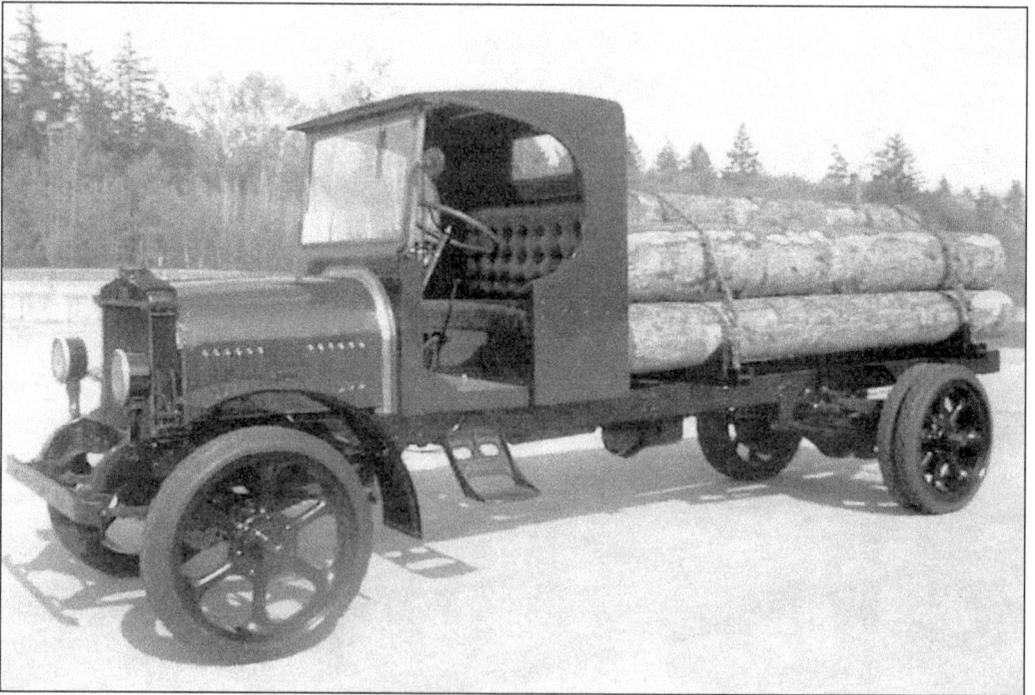

The Sedro-Woolley Museum's 1925 Kenworth log truck is carrying a load of logs. This was the first Kenworth log truck produced.

Five

BUSINESS DISTRICT

Charles A. Schwantes stated in *The Pacific Northwest*: "The straggling village of wooden structures and dirt streets had blossomed into Metropolis of brick and stone, its thoroughfares bustling with trade and commerce." This could easily describe Sedro-Woolley.

Sedro and Woolley experienced rapid growth in the early 1890s. Settlers came and so did businesses to supply their needs. Industries, mainly logging, mining, and agriculture, depended on the new railroads for their survival.

This boom was short-lived due to the depression of 1893 and the railroad system collapsed (except the Great Northern). To some extent this killed Sedro-Woolley's industry, except for the Cokedale mine, which had been purchased indirectly by James J. Hill of Great Northern Railroad fame. The mine supplied a steady payroll and an economic base.

Because of the individual and cooperative effort of its citizens, the towns survived. Sedro-Woolley became the hub for the loggers and miners that came into town on the weekends. Saloons and brothels sprang up and were licensed by the city; because of this income the city levied no property taxes on its citizens.

Electricity supplied the next boom to businesses. Between 1902 and 1912 the town got street lights, and city homes received electric lights after dark. By 1912 electricity was provided 24 hours a day. Rural electrification began in 1912 and was not yet completed in the 1920s when hydroelectric power began being provided by the dams built on the Baker and Skagit rivers.

The depression in the 1930s hit hard: one-fourth of the businesses either changed hands or went out of business. The Northern State Hospital was the stabilizing industry supplying jobs.

This chapter recounts some of the different businesses in the business district, from those in early wooden structures to ones in the present brick buildings.

Sedro-Woolley Iron Works (forerunner to Skagit Steel & Iron Works) was started by John Anderson, nine men, and a horse, in June of 1902. It burned in 1909 and moved to the present location on Metcalf Street.

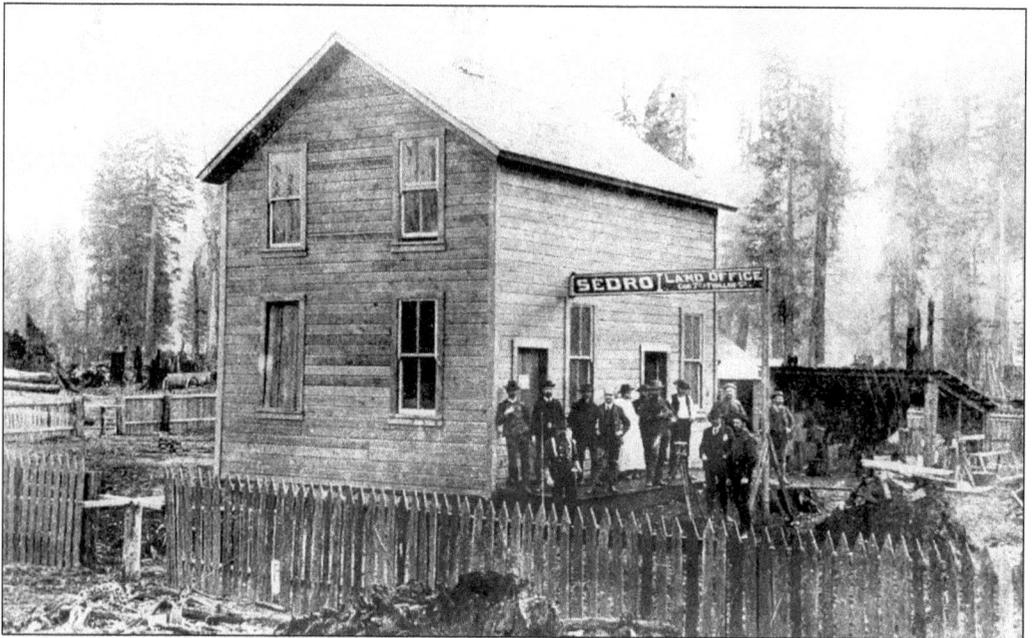

In 1889, the Sedro Land Office was located on Fidalgo Street. Notice the turn-style gate which was used to keep the cows out.

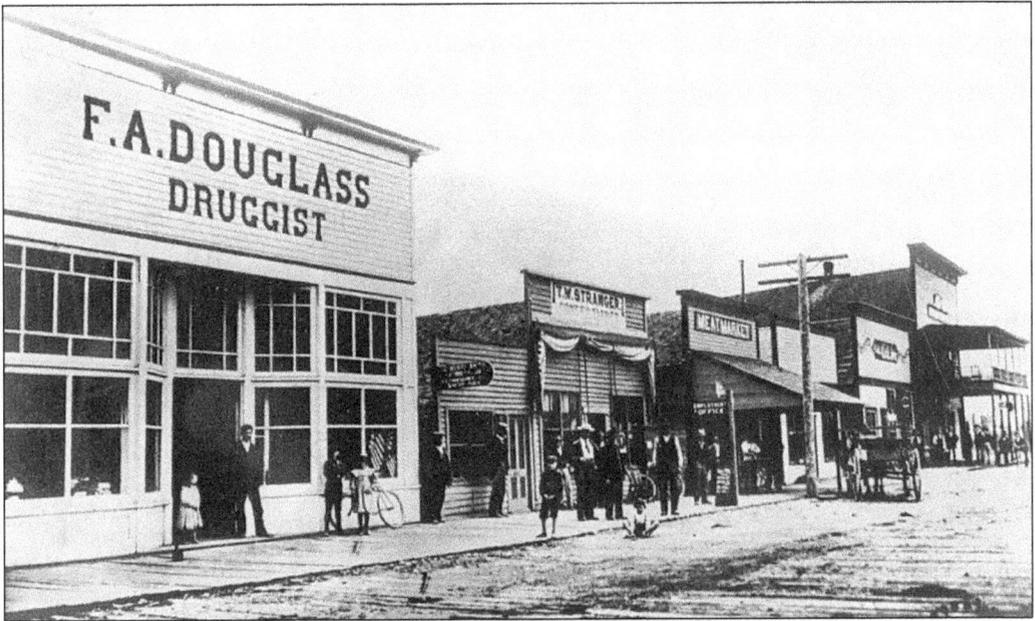

The pioneer druggist Frank A. Douglass' first drug store was located on Northern Avenue, opposite the railroad depot, in Woolley, Washington, c. 1898. Notice the planked road.

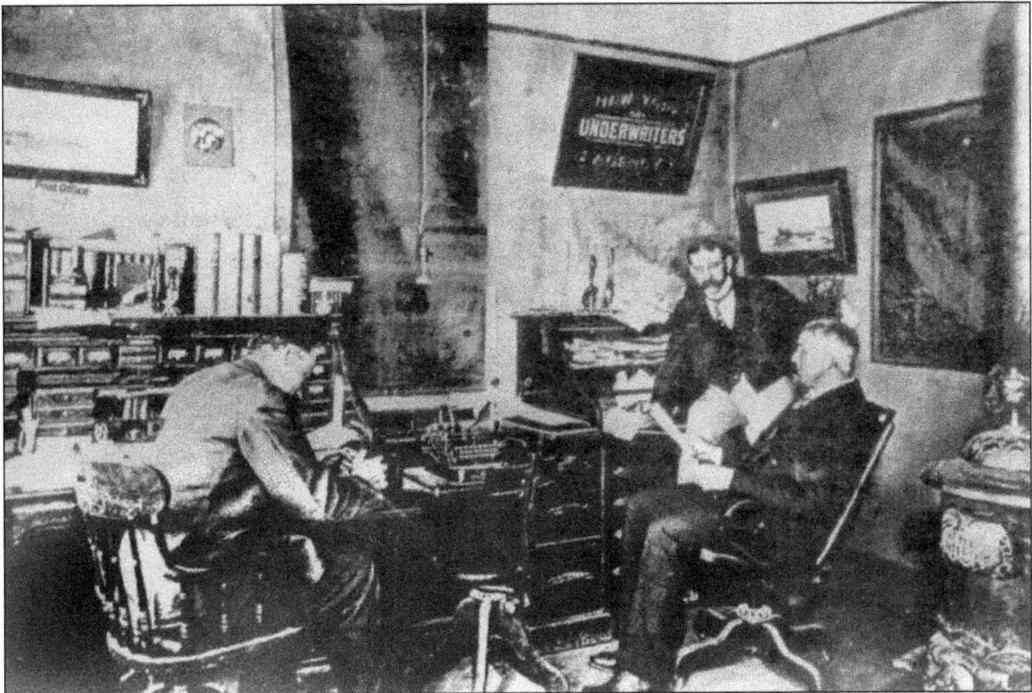

Members of the Skagit Reality Company are pictured here in 1902. From left to right are Harry Devin, Charles Wicker, and J.B. Alexander (seated on desk).

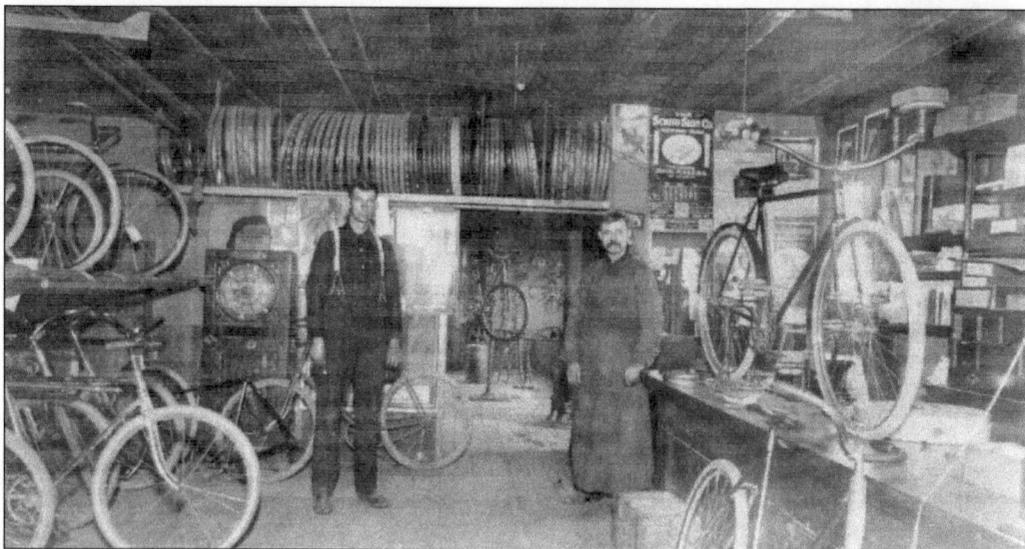

Bagley's Bicycle shop was located at Third and Warner Streets in Sedro-Woolley, c. 1914. Pictured are Charlie Nolan and Ed Sanders.

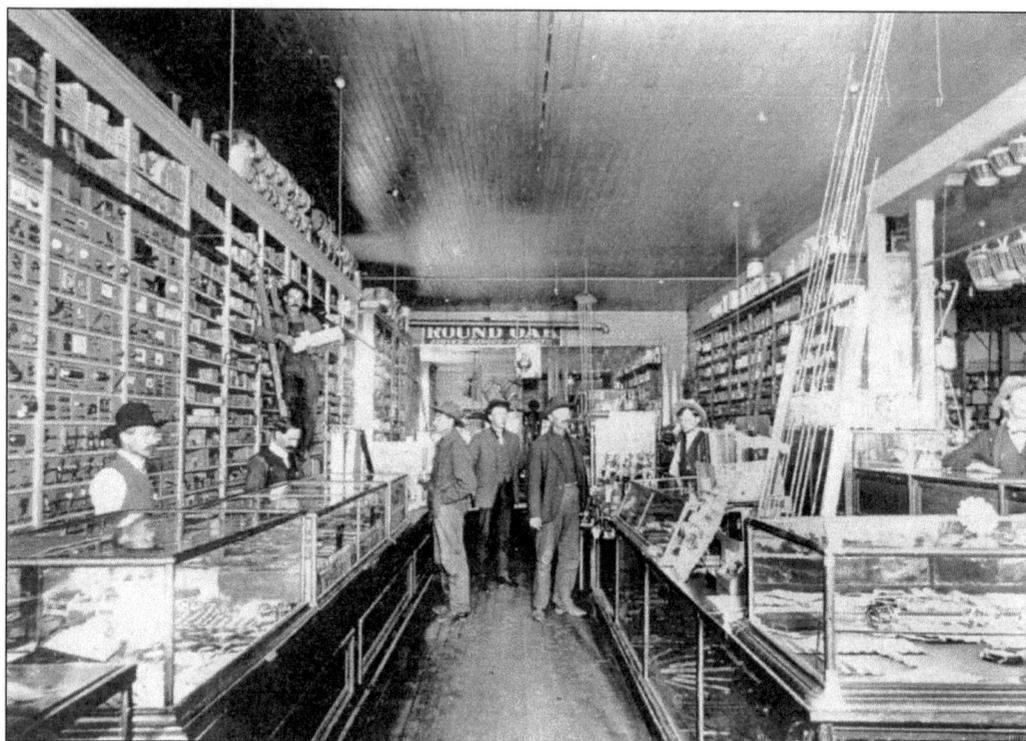

This is an interior shot of the Fritsch Brothers Hardware Store in 1910.

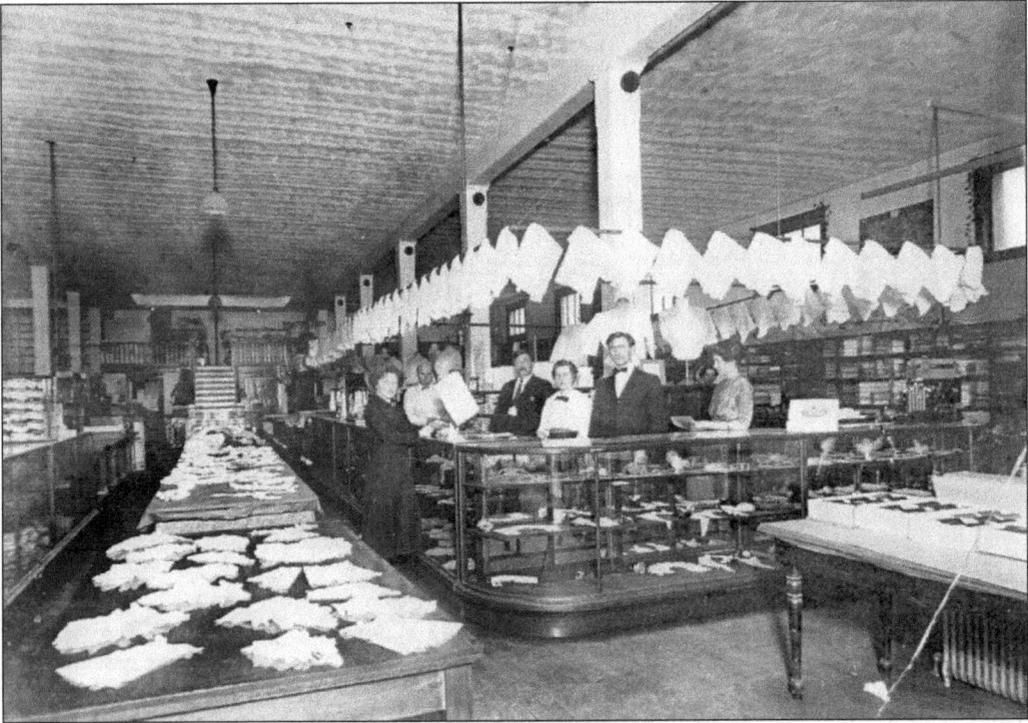

At the Union Mercantile Company in 1912, pictured from left to right are a customer and male clerk, unidentified, Emerson Hammer, Miss Thomas, William Holtcamp, and Minda Bratley, who was later Mrs. William Holtcamp.

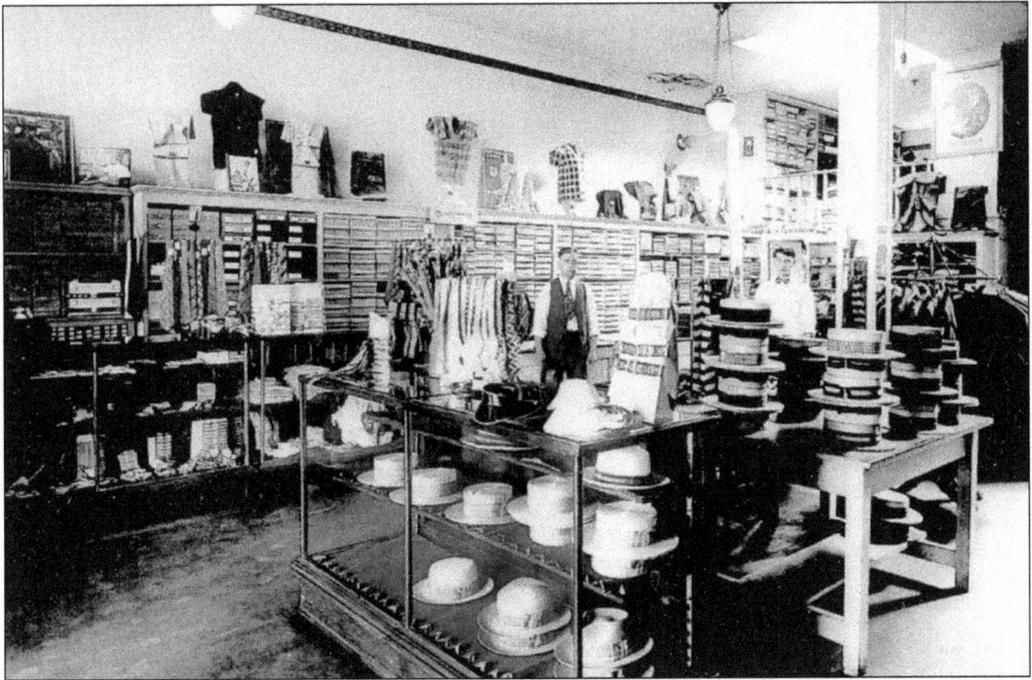

At the Oliver and Hammers Clothing Store, c. 1920s, are George Hammer and Ford Cook.

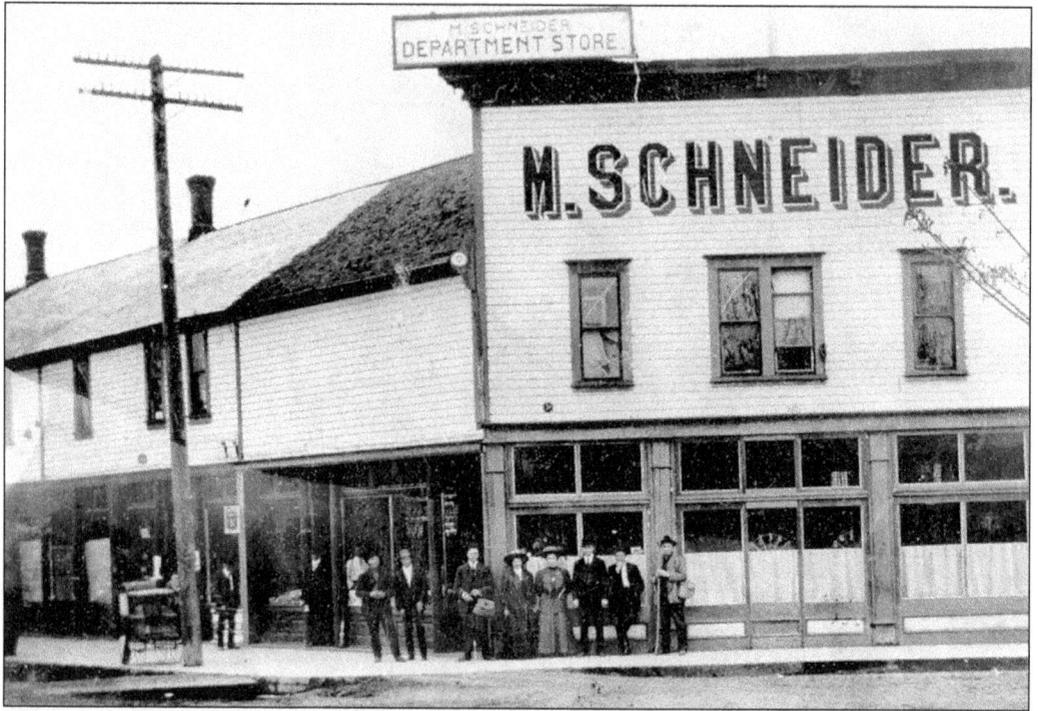

The Schneider Building on Metcalf and Northern Avenue *c.* 1905–1906 is pictured here. It burned in 1914 and was rebuilt as a one-story brick structure.

This local saloon, one of about thirteen in town, was located in the Schneider building.

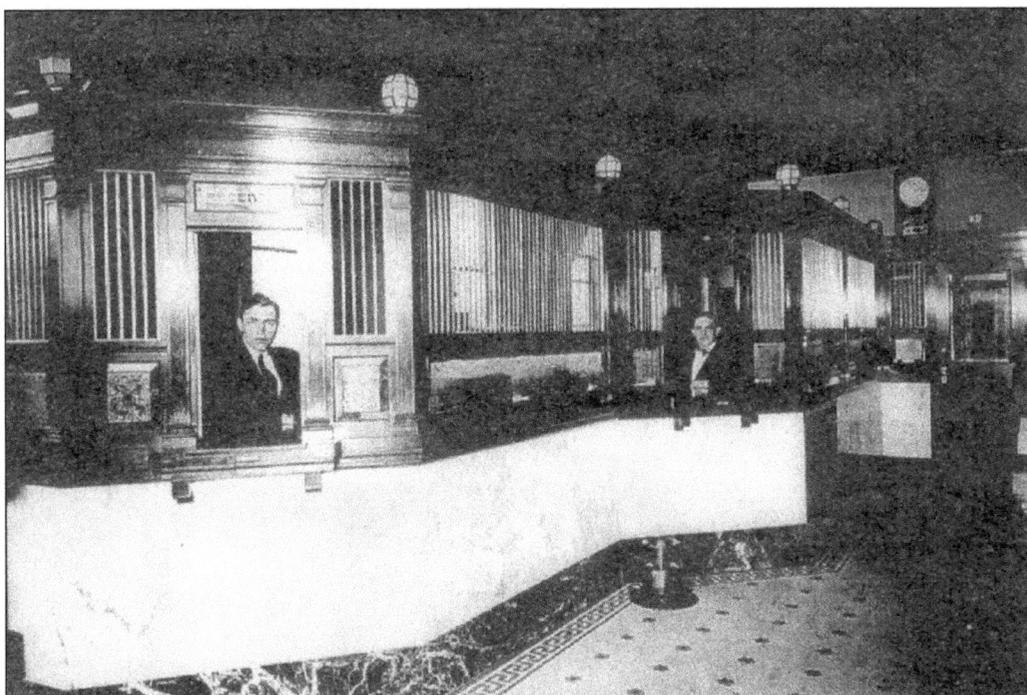

This is the interior of the Bingham Bank, which was located at the corner of Woodworth and Metcalf Streets, c. 1910 or 1911. These gentlemen are tentatively identified as Bill West and Quinby Reno.

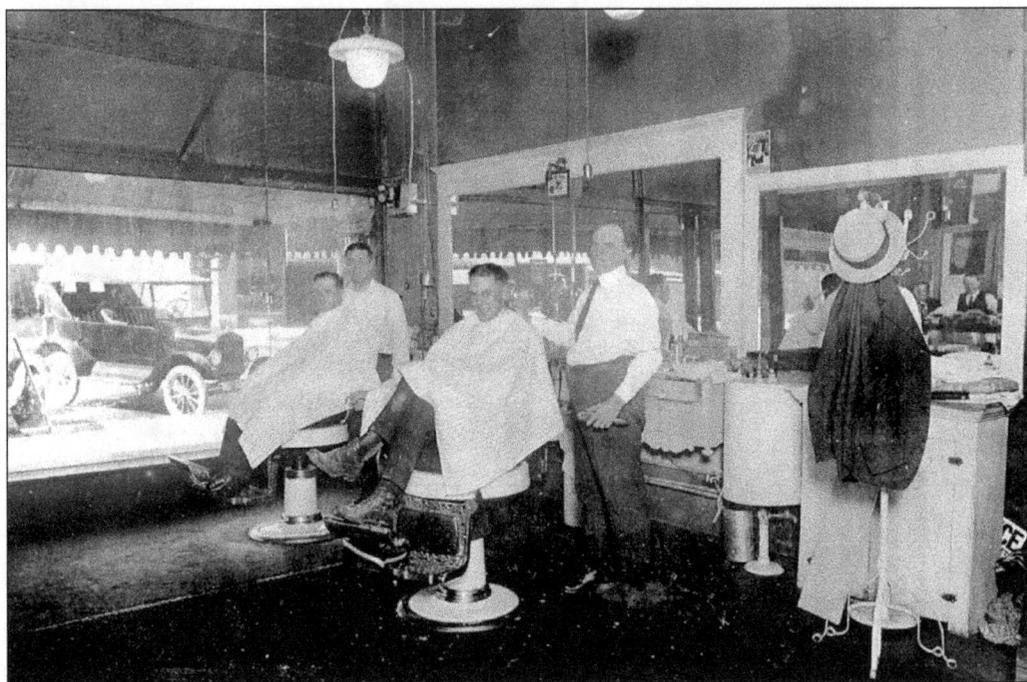

In the Barber Shop of the Wixson Hotel, c. 1920s, are Dewey Thomas and his partner Wilbur Harrison.

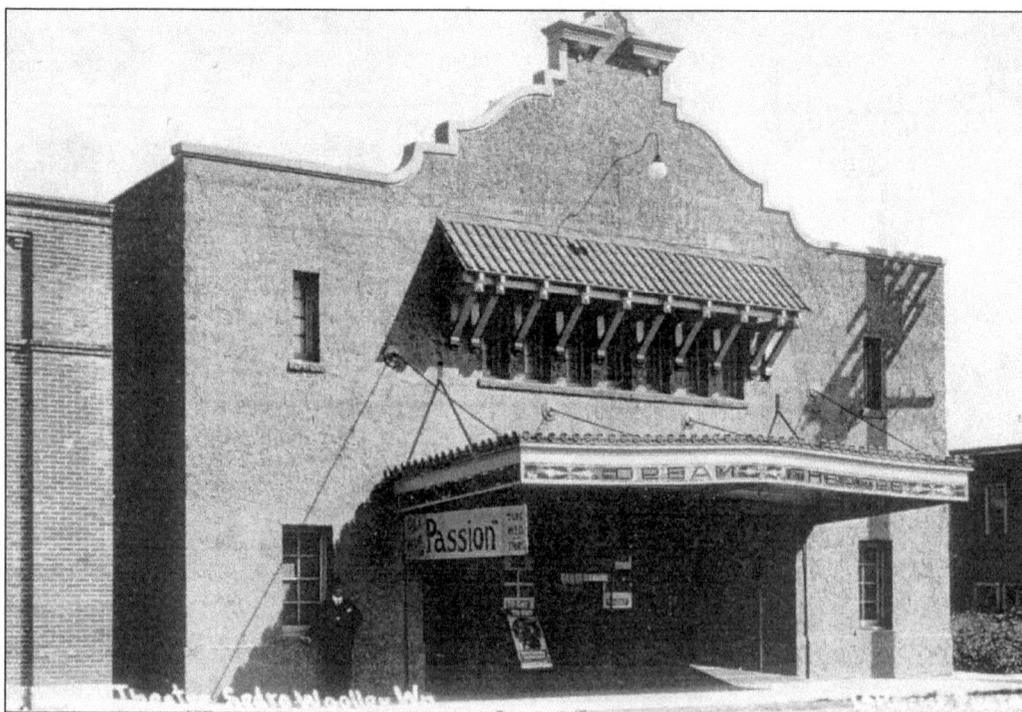

The Dream Theatre was located on Woodworth Street, photographed c. 1920. The theatre was opened on Christmas Day, 1913, remodeled in the 1950s, and torn down to make way for a bank in 1963. The theatre was used for stage and movies (or photoplays).

The Fern Rooms at 500 Metcalf Street was a brothel run by the Seibert sisters, Elsie Moore and Kate McMurray. Kate retired around 1938. Elsie continued to run the rooms until her death in 1947. Her funeral was one of the largest in Sedro-Woolley's history. All businesses closed to allow everyone to attend. Ruth Mason took over until it closed in 1952.

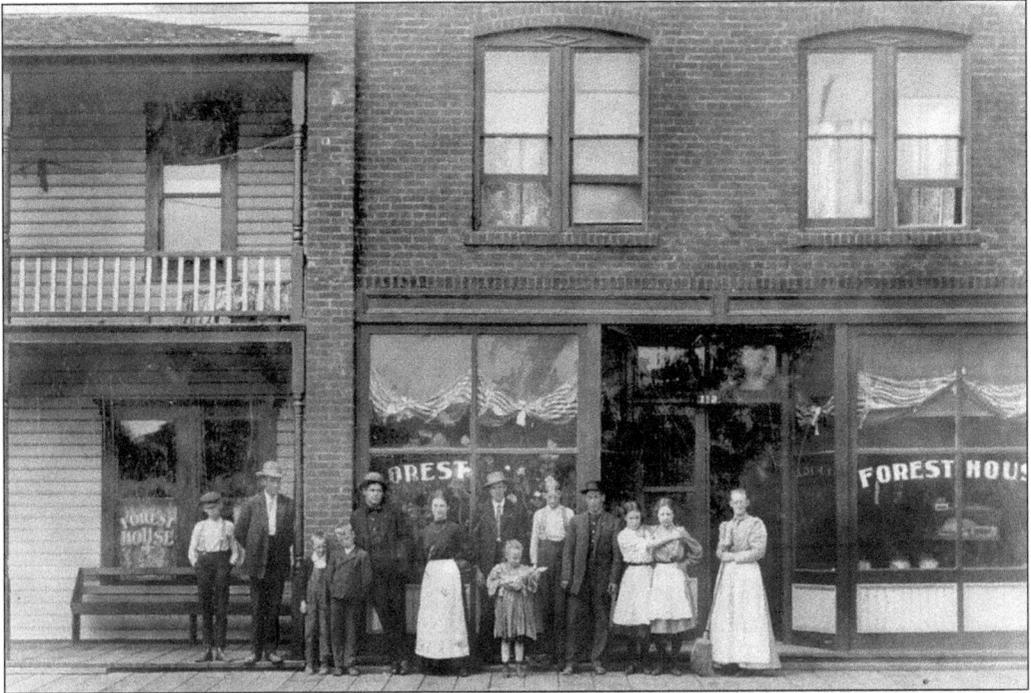

The Forest House, a restaurant and hotel, was located on Ferry Street about where Coast to Coast is now, *c.* 1908. Note the wooden boardwalk.

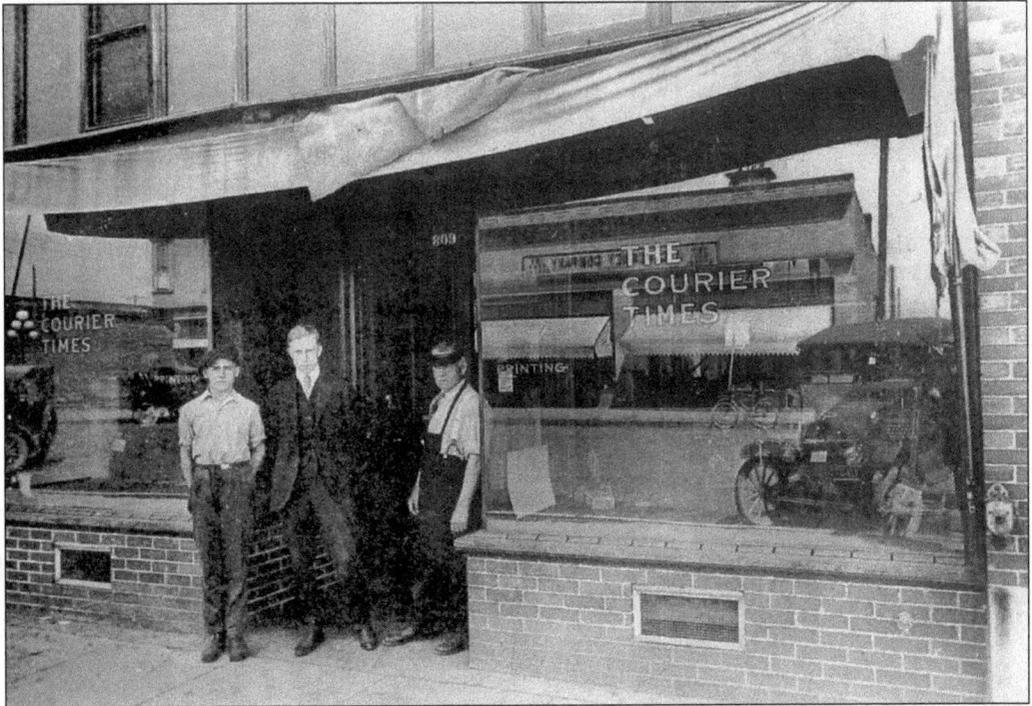

In front of *The Courier-Times* newspaper building, from left to right, are Harold Renfro, Frank Evans, and William Maw, *c.* 1920.

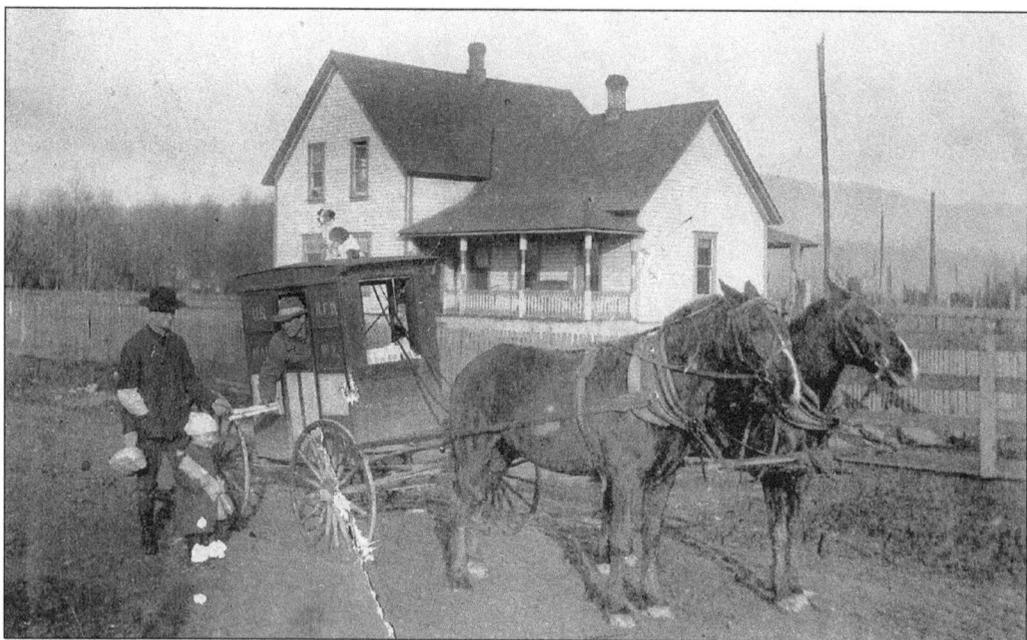

Lundy A. Perry and his rural mail delivery buggy are delivering mail to the Sinclair house. This was the way mail was delivered until automobiles and paved roads replaced the horse and wagons.

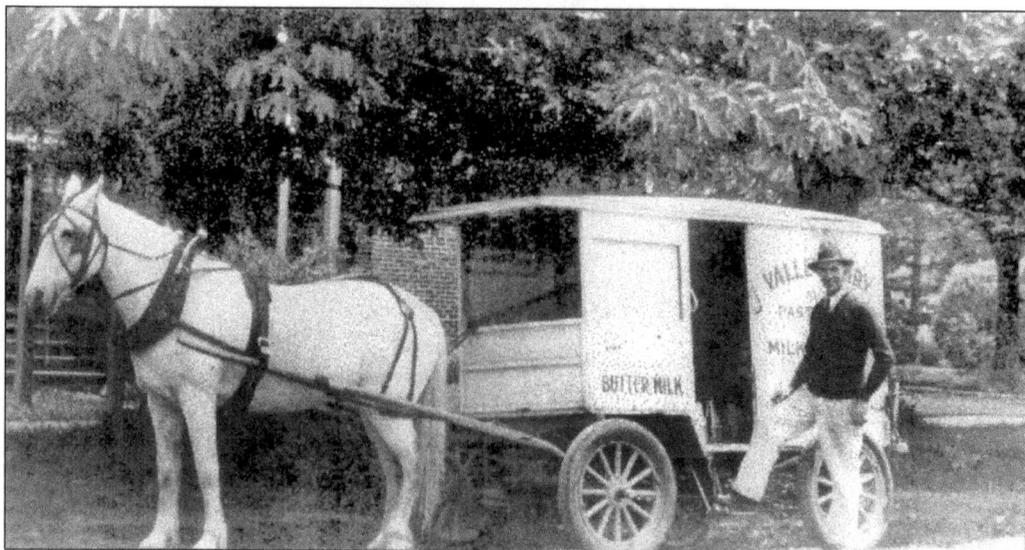

George W. Miller poses with his horse-drawn Valley Dairy wagon in the early 1930s.

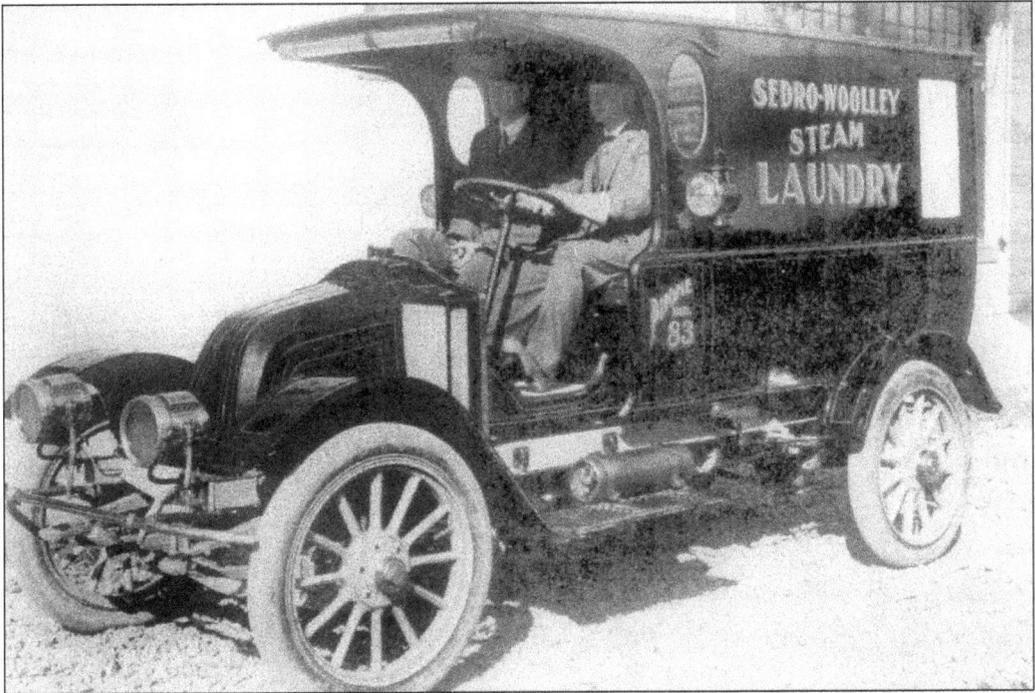

This 1916 Mac delivery truck for the Sedro-Woolley Steam Laundry was owned by Elza Harris. It was his second commercial delivery truck in Sedro-Woolley. The laundry burned in the mid 1960s.

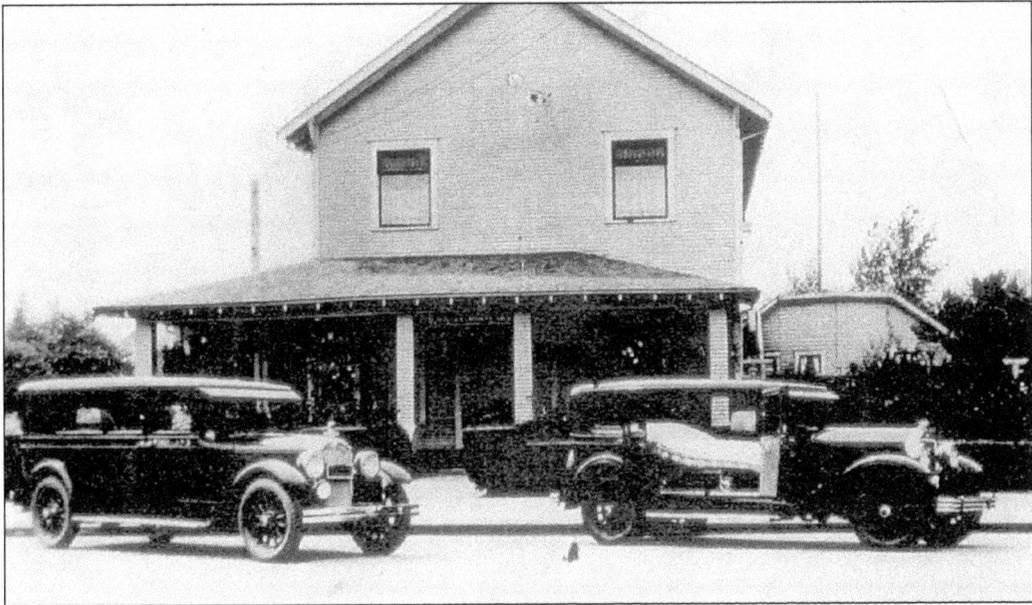

Hume Higley's Undertaking Parlor on Third Street was a forerunner to the Lemley Chapel, c. 1930. Notice the hearse in front.

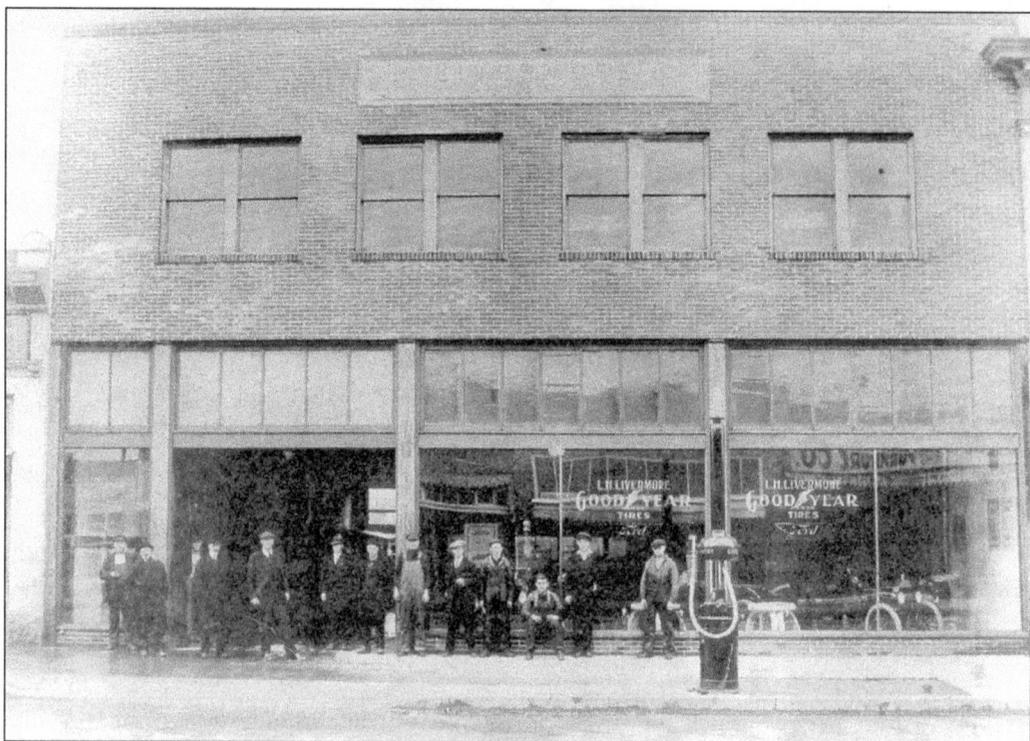

Livermore's brick Ford garage on Metcalf Street, *c.* 1917, is on the site where Oliver and Hammer's is now. Note the gas pump on the sidewalk.

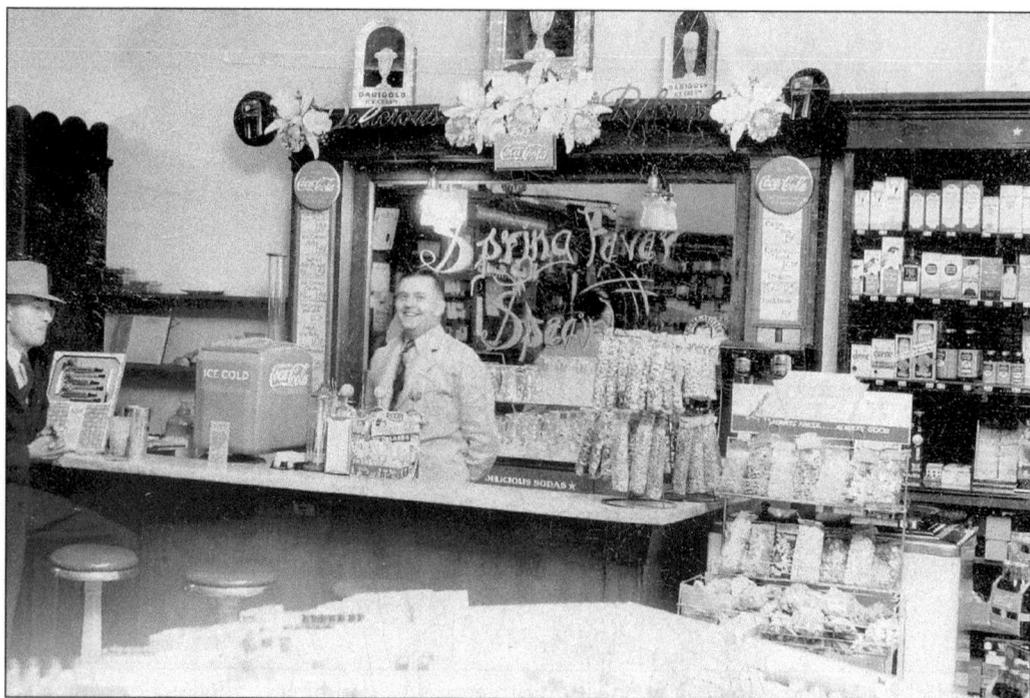

McClintok's Soda Fountain was located in McClintok's Drug Store, *c.* 1930.

Six

SCHOOLS, CHURCHES, AND HOSPITALS

Oliver Wendell Holmes once said: "I find the great thing in this world is not so much where we stand, as in what direction we are moving." The pioneers always strived to improve themselves and the life of their families and surroundings.

The pioneers arrived, cleared the land, built houses, and established a school and church, using a makeshift building or someone's home.

Education—learning to read and write—was important. They realized the necessity not only to improve themselves financially but culturally. By the 1920s education had become a growth industry due to the growing emphasis on a high school education. Small country schools were consolidated into larger school districts. The Federal government had set aside money to support public education.

Sedro's first church group was the Methodists, organized in 1884. The Presbyterians organized in 1889 and met in a tent shack until they built a church in 1892.

In Woolley a group, "New Hope Society," met in "church parlors" provided by Mr. Woolley from 1890 to 1897. As church populations grew, buildings were erected. By the turn of the century, the Episcopalians, Presbyterians, Methodists, and Catholics all had buildings. Others held services but not on a regular basis.

The first hospital was opened in 1891; the St. Elizabeth also served as the Episcopal Chapel until the church was built in 1907. In about 1909 the Frazee hospital on W. Ferry St. opened. It operated until 1917 when Dr. Mills opened his home as the Valley Hospital on Ferry and Ball Streets. Dr. Mertzís home was also a hospital until he moved to Concrete.

The Memorial Hospital opened in 1929 and the Northern State Hospital (a state mental hospital) was founded in 1911 and operated until 1972.

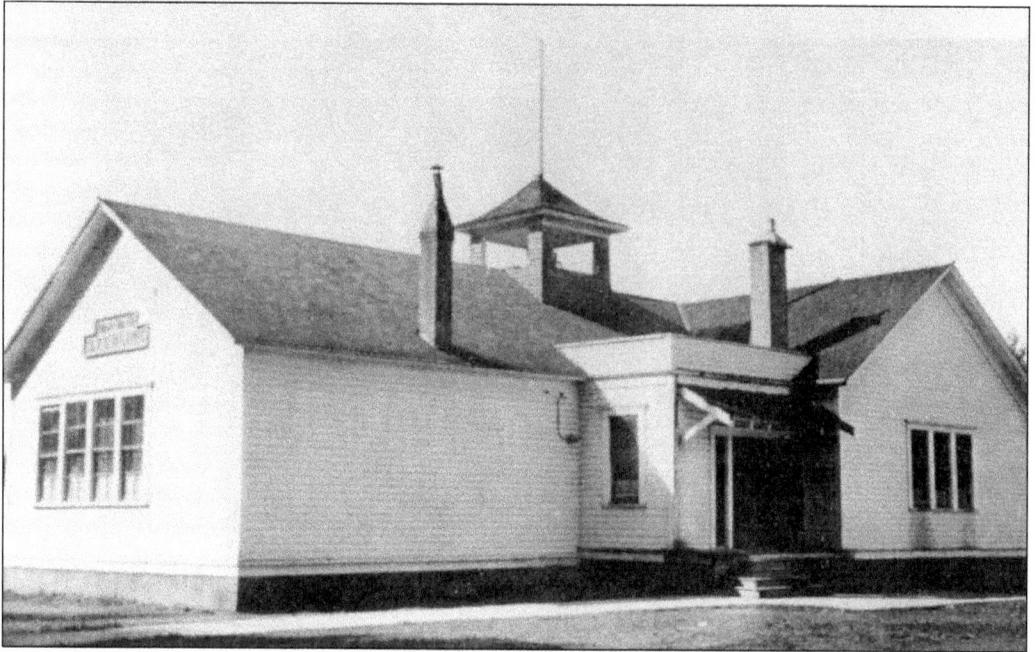

Sterling School was the first school established in the Sedro-Woolley area. The school pictured above was the second structure; it was built on higher ground. The first school was a log building raised on stilts to avoid possible flooding.

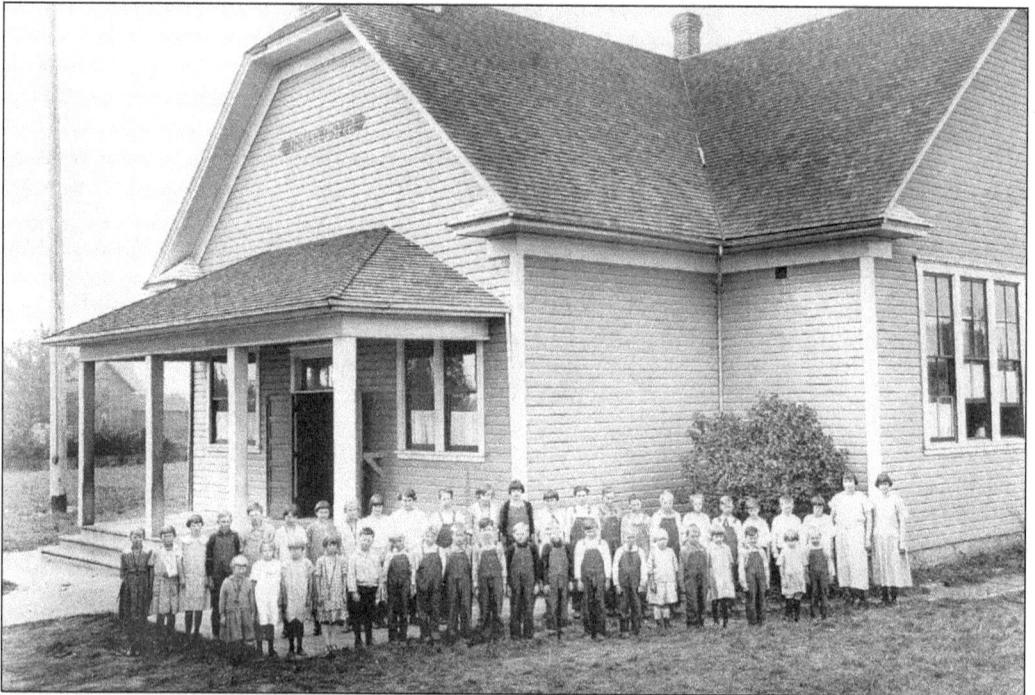

McRae School was formed in 1899 when George McRae donated two acres for a community school. It was a one-room school on what is now the Ratchford road. A few years later the school pictured here was built with two rooms. McRae closed in 1943.

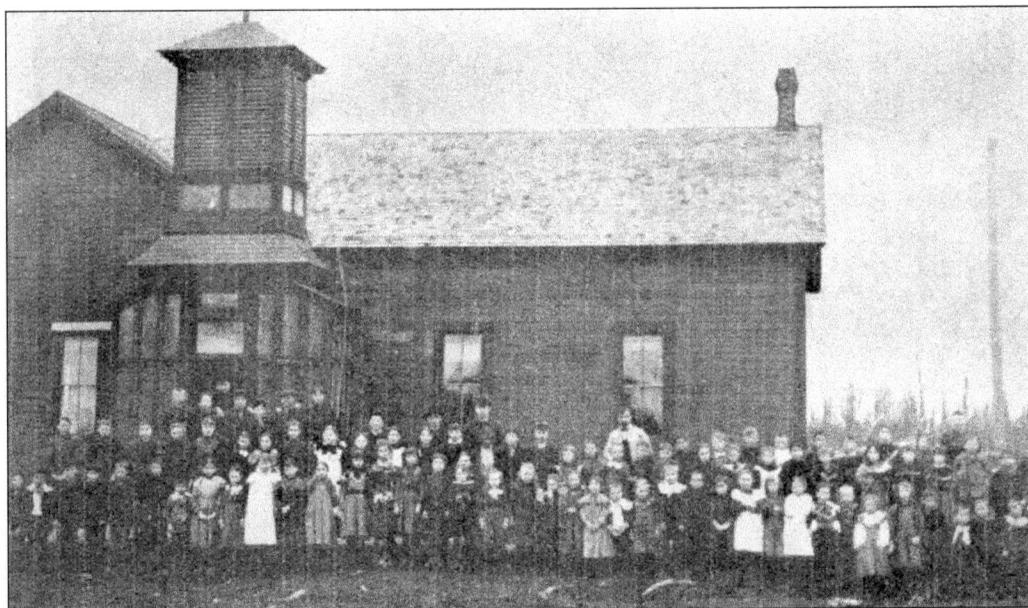

Woolley School was established in 1890. This picture was taken c. 1897 or 1898, before the merging of the two towns. Mr. Look was the teacher.

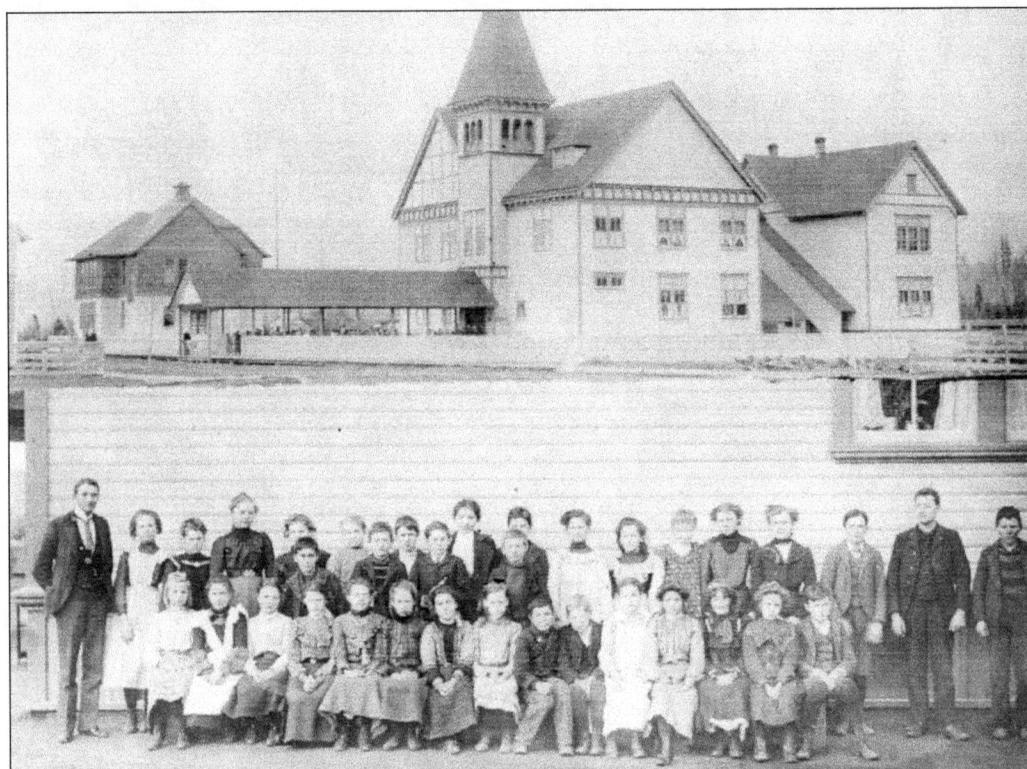

Sedro-Woolley's early schools were the Franklin Grammar School in the foreground and the Sedro-Woolley High School (Irving School) in the background. Students are from the sixth grade class of 1902–1903.

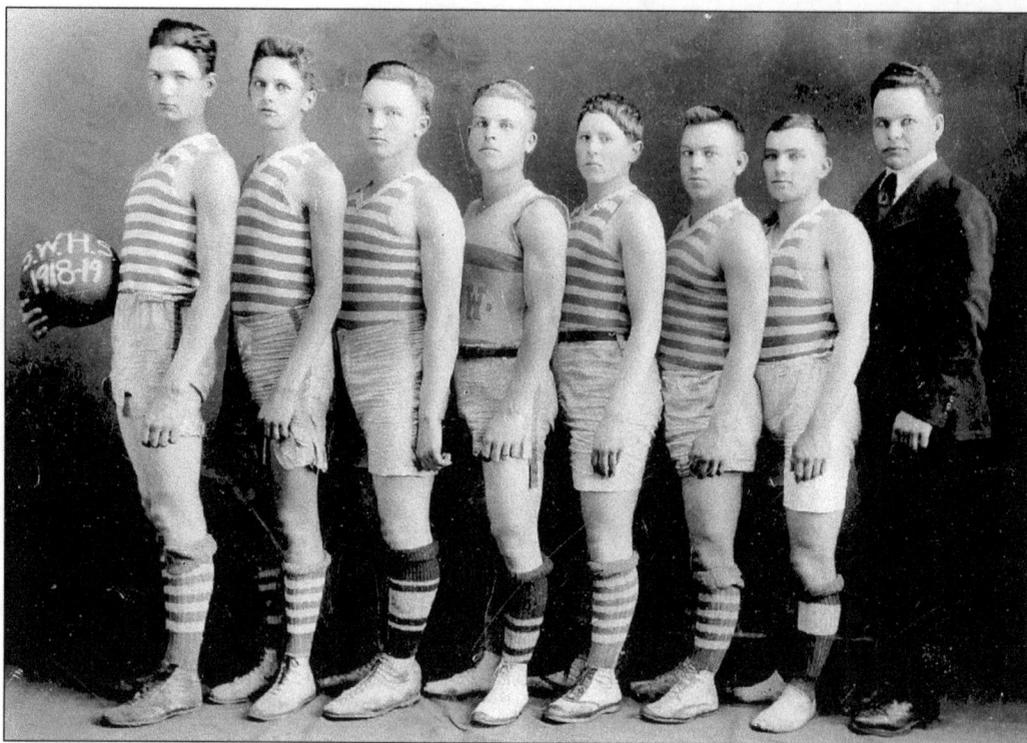

The boys' basketball team, 1918–1919, from left to right, were Bill Coffee, Pete Douglass, Ed McRae, Darrell Leavitt, Ralph Miller, Buster Atterberry, Everett "Ike" Blackburn, and Coach Scheiss.

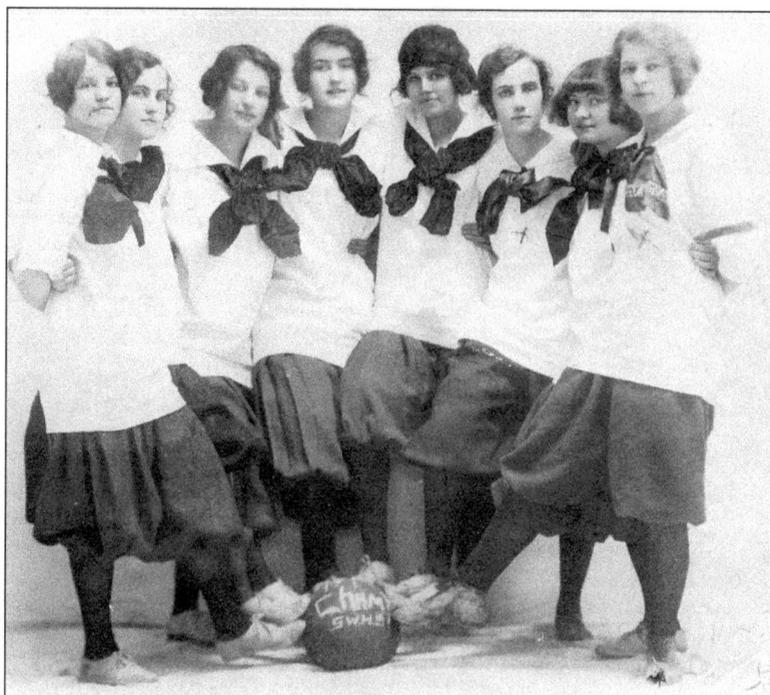

The girls' basketball champs are pictured here, c. 1917.

Central school in Sedro-Woolley opened in 1926 and closed in 1974. In 1992 it was extensively remodeled and reopened. Mary Purcell, a teacher in the local schools for 45 years, was the long-time principal.

This section of Union High School (Sedro-Woolley High School), called the B building, was opened on February of 1924. Today it still serves as a high school and has had several additions and changes over the years.

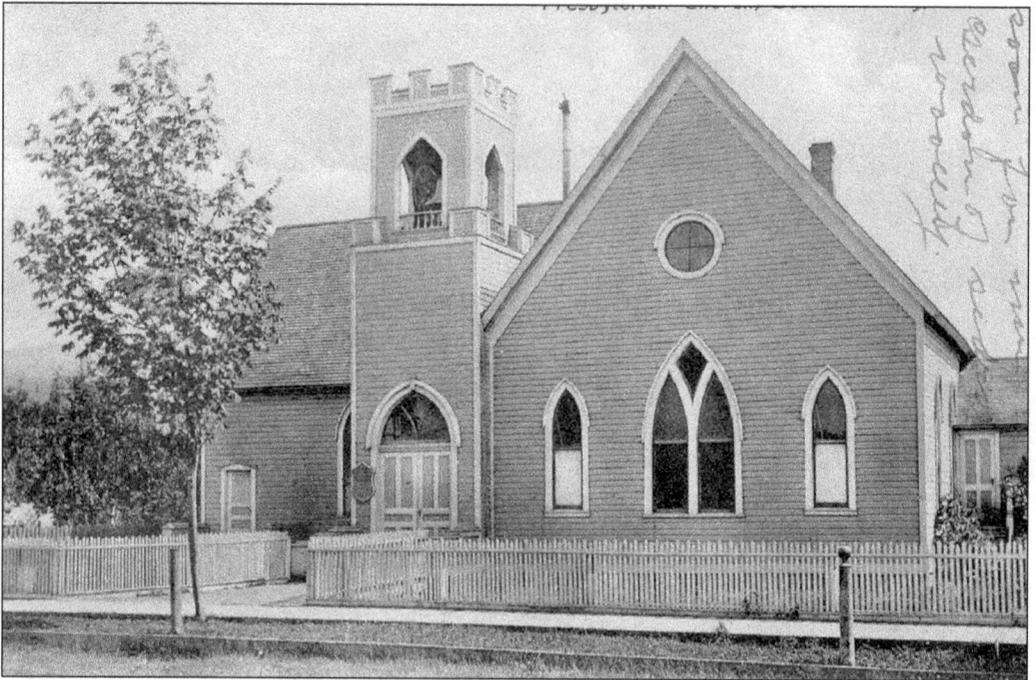

The Presbyterians, organized by Rev. George Raymond, met in a tent until this church was built the 300 block of Talcott Street.

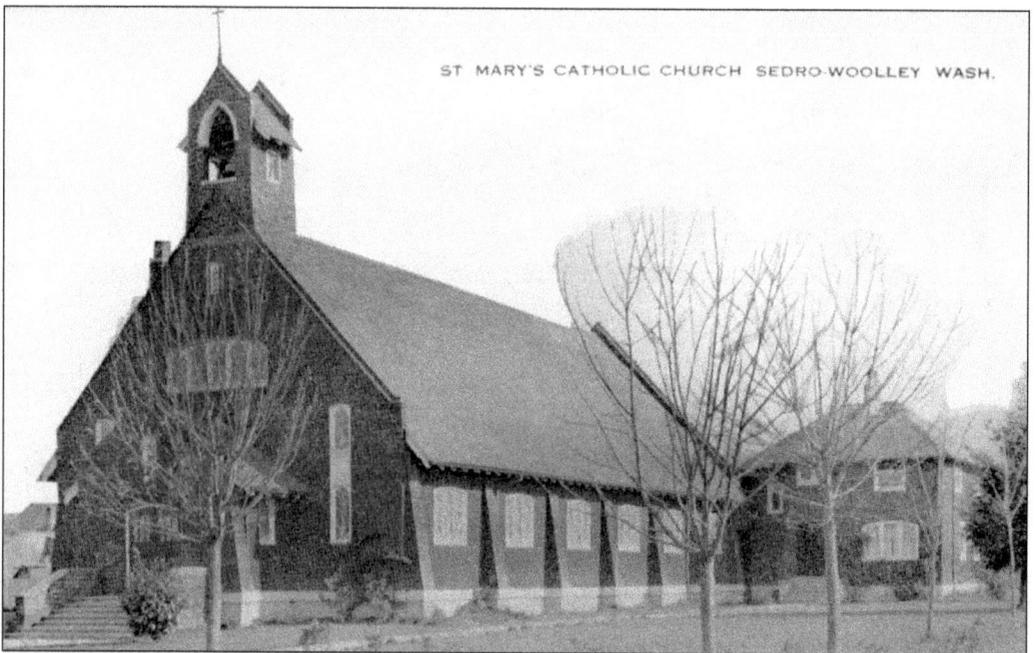

ST MARY'S CATHOLIC CHURCH SEDRO-WOOLLEY WASH.

The original St. Mary's Catholic Church was located on Puget Street before they built this new church on Ferry Street. The church on Puget Street was then sold to the Lutherans.

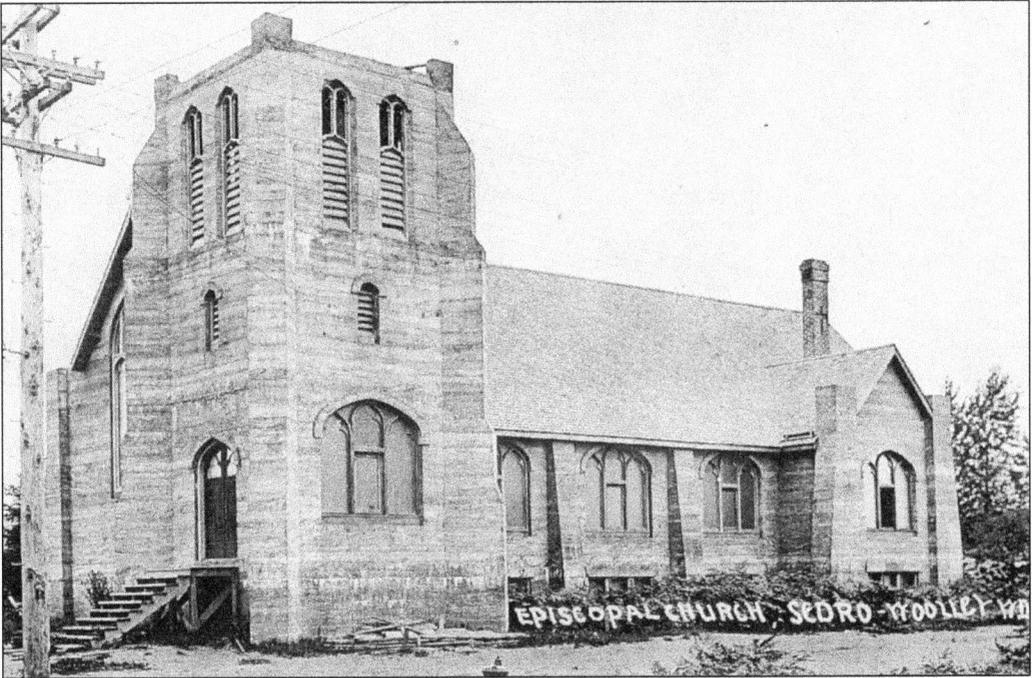

The St. James' Episcopal Church on State and Puget Streets was built in 1907. In 1965 the steeple was added.

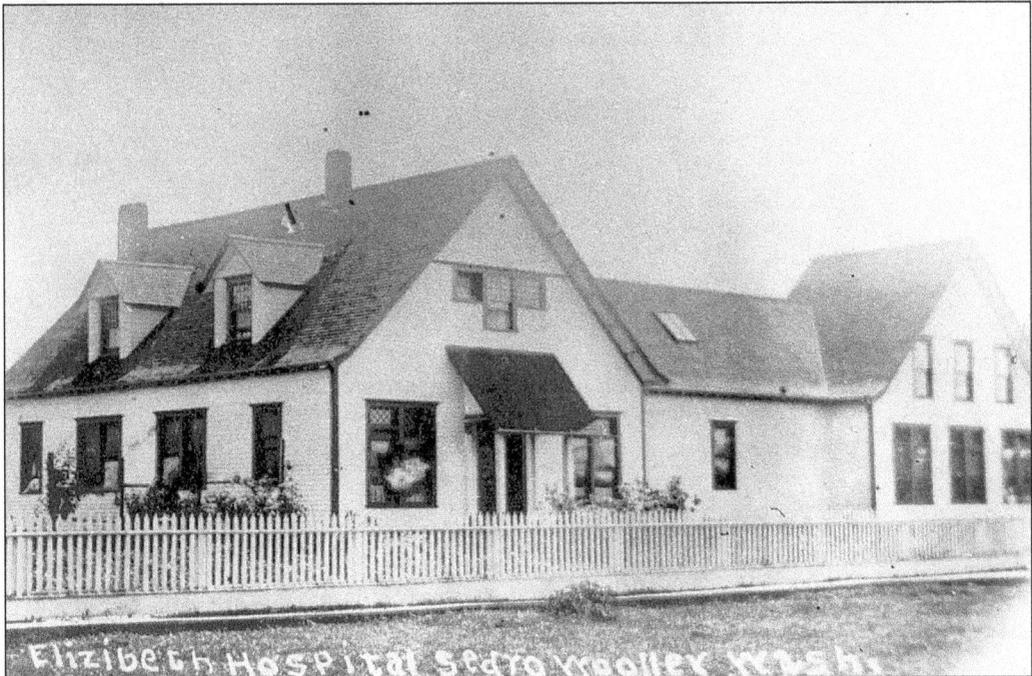

St. Elizabeth's Hospital in 1891 is pictured here on Township and Fidalgo Streets. It was the first hospital in Skagit County and also served as the Episcopal Chapel until the above church was built. Father Buzzelle was the vicar.

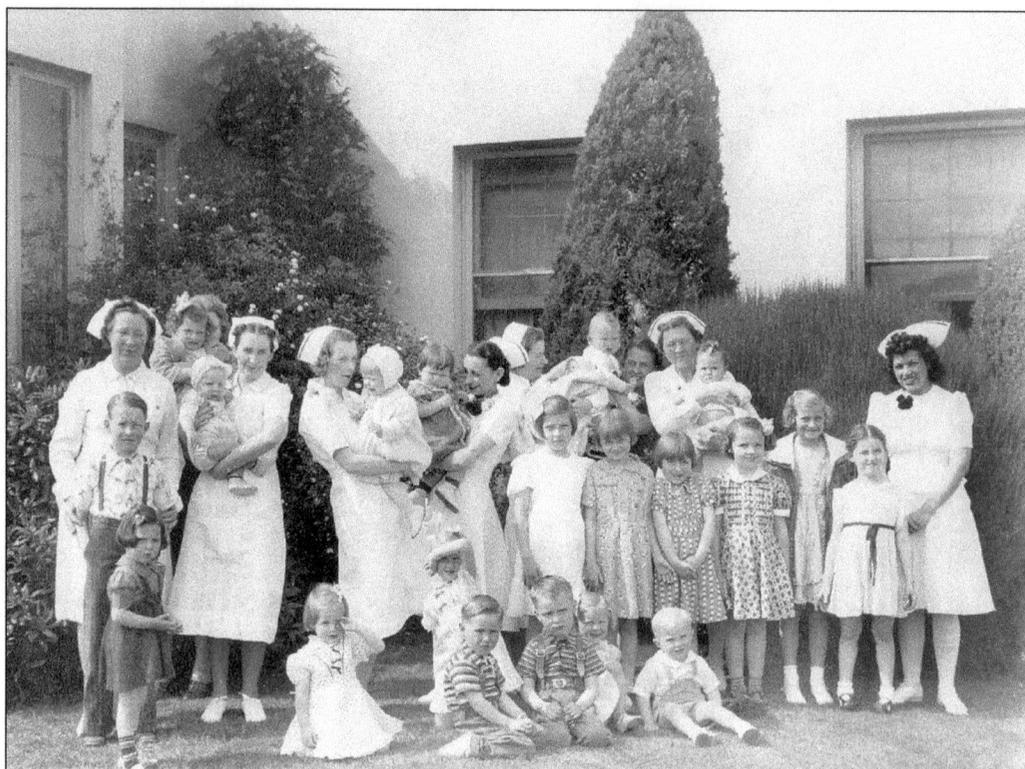

This is a reunion picture of nurses and the children who were born at the Memorial Hospital. The nurse at far left is Gertrude Linn Sawyer; the nurse second from the right is Mrs. Burkhart.

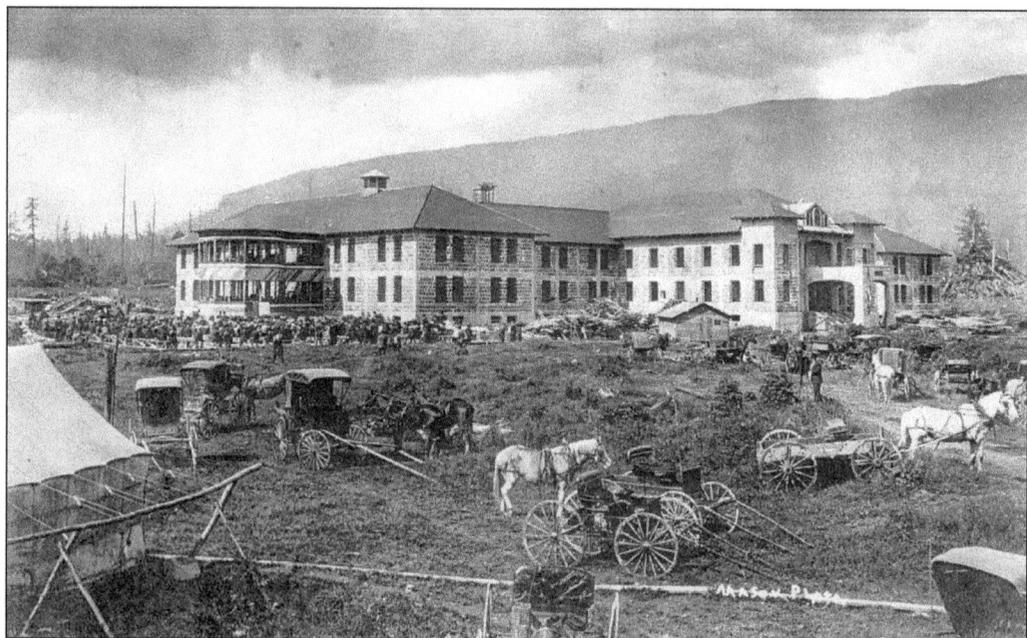

This was the dedication ceremony of the Northern State Hospital in 1912, which was a state-run mental hospital in Sedro-Woolley.

These are staff and attendants at the Northern State Hospital.

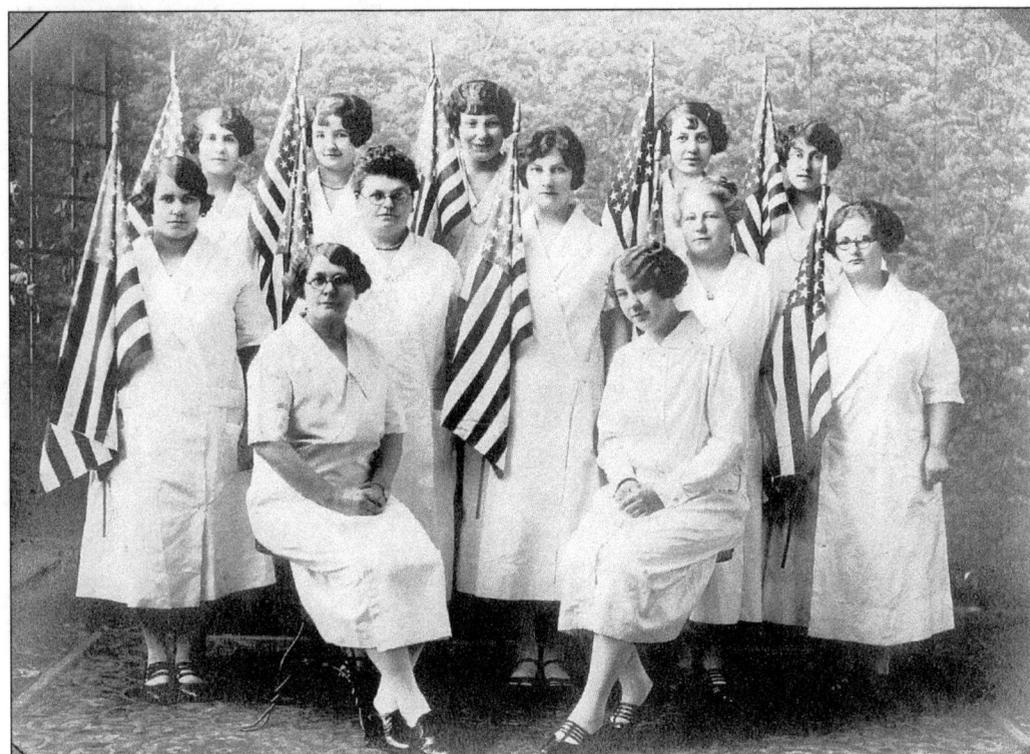

These nurses are posing with American Flags, *c.* World War I. Gertrude Linn Sawyer is seated at the right.

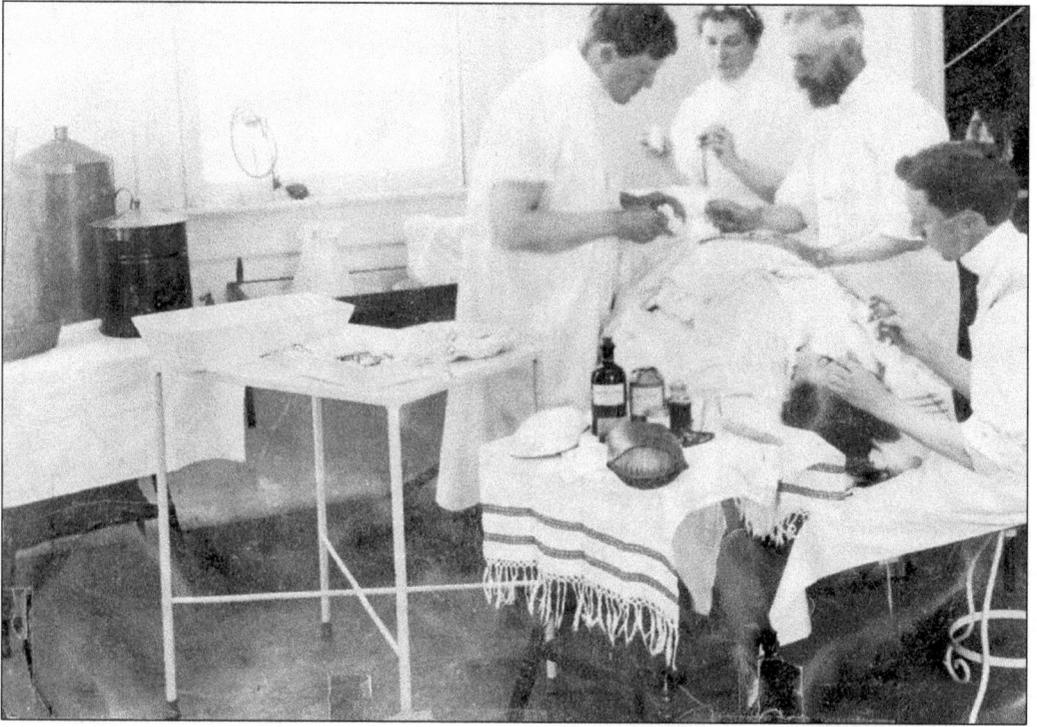

This operating room, pre-World War I, was possibly in the Frazee Hospital. From left to right are Dr. Charles C. Harbaugh, an unknown nurse, Dr. M.B. Mattice, and anesthesiologist Dr. Ben F. Brooks.

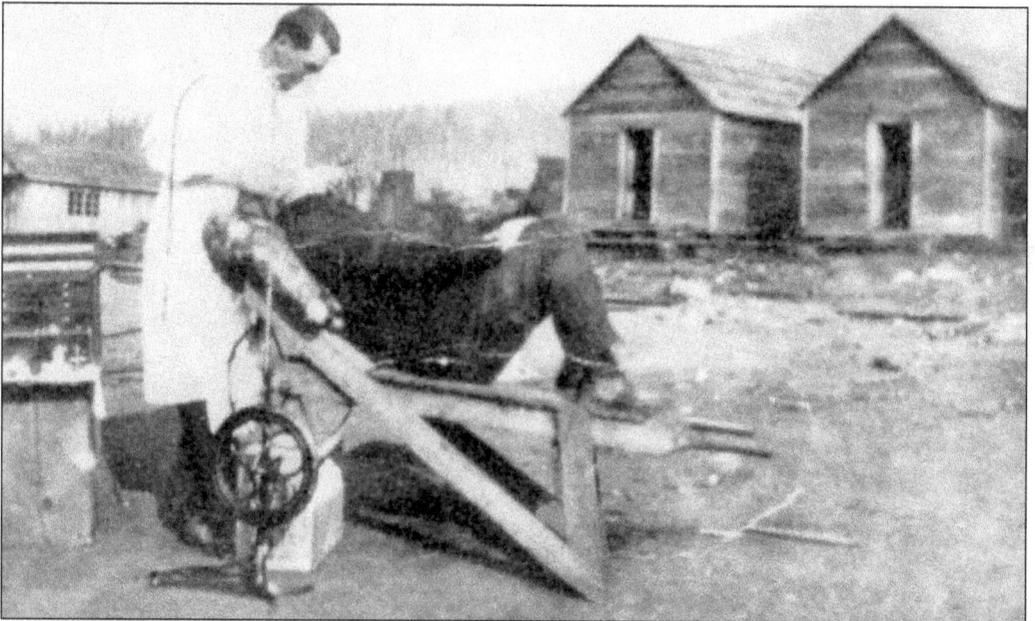

Dr. Thompson is working on Al Stendal with his foot powered drill at the Skagit Mill Logging camp. The advantage of the old-style equipment was that it was portable.

Seven

POLICE AND FIRE
DEPARTMENTS, CRIMES
AND DISASTERS

Who was it that said "we live in a Perfect World?" Well, that utopia does not exist. However, the early pioneers felt secure and often left their doors unlocked.

In the early days crimes were mainly assaults, committed by men who were drunk, seldom involving the community. Gambling and prostitution were legal and taxed. Moonshine stills were abundant in the hills but whisky was legal. It only became big business during prohibition. People didn't have much money so robbery wasn't much a problem, except for banks and logging offices just before payroll. That is why the First National Bank was robbed in 1914.

When Sedro-Woolley merged a marshal was appointed and an office and jail cell was provided. Over the years the marshals have been involved in some highly publicized incidents.

The local fire department was staffed entirely by volunteers and under the direction of the police. Bill Ropes organized them in 1921 and the official Sedro-Woolley Fire Department began. They purchased their first modified Model T fire truck in 1922. In 1925 they purchased their first regular fire truck.

Because of the wooden structures and kerosene lamps, fire was an ever-present danger. The towns of Sedro and Woolley experienced many a disastrous fire, as did Sedro-Woolley. Flooding was also an ever-present danger, both in the spring and in the fall. Including the police and fire departments, this chapter also covers some of the historic events and disasters that occurred in Sedro-Woolley.

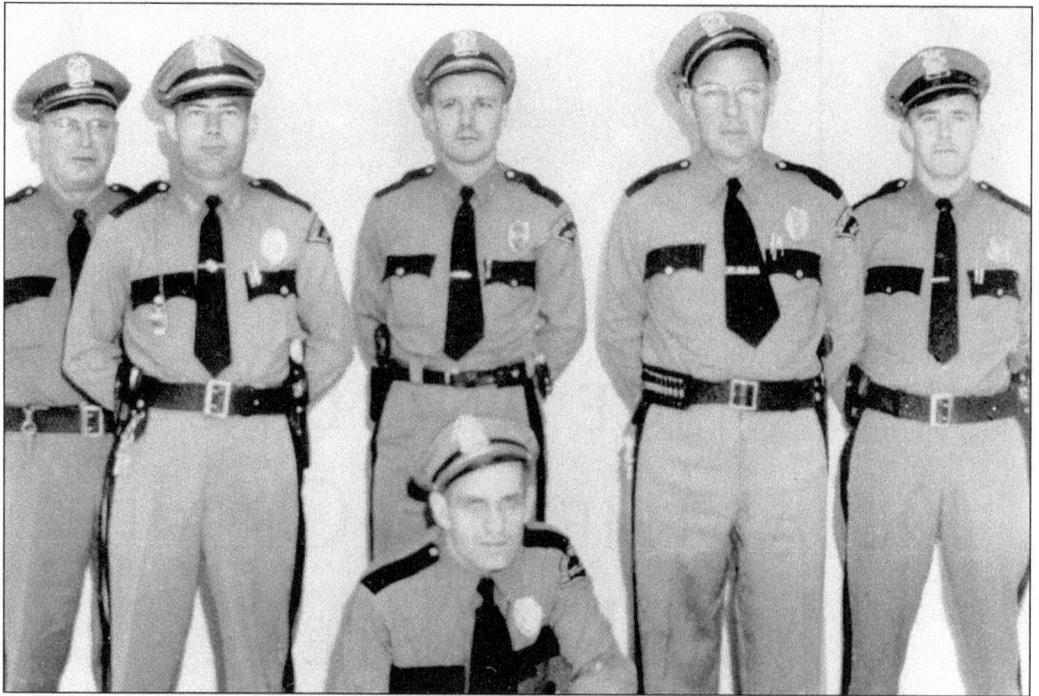

These Sedro-Woolley police officers in the late 1950s are, from left to right, Maurice Davis, Jim Williams, Harold Beitler, Ted Jackson, Bud Heitman, and Chief Norm Lisherness, (kneeling).

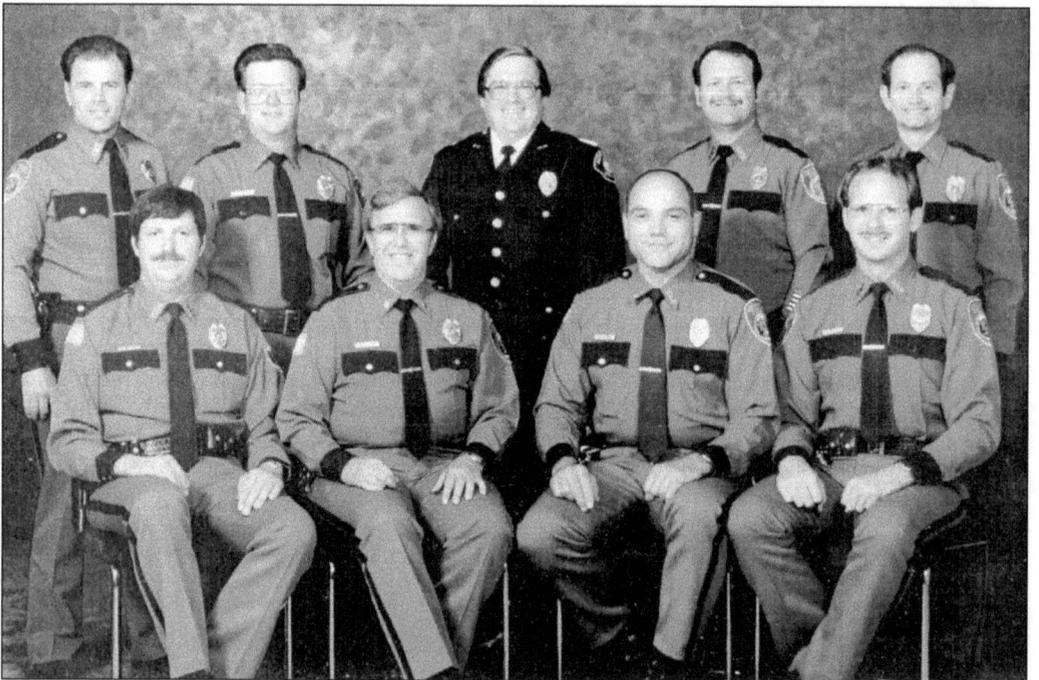

These Sedro-Woolley police officers, c. 1980s are, from left to right: (front row) Frank Spane, Bud Heitman, Ken Rosencrantz, and Doug Wood; (back row) Gary Caffery, Ken Clark, Chief Ron John, Lance George, and Doug Salyer.

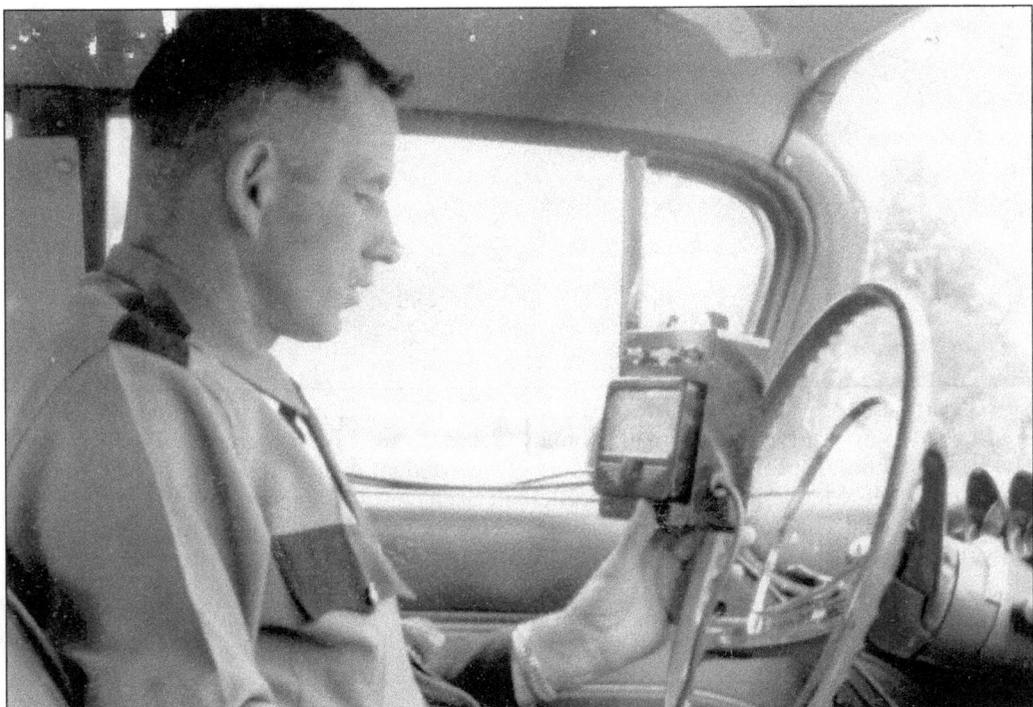

Norm Lisherness, chief of police, poses with the new radar unit in the patrol car, *c.* 1960.

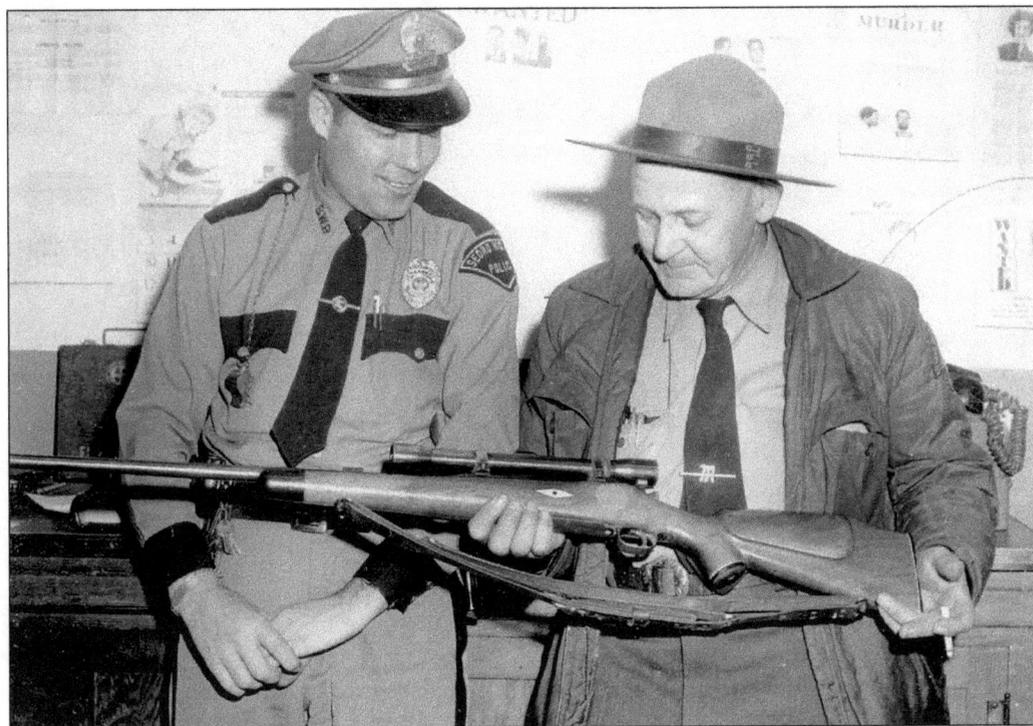

Jim Williams, patrolman, and Maurice "Pappy" Splane, State Game Warden, are inspecting a riffle.

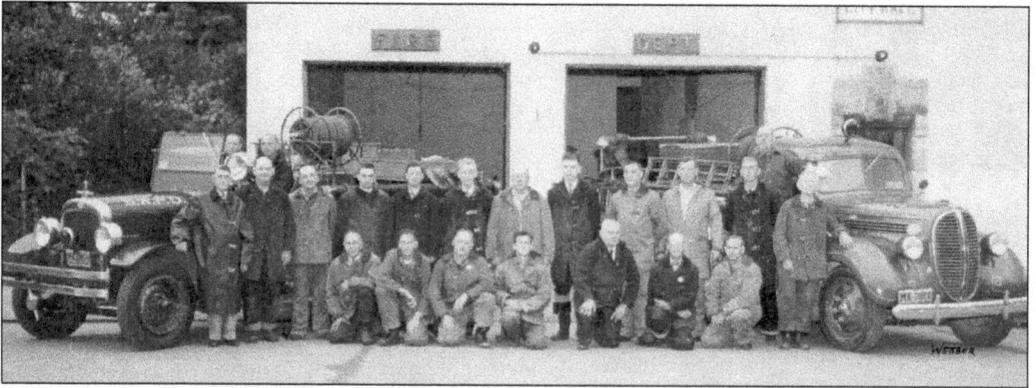

Fire department volunteers in front of the fire hall, 1948, are, from left to right: (kneeling) Fred Leber, Lynn Curry, Henry Small, Tommy Oakes, Everett Blackburn, Earl Porter, and Al Hyldahl; (standing, second row) Eddie Carr, Tom Mullen, Elmer Ecklund, A.H. Bingham, Ford Cook, "Hi" Mueller, John Hawkins, Richard Sackman, Jack Hebert, Maurice Davis, Earl Mericle, and Fred Therkelson; (on trucks) "Fuzz" Hegg, Chuck Rings, and "Puss" Stendal. (Jack Hebert invented the Hebert Hose Clamp, which is used nationally).

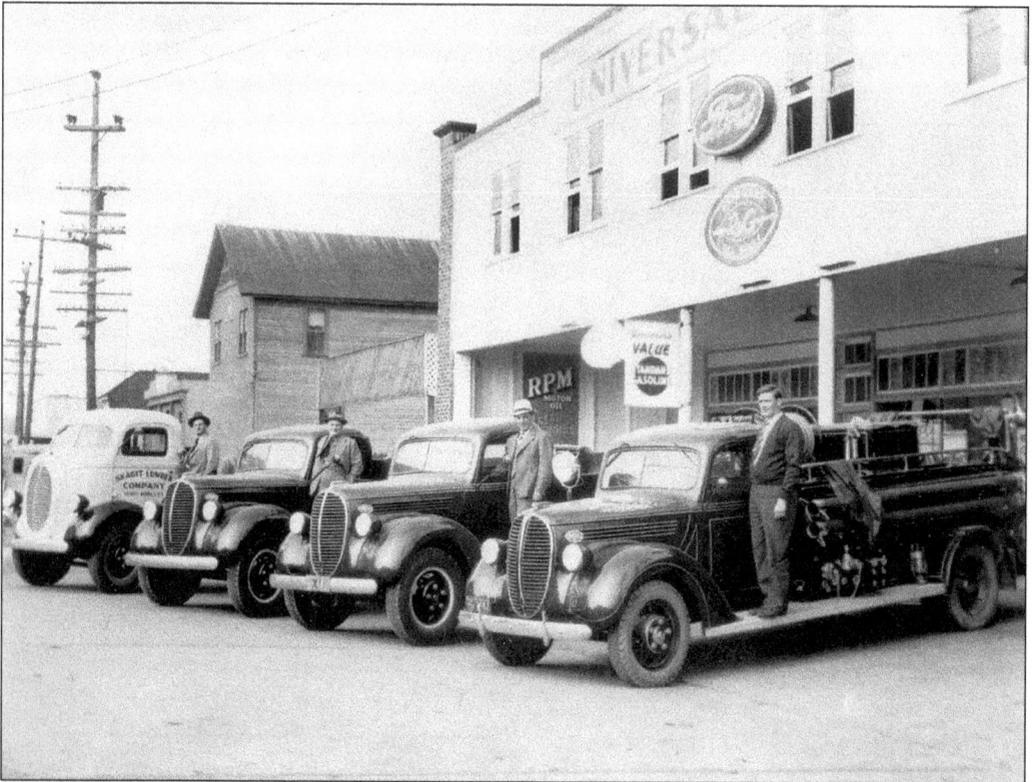

Fire trucks are in front of the Universal Motors Ford garage on Murdock Street, which is now the Sedro-Woolley Museum. Note the wooden building in the background; it was the Eagle's Hall, which burned down in 1949.

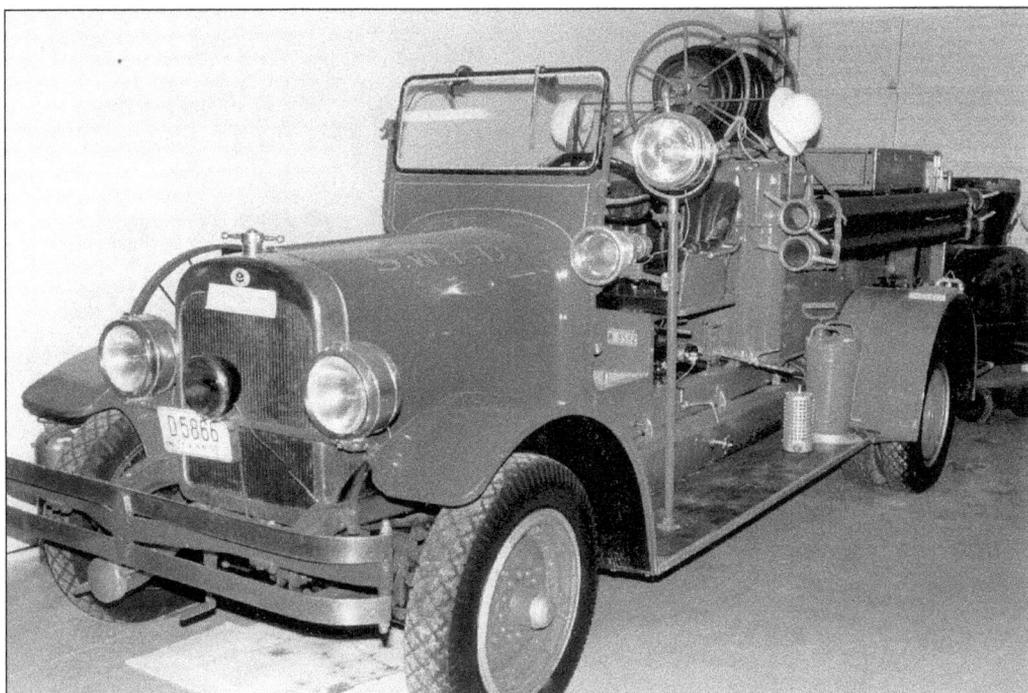

This 1929 Seagrave fire truck was originally purchased new by the Sedro-Woolley Volunteer Fire Department. It is now housed in the Sedro-Woolley Museum.

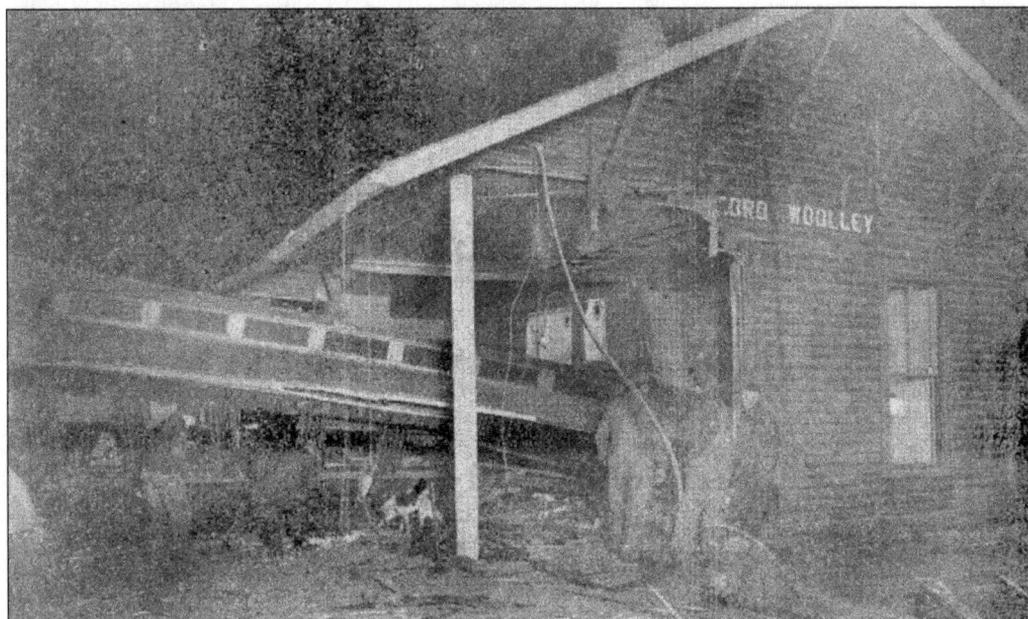

Pictured is the result of the 1918 train wreck, when the Northern Pacific freight plowed into the rear of the Great Northern evening train, which plowed into the depot, demolishing one end. Twenty were injured and six killed. Those killed by the collision were County Commissioner Henry Thompson, Charles E. Patten, V.V. Schumaker, G.C. Tilford, Melvin Best, and J.E. Powell, a Sedro-Woolley business man.

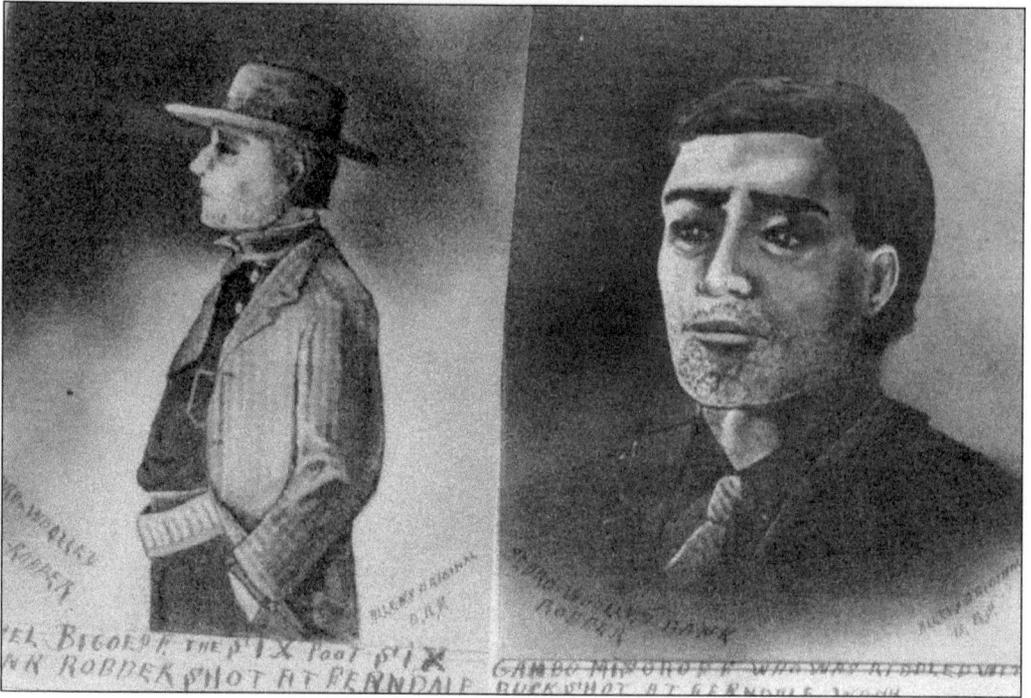

This page has pictures of four of the five Russian bank robbers who robbed the First National Bank in 1914. Above are Kasel Bigoff, 6 feet 6 inches tall, and Gambo Misoroff, both killed at Ferndale, Washington. Below are Eslan Jiseloff, who was wounded and later killed by the others because he could not keep up, and Jambobot Kadieff, the leader of the gang. Both died around Hazelmier, B.C.

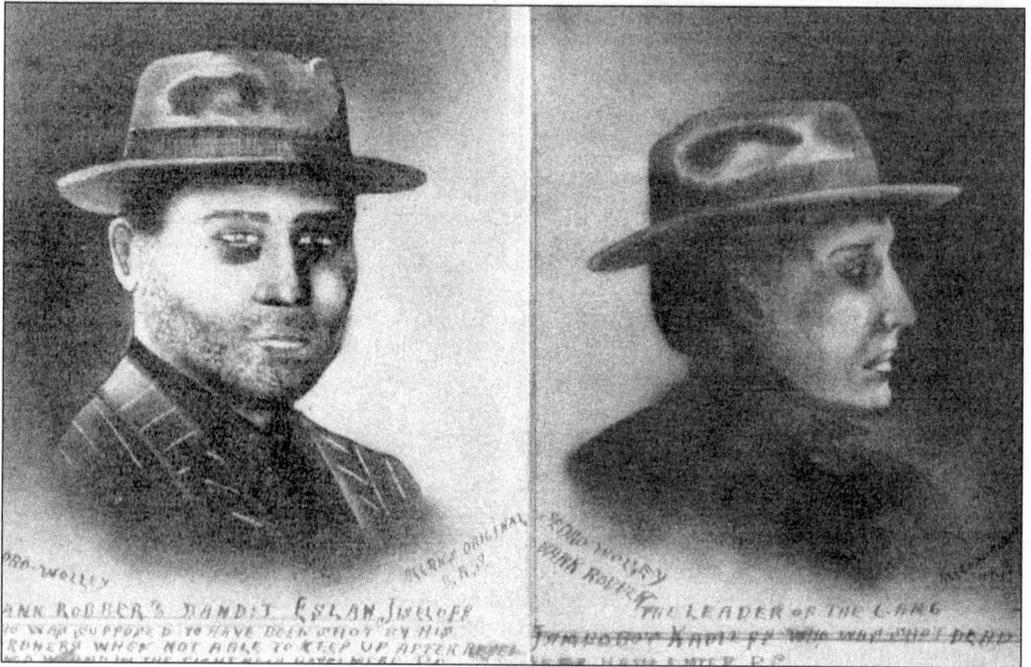

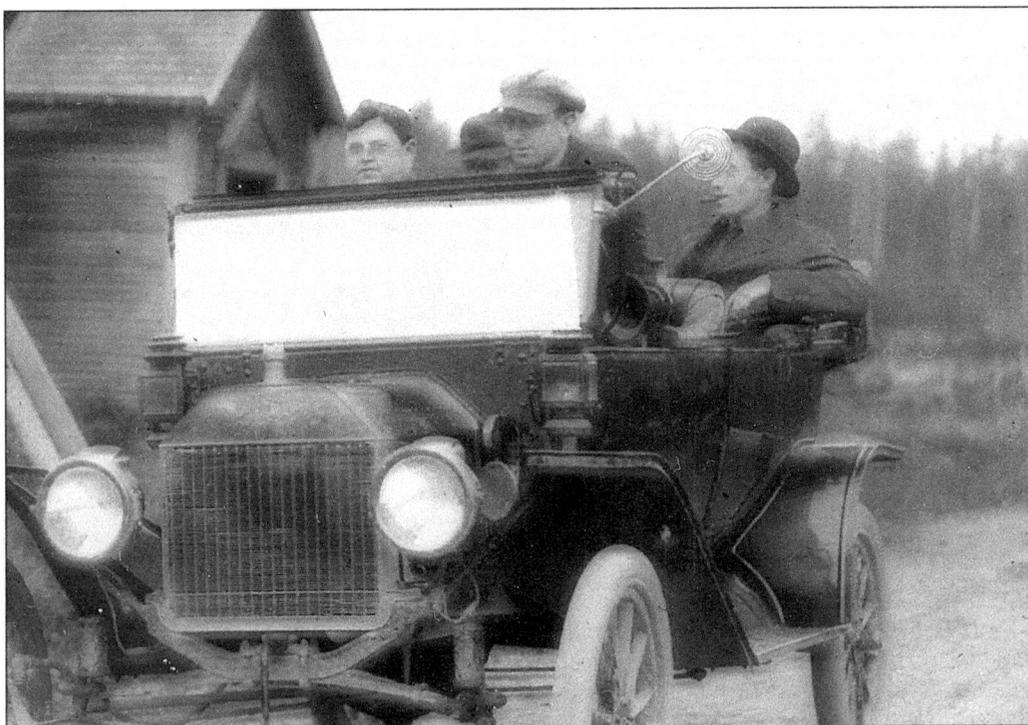

Skagit County Sheriff Well's armor-plated, wind-shielded Model T was used to track the bank robbers. The headlight from this car was used as a spotlight on the bridge at Ferndale to blind the robbers when they tried to cross the bridge.

The bullet riddled First National Bank in Sedro-Woolley was robbed by the five Russians. Over 200 shots were fired in downtown Sedro-Woolley. The only fatality was a 12-year-old boy, Melvin Wilson, who was hit by a stray bullet.

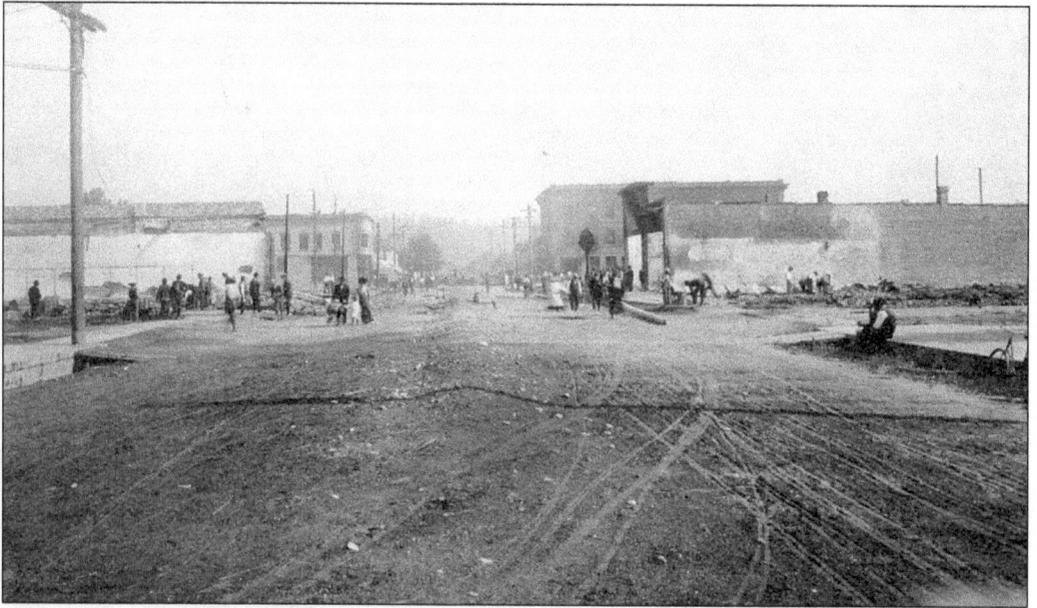

The 1911 fire destroyed two city blocks of downtown Sedro-Woolley. Note that Condy's clock (middle of the picture, to the right) withstood the blaze, and indeed the clock is still working today. This photo looks north on Metcalf Street.

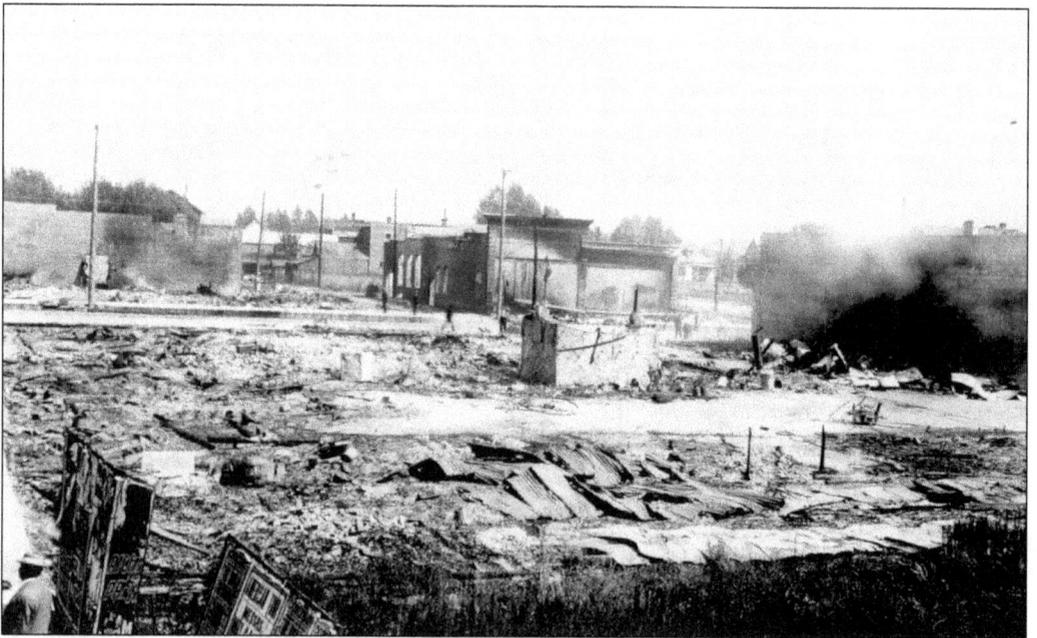

Here is another view of the destruction caused by the 1911 fire. The fire got out of hand because the volunteer fire brigade accidentally burned up their only hose in the early stages of the fire.

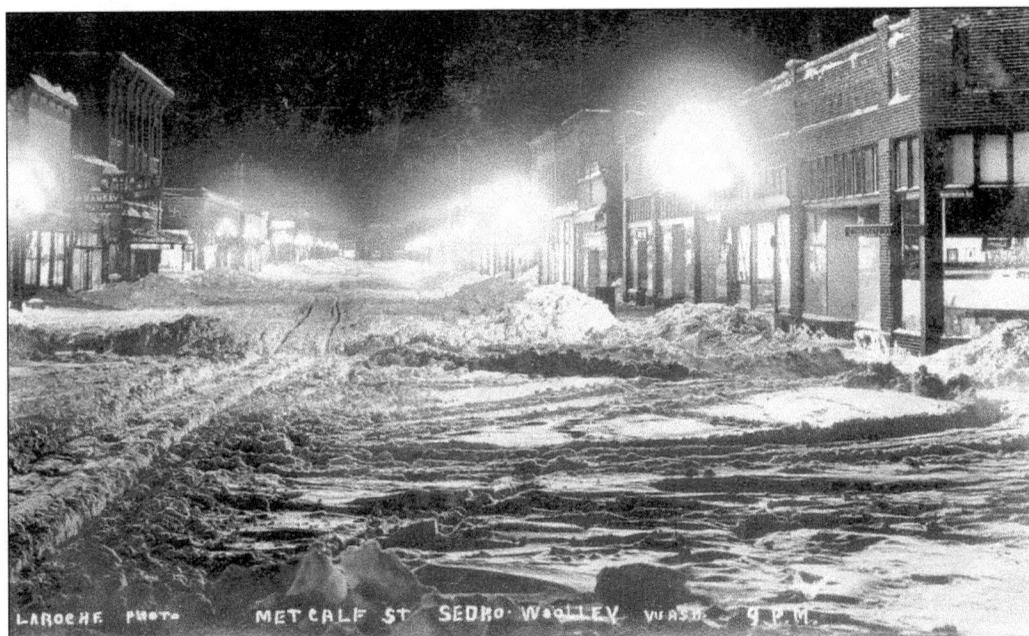

This is Metcalf Street looking south in downtown Sedro-Woolley, photographed at 9 p.m., during the big snowstorm of 1916.

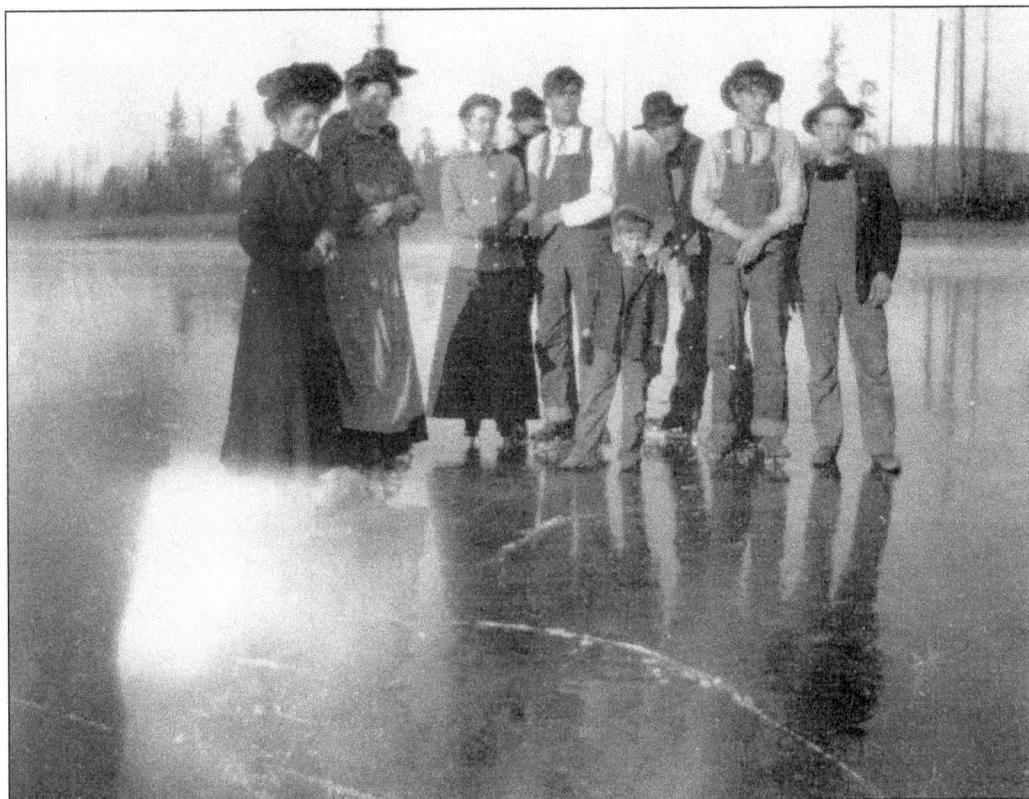

The Kinsey family was ice skating on the Skagit River after it froze during the 1916 storm.

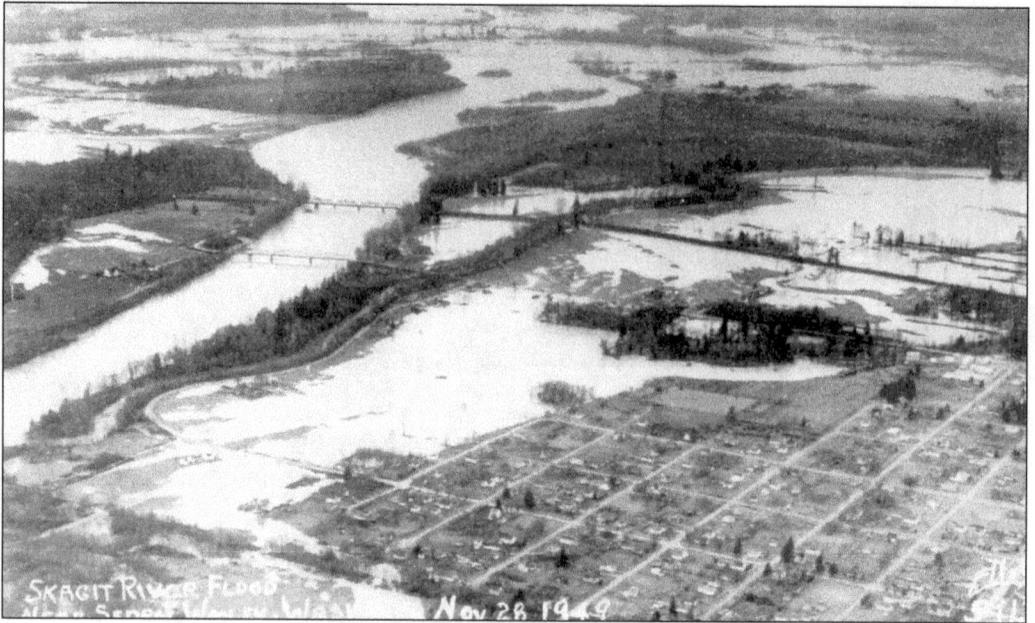

An ariel view of Sedro-Woolley shows the devastation caused by the November 1949 flood of the Skagit River.

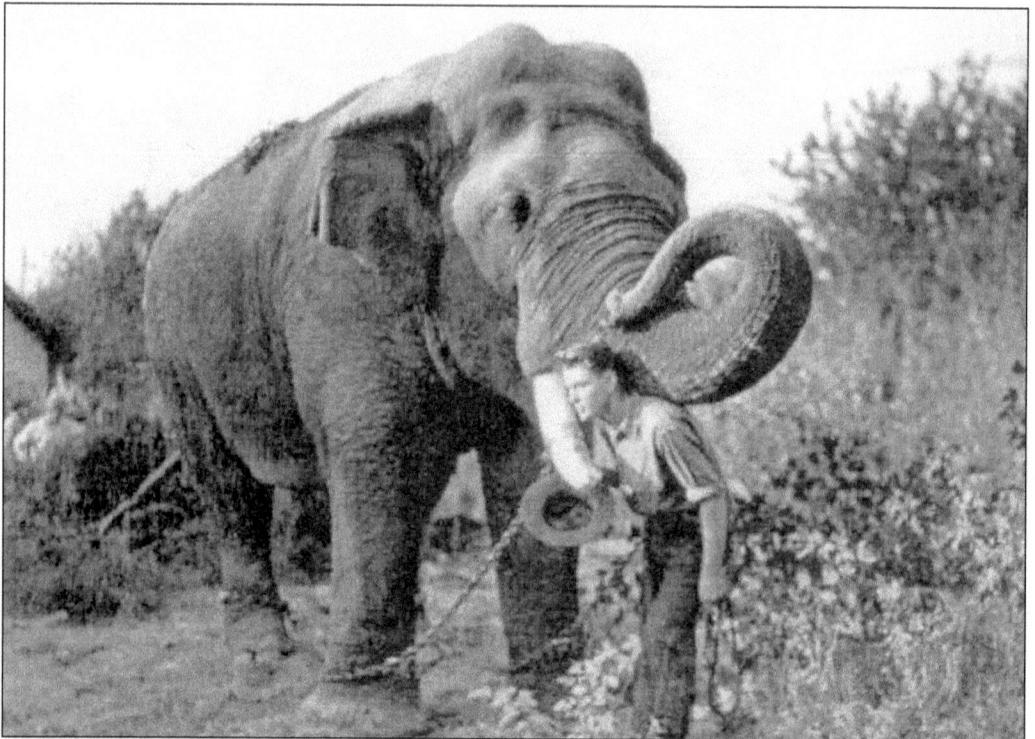

Tusko the elephant poses with his trainer Slim Lewis. Tusko toured with the Al G. Barnes Circus, broke loose, and ran amuck in Sedro-Woolley in May of 1922. His all-night romp caused a great deal of havoc and the story made the front page of many U.S. newspapers.

Eight

AGRICULTURE

Daniel Webster is reported to have said, "The Farmers are the founders of civilization and prosperity." He could have been speaking about Skagit County, where agriculture has always been the basis of prosperity.

The early settlers, through necessity, became self-contained. As the land was cultivated, crops were planted, vegetables were grown; they acquired a few cows, chickens, and a pig; fruit trees were planted; and some even kept bees. This was the way to feed their families, as getting supplies and food took a long time. As the population grew, the excess crops were used for barter with their neighbors and the early stores.

The 1899 *Skagit County Times* noted "The new town of Sedro-Woolley . . . is at present moment the smartest and most progressive town in Washington. It is the heart of Skagit County at the junction of the Seattle and International railway (over which the Canadian Pacific reaches Puget Sound), the Seattle and Northern railway and the Fairhaven and Southern. It is also on the banks of the Skagit River, the largest navigable stream in the State. The resources of the immediate tributary territory are lumber, shingles, gold, silver, iron, coal, fruit, hay, oats, and vegetables."

At the time of the State's centennial in 1989, the Washington State Department of Agriculture compiled a list of centennial farms, farms that have been owned by the same families for at least 100 years. Sedro-Woolley has three such farms that are still in operation today by descendants of the original founders. The Holtcamp Farm founded by Henry Holtcamp, whom we covered in Chapter 1, was one of the first five men in the area. The McRae farm was founded in 1885 by George McRae. It was George McRae that donated an acre of land in 1890 for the local neighborhood school (pictured in Chapter 6). The third centennial farm still in operation today is the Hall farm, founded by Woodbury Hall in 1884.

Today the rich soil and productive climate have made the Skagit Valley a major United States seed production area.

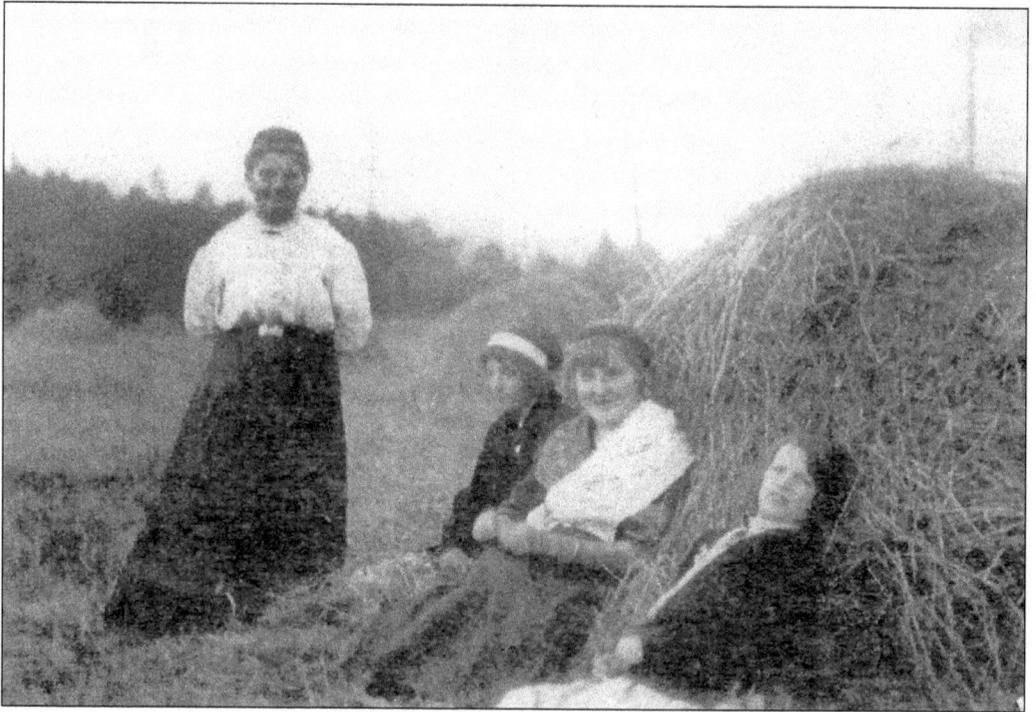

Working in the field in 1912 are, from left to right, Mary Thiele Kiens and her daughters Elizabeth (Liz), Anna, and Babe.

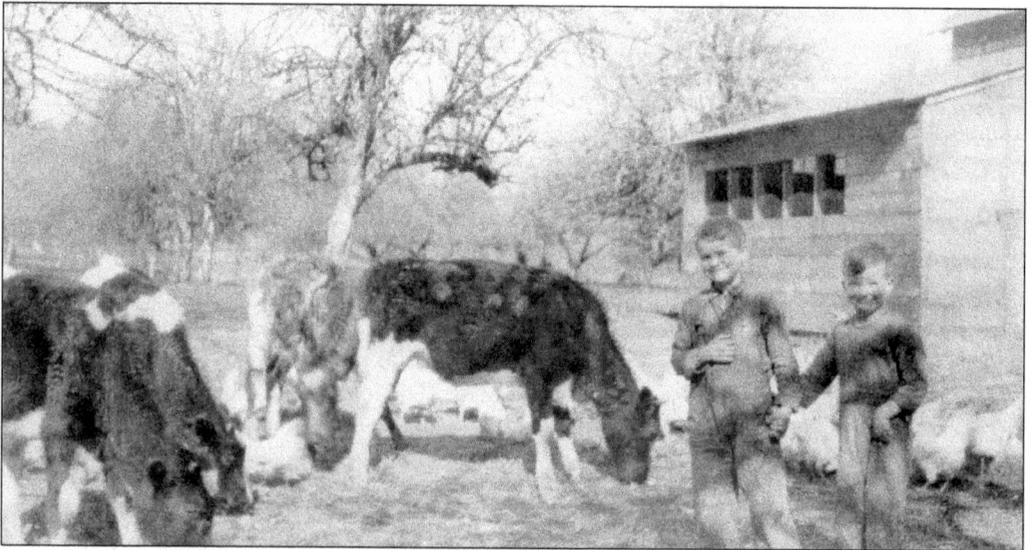

Ray and Virgil Van Fleet are posing with the cows and chickens, c. 1922.

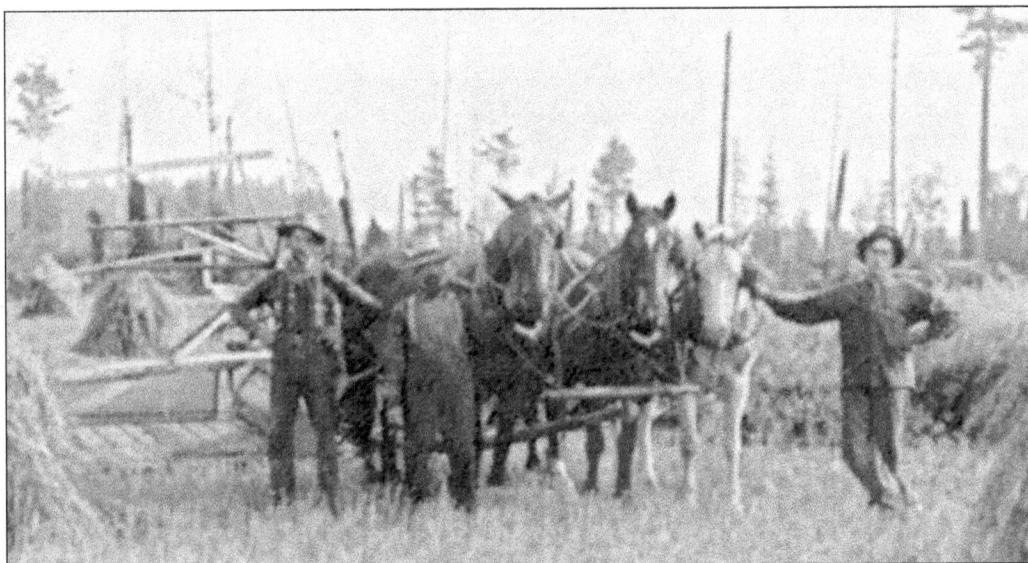
Ernie, Henry, and Whetzel Dreyer are pictured during harvest time on the Dreyer farm.

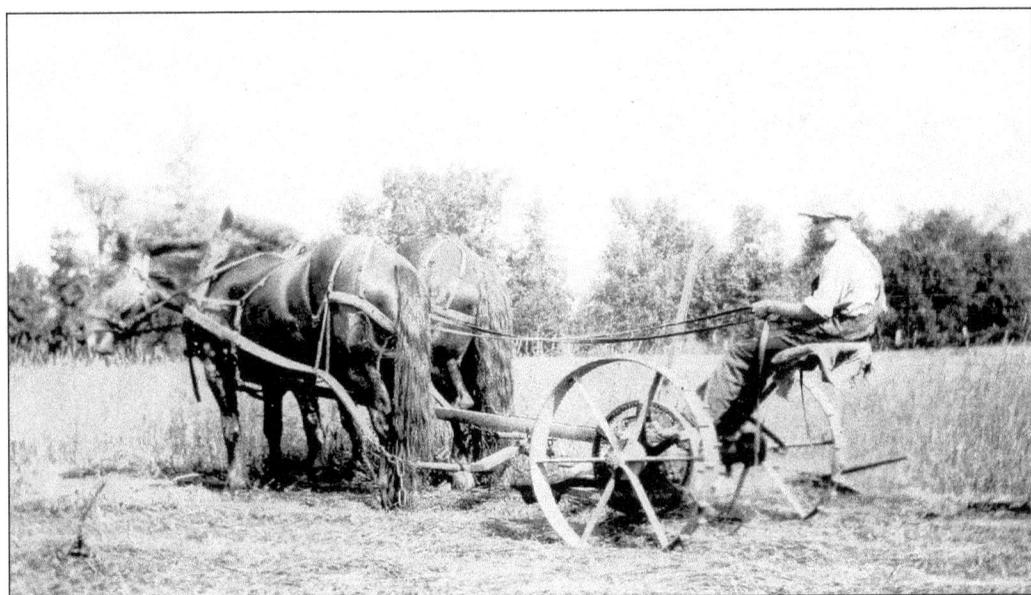
Virgil Van Fleet is mowing in this photograph, c. 1930.

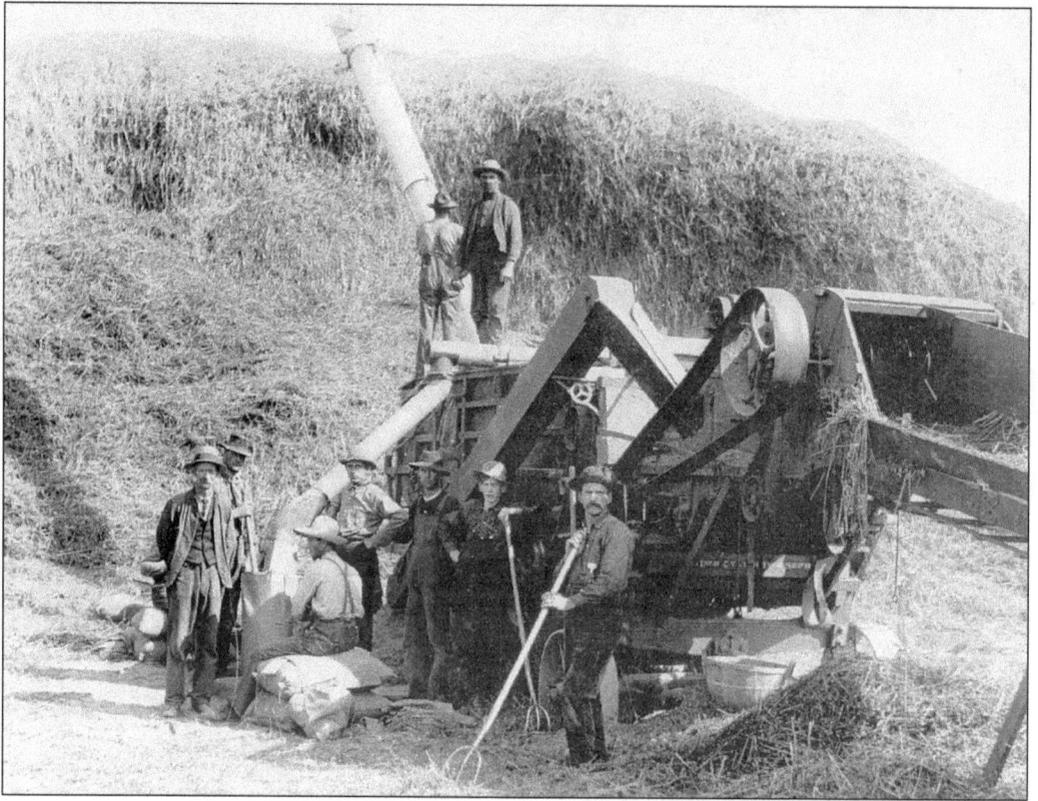

This thrashing crew is working on the Holtcamp farm.

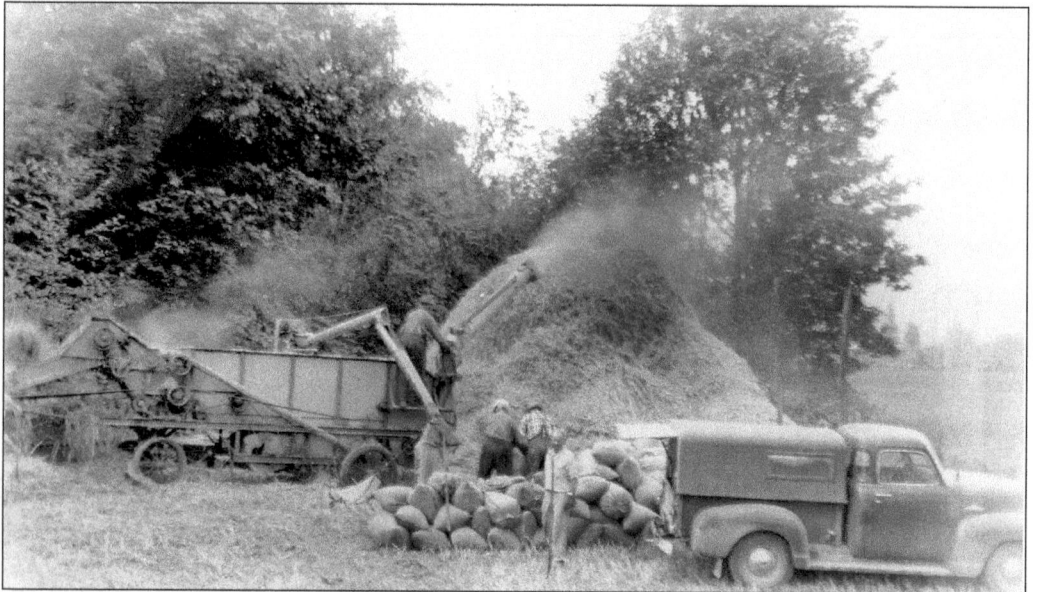

This crew thrashing on the Van Fleet farm from left to right, is Howard, John, Clinton, Charlie, and Chester.

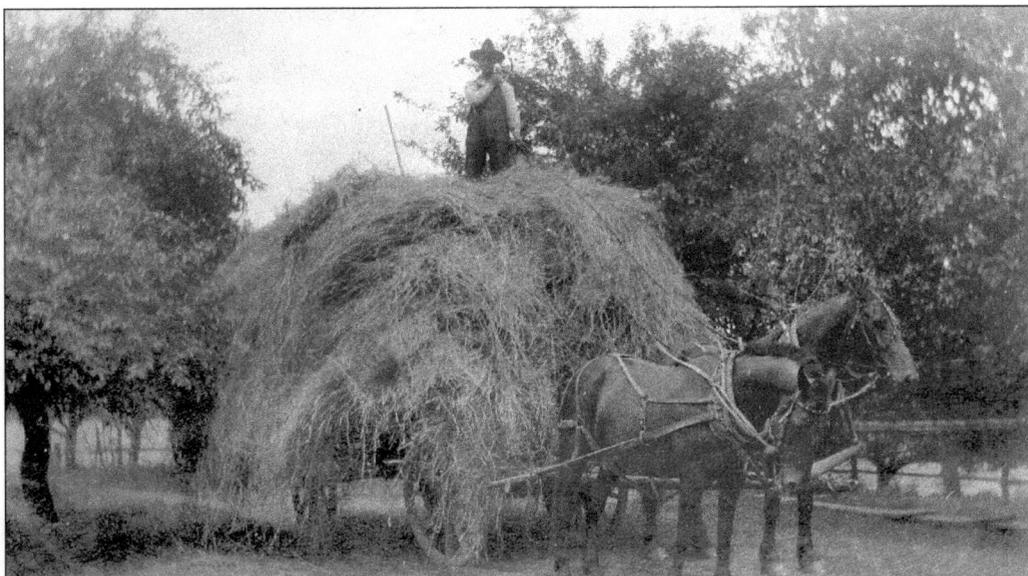

This is a typical hay wagon during harvest time in July 1923.

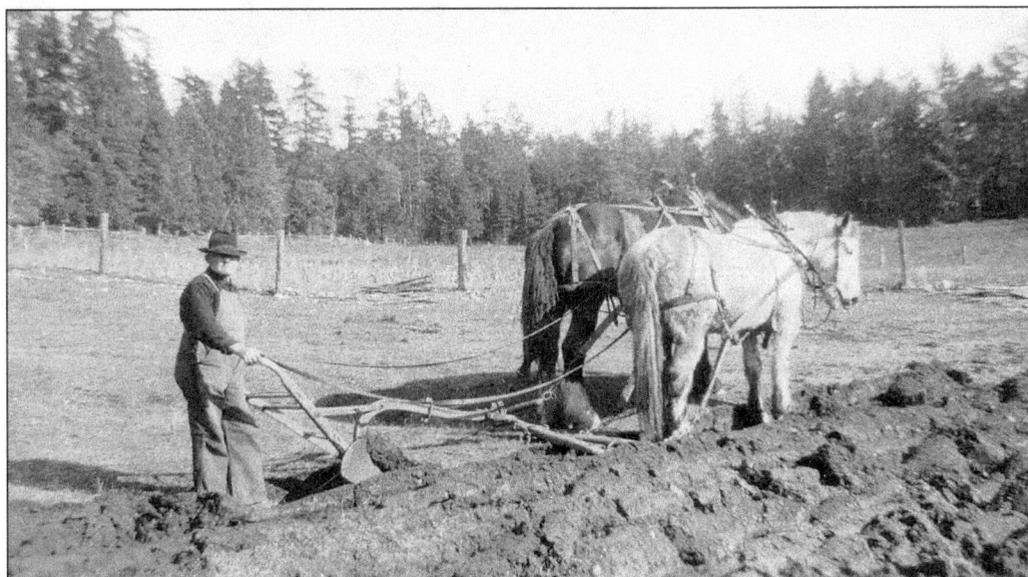

George Morgan is plowing, c. 1942.

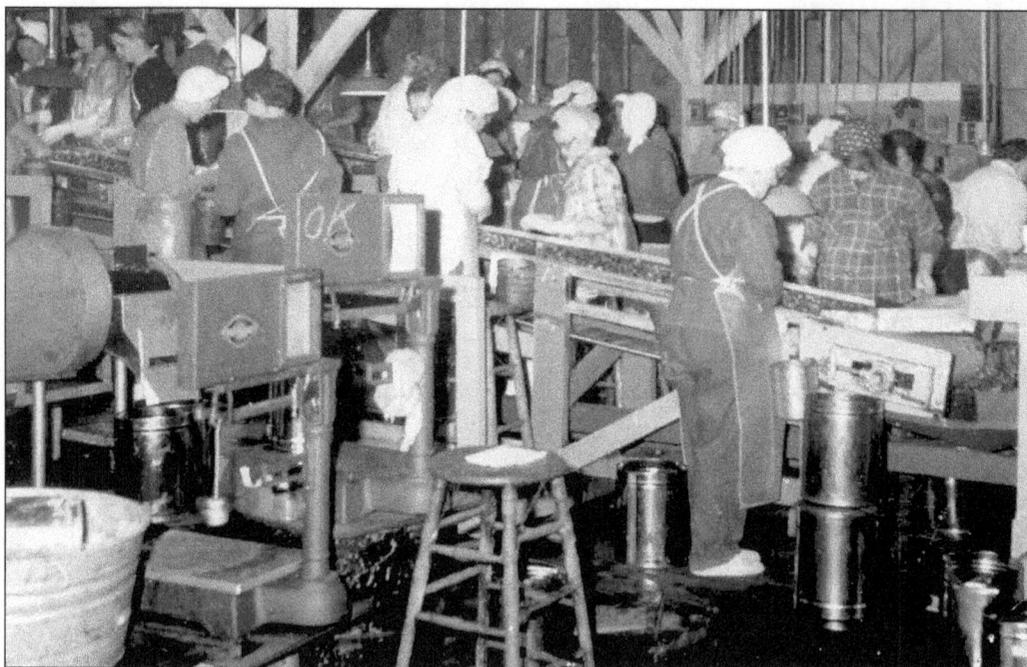

Strawberry processing is taking place at Johnson Feed and Seed, located on State Street in Sedro-Woolley, c. 1950.

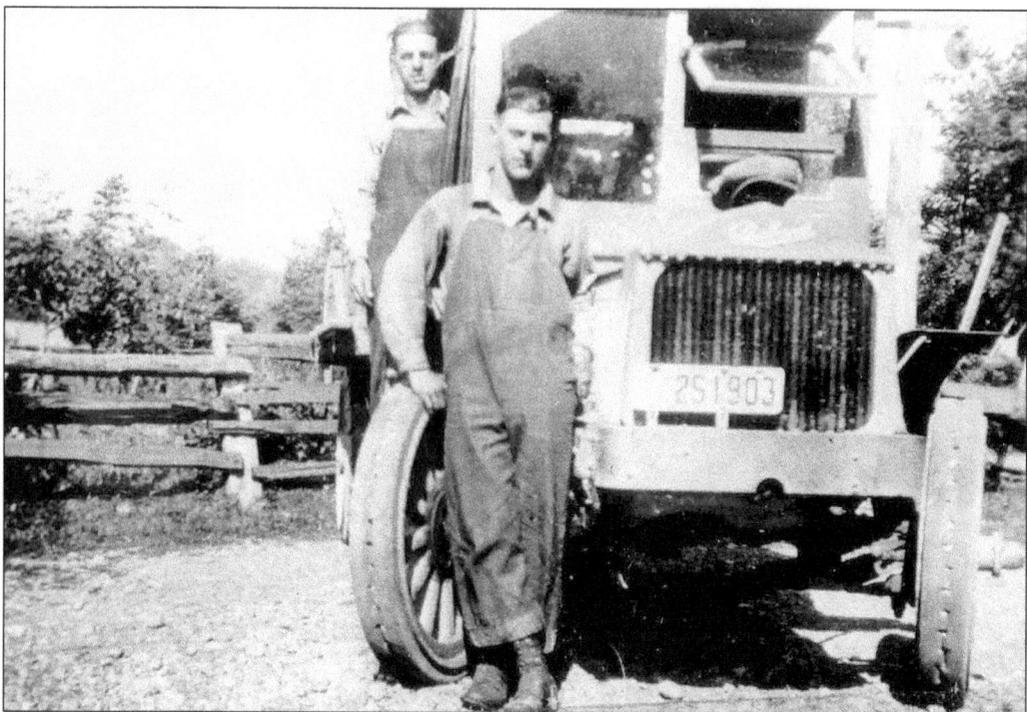

Ernie and Fritz Albertine and their Packard milk truck was one of the first trucks used to haul milk. They contracted with the Carnation Company for more then 35 years. This photo was taken c. 1942.

The Henry Holtcamp farm yard, west of Sedro-Woolley is pictured here in the early 1900s. Notice the rail fence, horses, cows, colt, windmill, and farm building with old stumps still scattered around.

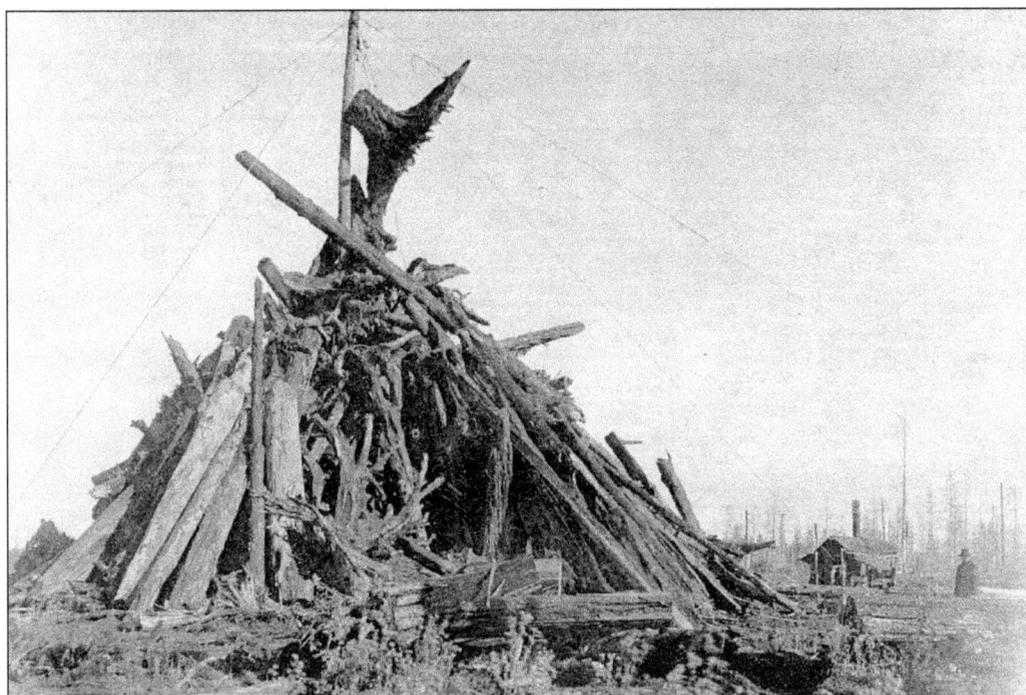

The farmers clearing their land used a steam donkey to pull the logs into huge piles for burning. Note the steam donkey in the background to the right and the spar pole in the center of the stump pile.

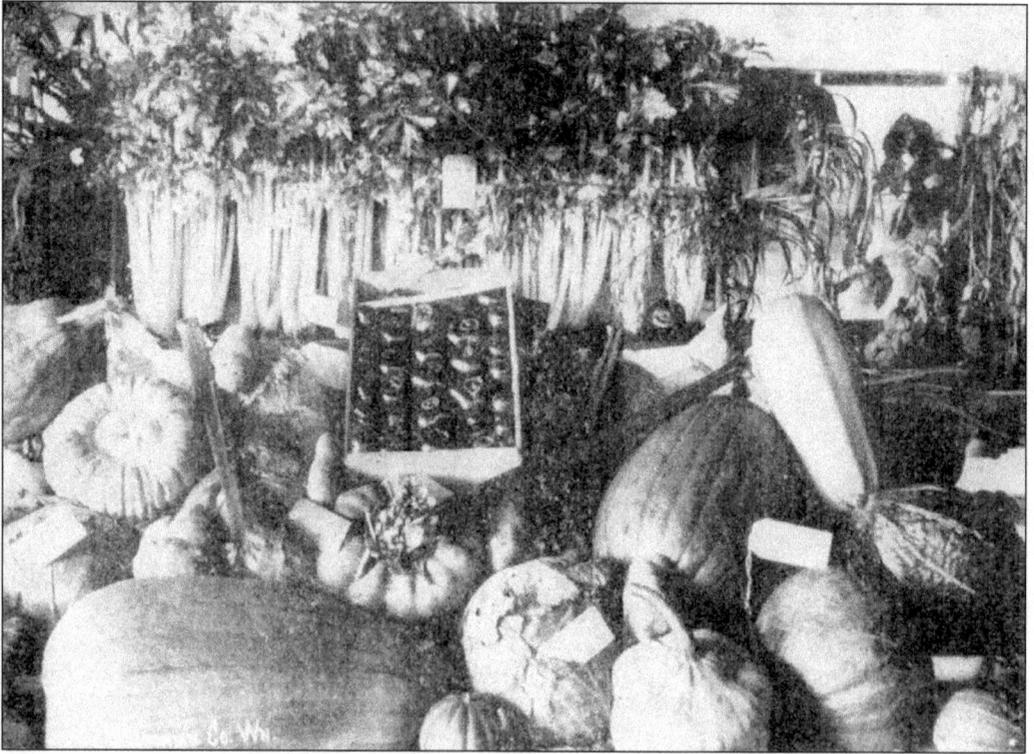

This picture was taken from the 1906 book. It shows the typical produce grown in the area.

This is the window of the Star Grocery in downtown Sedro-Woolley in 1910.

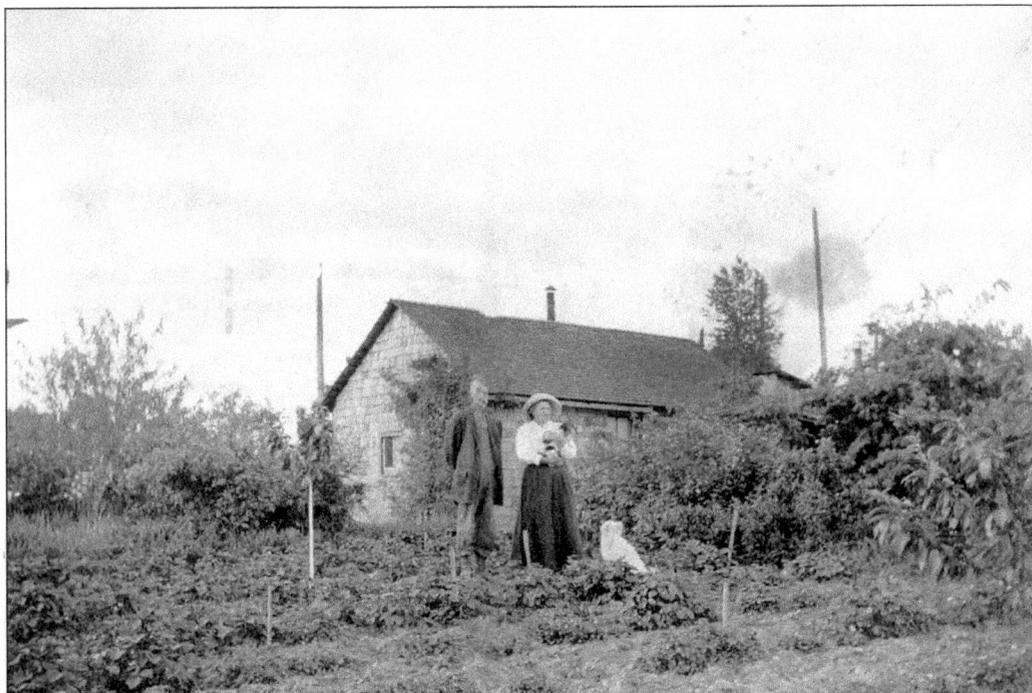

In this photo of the Healys at home in their garden, Mrs. Healy is holding a baby lamb.

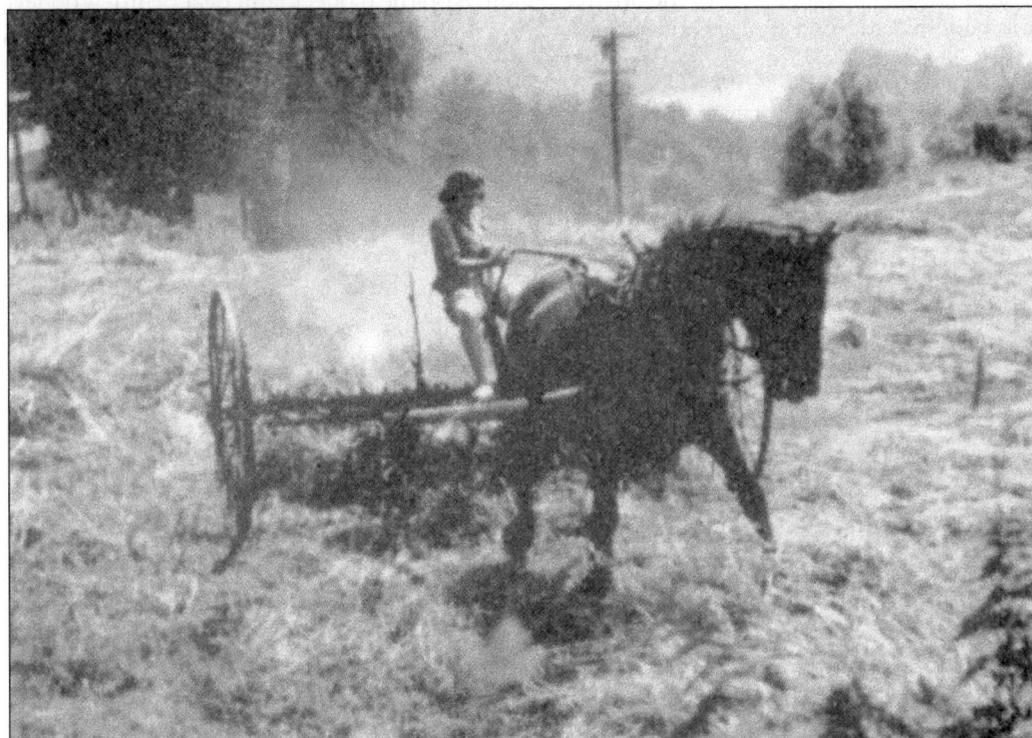

"Who says our girls aren't helping win the war of the farms?" Ethel Robertson helps with the haying (the 1943 high school annual ran this picture and text).

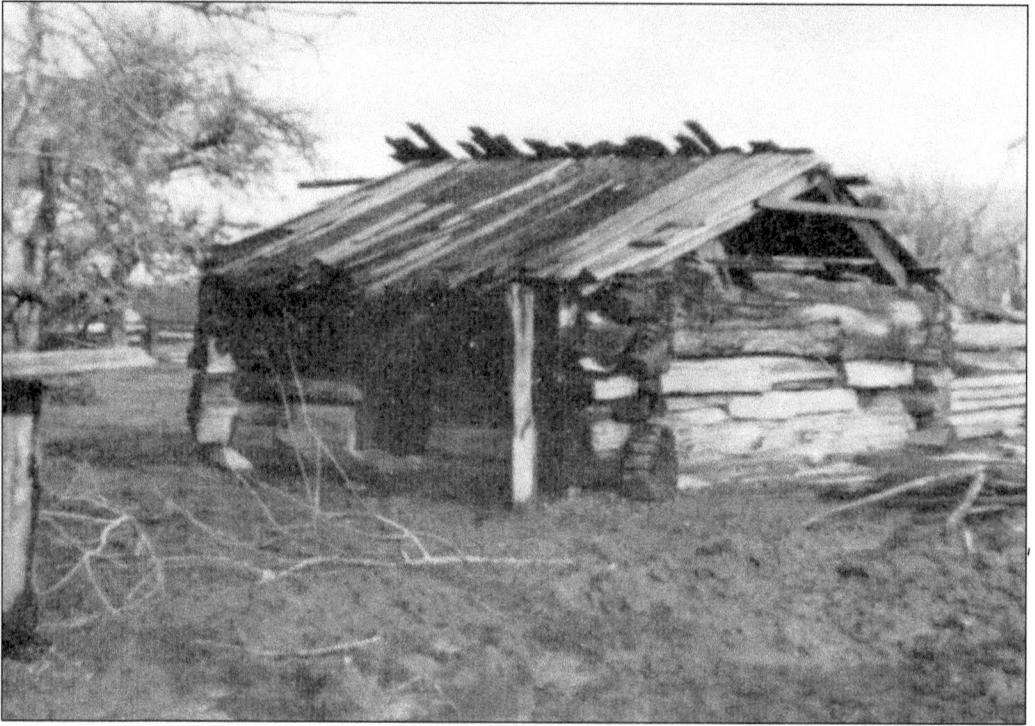

The Holtcamp pig house, one of the original buildings on the pioneer farm near Sedro-Woolley, was built by hand-split timbers and shakes.

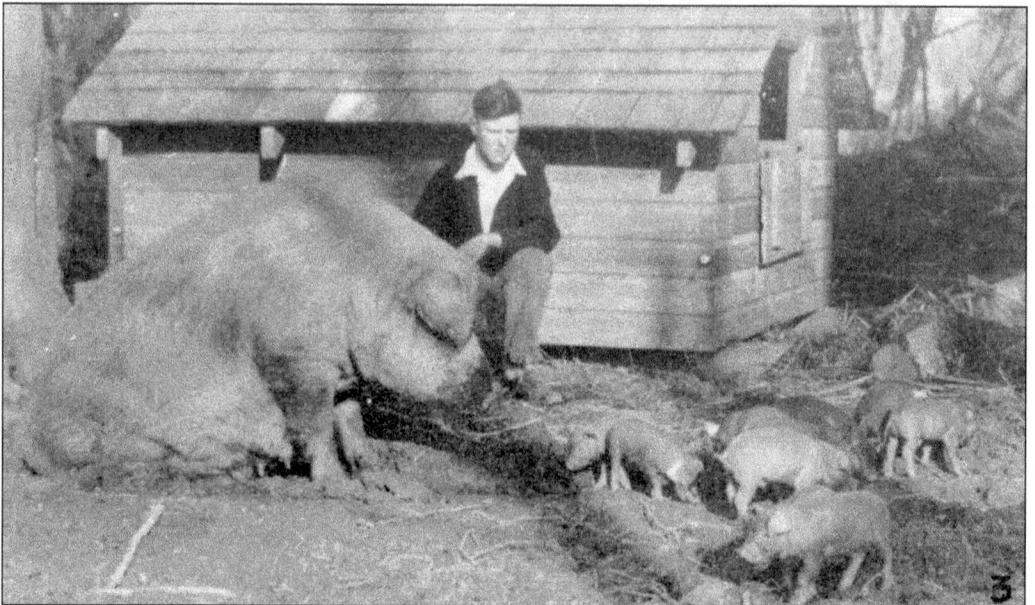

Rodney Christianson and Miss F.A.A. Girl are looking at piglets. "Increasing production of farms" as well as in war industries, was the F.A.A.'s motto in 1943. Every F.A.A. home also had a victory garden. (From the 1943 high school annual.)

Nine

CLUBS AND
ORGANIZATIONS

"Gather ye rosebuds while ye may, old time is still a-flying, and this same flower that smiles today, to-morrow may be dying."—Robert Herrick.

The Sedro-Woolley newspaper, *The Courier-Times*, stated in their centennial edition in 1953: "One of the things which has made America and the State of Washington great is the ability and willingness of its citizens to band themselves together voluntarily into groups to accomplish a common purpose.

Nowhere else in the world do so many free men and women freely work together. Typically American from its pioneer days to the present, Sedro-Woolley has seen many civic, fraternal, and commercial groups organize and grow into influential parts of community life."

Some of the early fraternal organizations formed before the turn-of-the-century have died out, like the Knights of Pythias, Odd Fellows, and Rebekahs. Many organizations flourish today, including the Rotary, Soroptomists, Lions, and Masons. We are sorry that space limits naming all the great civic, fraternal, or commercial organizations that have been formed in Sedro-Woolley over the years.

The service they have provided the community cannot be over-estimated. They have organized Little League, provided scholarships, promoted civic pride, built ballfields and provided the lights. The Sedro-Woolley Museum would not be where it is today without these organizations' generous contributions.

They have also provided good old American fun for their members and their families, especially in the early years, from picnics and Christmas parties, to family socials throughout the year.

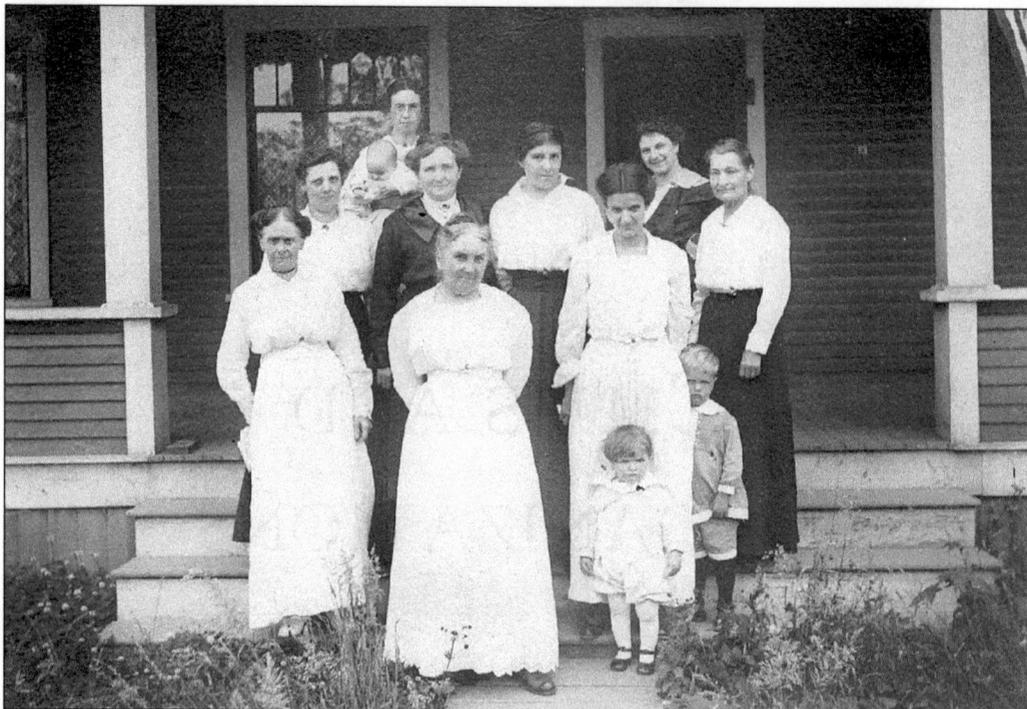

The Skiyou Club is posing in front of Mrs. Benecke's. From left to right, the club was: (in front) Eliza Van Fleet, Mrs. Gillman, Mrs. Frank Kirby, Eva Van Fleet Parker, Ethel Van Fleet Harris, Frances Chase, Mrs. Healey, and Mrs. Frank Hamilton; (in back) Mrs. Benecke with baby; (little boys) Robert and Milton Chase.

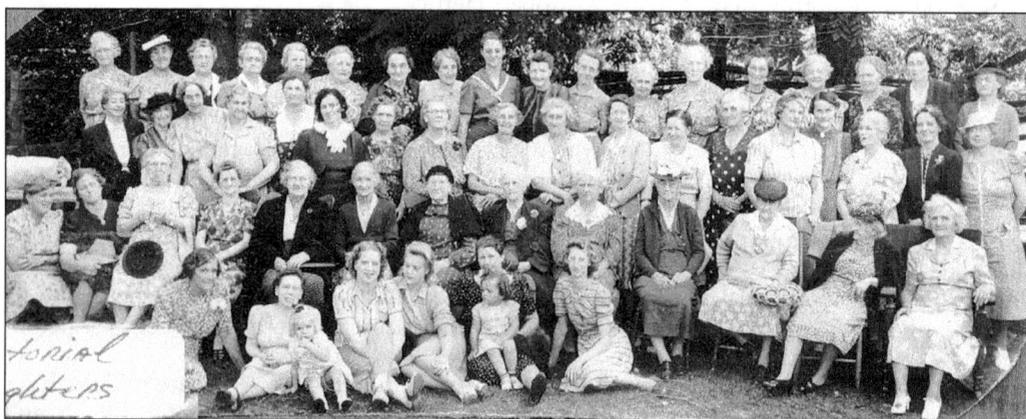

Territorial Daughters of Washington, Chapter 1, was conceived during Joe Napoleon's funeral, a highly regarded Indian known by all. Before the funeral a group of pioneer ladies decided to get together for a picnic. Susan Batey Taylor suggested the name. The organizational meeting was in the fall of 1936.

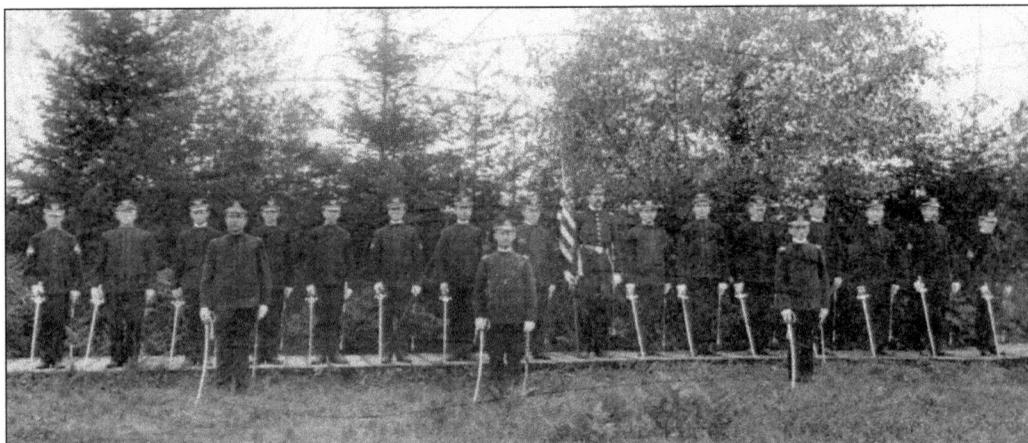

The Knights of Pythias, Mt. Baker Lodge #73, was chartered in 1891. This picture of the Knights was taken c. 1917. The front three men are Mr. Koster, 1st Lt.; Homer Shrewsberry, Capt.; and Paul Rhodus, 2nd Lt.

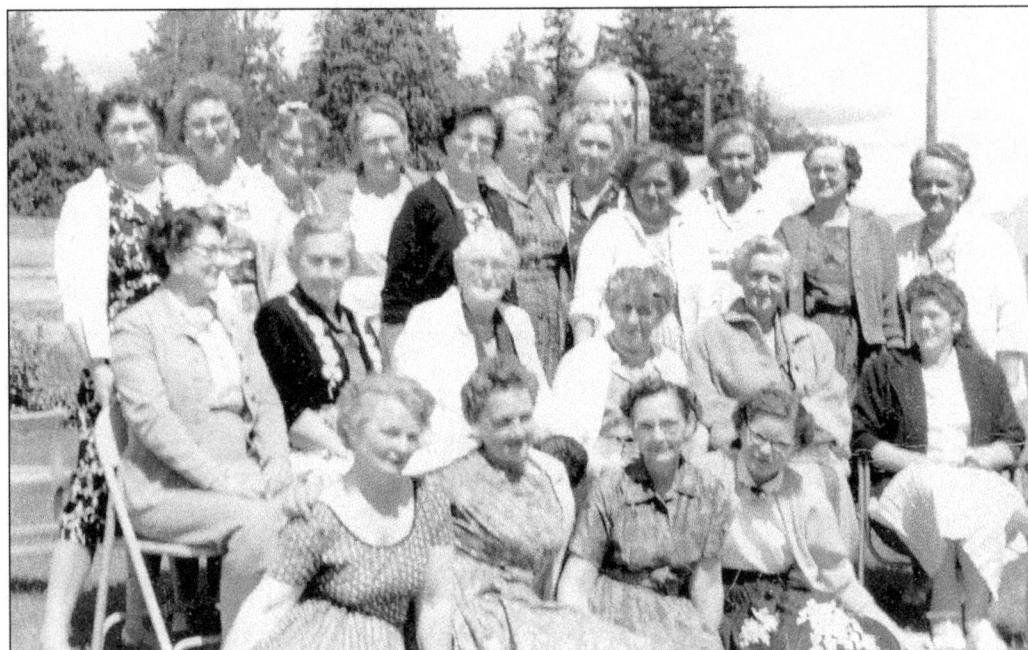

The Pythian Sisters' Lodge, Temple #92, was organized in 1924. From left to right are: (first row) Mae Parker, Marguerite Bennet, Lou Alice Baker, and Kate Olsen; (second row) Etta Mae Fish, Ina Allen, Flossie Hustead, Cora Hegg, Lillian Jeck, and Ann Rings; (back row) Rose Johnston, Ellen Anderson, Myrtle Benson, Fern Hanson, Leveta Jones, Bertha Stephens, Laura Jones, Christine Hill, Alta Greene, Marie Mast, and Hilma Beecraft. This picnic took place in the early 1950s.

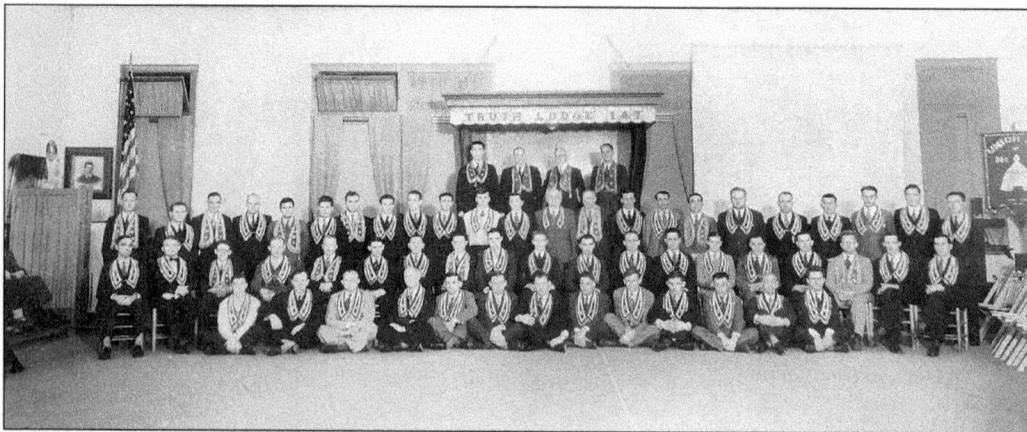

The IOOF-Truth Lodge #147 was organized in 1895, as was the Success Rebekah Lodge #7, so named by Mr. and Mrs. F.A. Douglass because they believed that success always follows truth. In the above picture 55 candidates receive the third degree.

United Lodge #93 of the Free Masons of Washington was formed in 1893. Pictured from left to right, are: (front row) Louie Harding, Robert Henerson, John D. McNab, Victor Lewis, and James S. Rouse; (back row) Carl E. Seidel, Richard A. Greenfield, Charles M. Tewalt, Tom Forsyth, and John S. Evans.

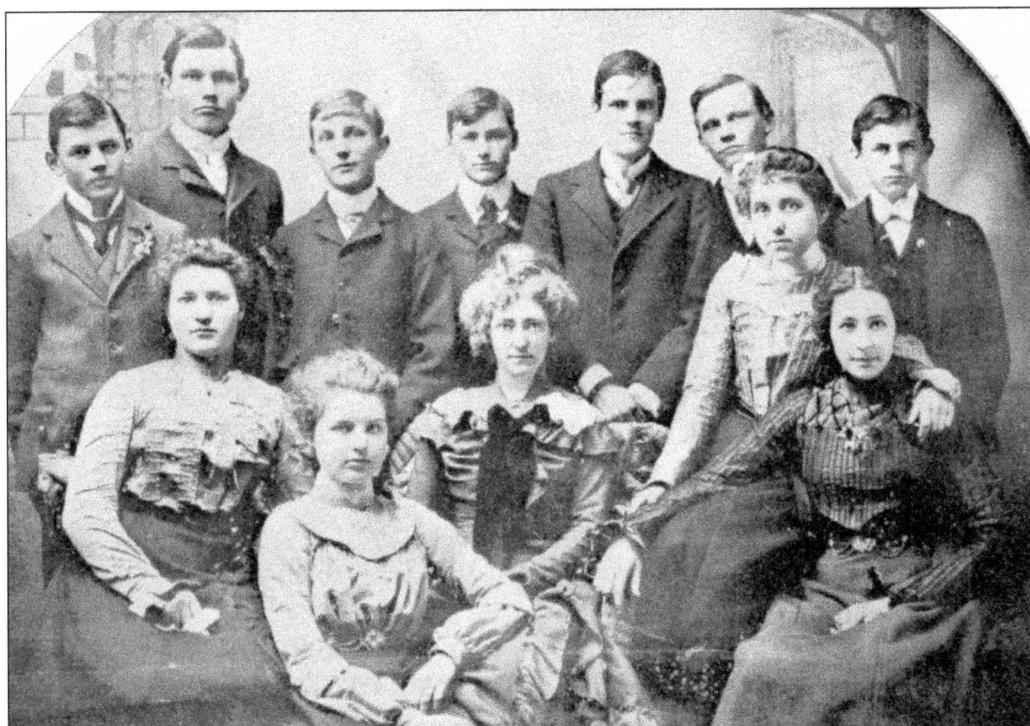

The Criterian Club of the Sedro-Woolley High School produced the high school's first annual in 1901. This was the first production of its kind ever attempted by any school in Skagit County.

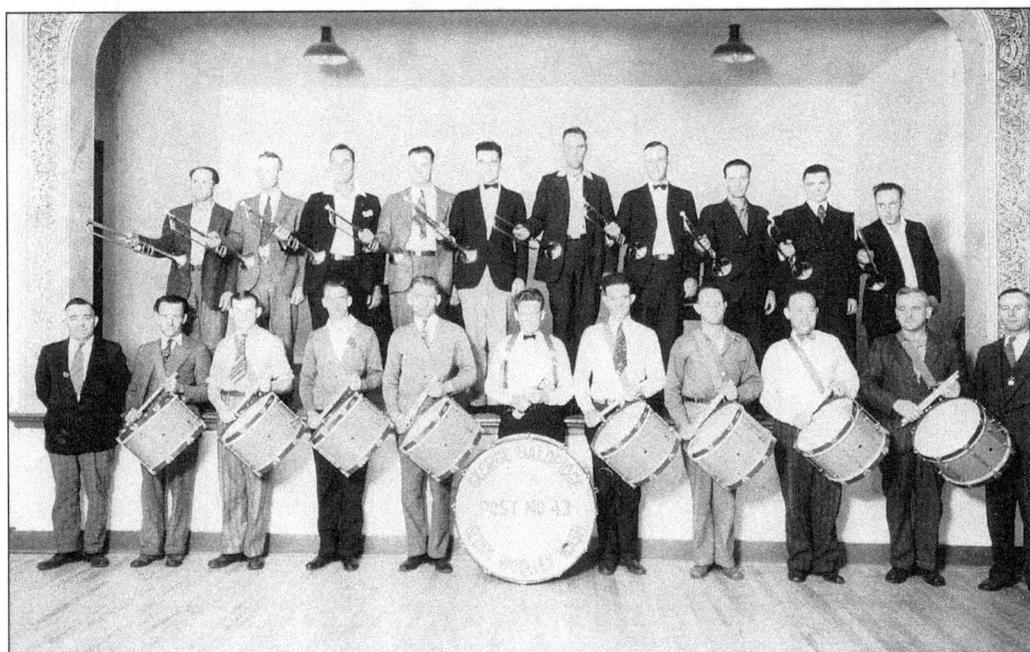

The legion Drum and Bugle Corp of the American Legion, George Baldridge Post #43, was formed in 1919 and named after the first local boy killed in World War I.

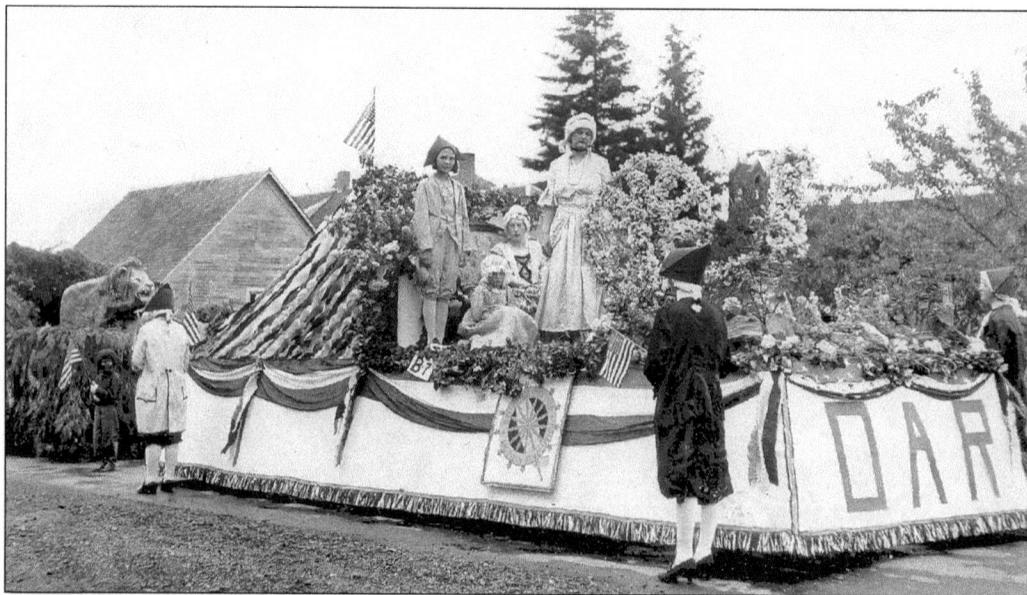

This chapter of the D.A.R. formed in 1922 and was named "Charles Carroll of Carrollton" in honor of the first American patriot to sign the Declaration of Independence. Mrs. Paul Rhodius was a direct descendant of this distinguished citizen. Pictured is their 1939, 4th of July float. At the spinning wheel is Mrs. Maurice Splane; seated is Inez Gilbertson; the little boy is Lila Buchanan; the girl, Donna Hyldahl; and walking are Marilyn Jenson and Evonne Dinkins.

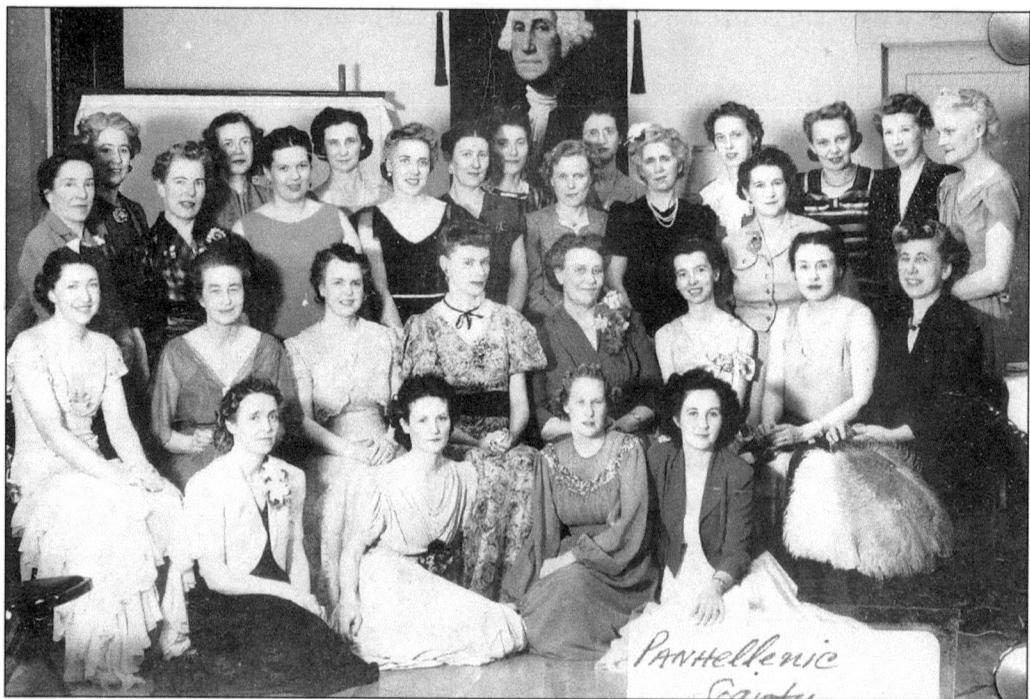

The Panhellenic Club formed in 1919. The membership is comprised of members of national sororities. This was one of the first organizations in town to sponsor the new, popular money-raising device: the rummage sale.

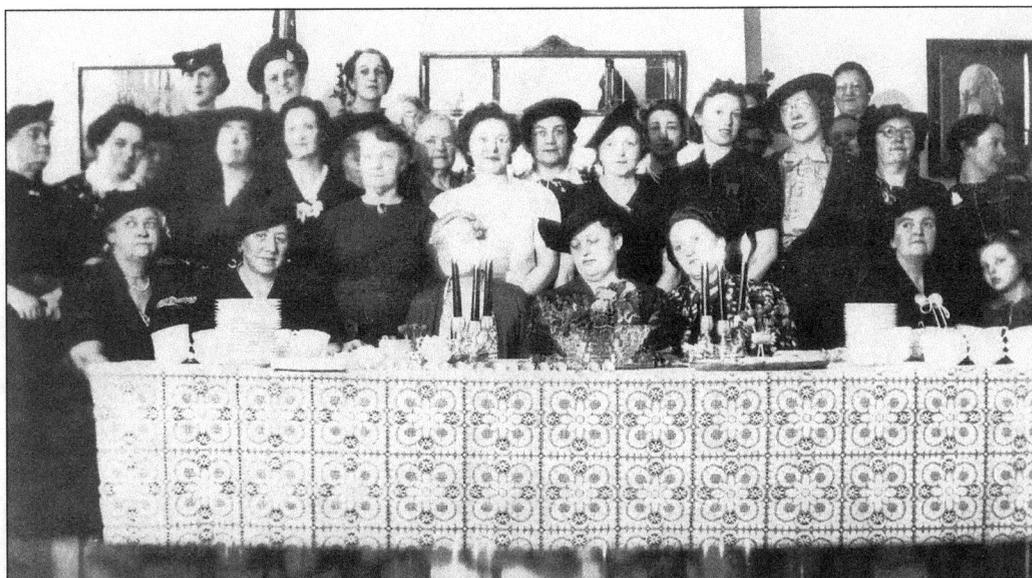

The Sedro-Woolley Women's Club was organized in 1920. The purpose of the club was to promote the welfare of Sedro-Woolley. The picture was taken *c.* 1935.

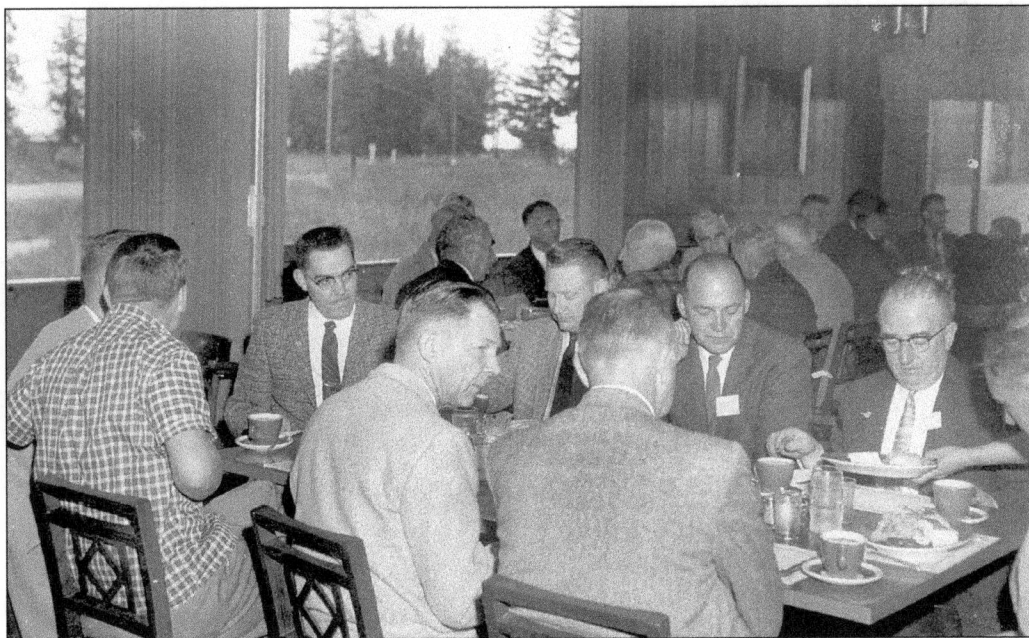

A United Good Way luncheon was held at Scotty's Restaurant, *c.* 1960s.

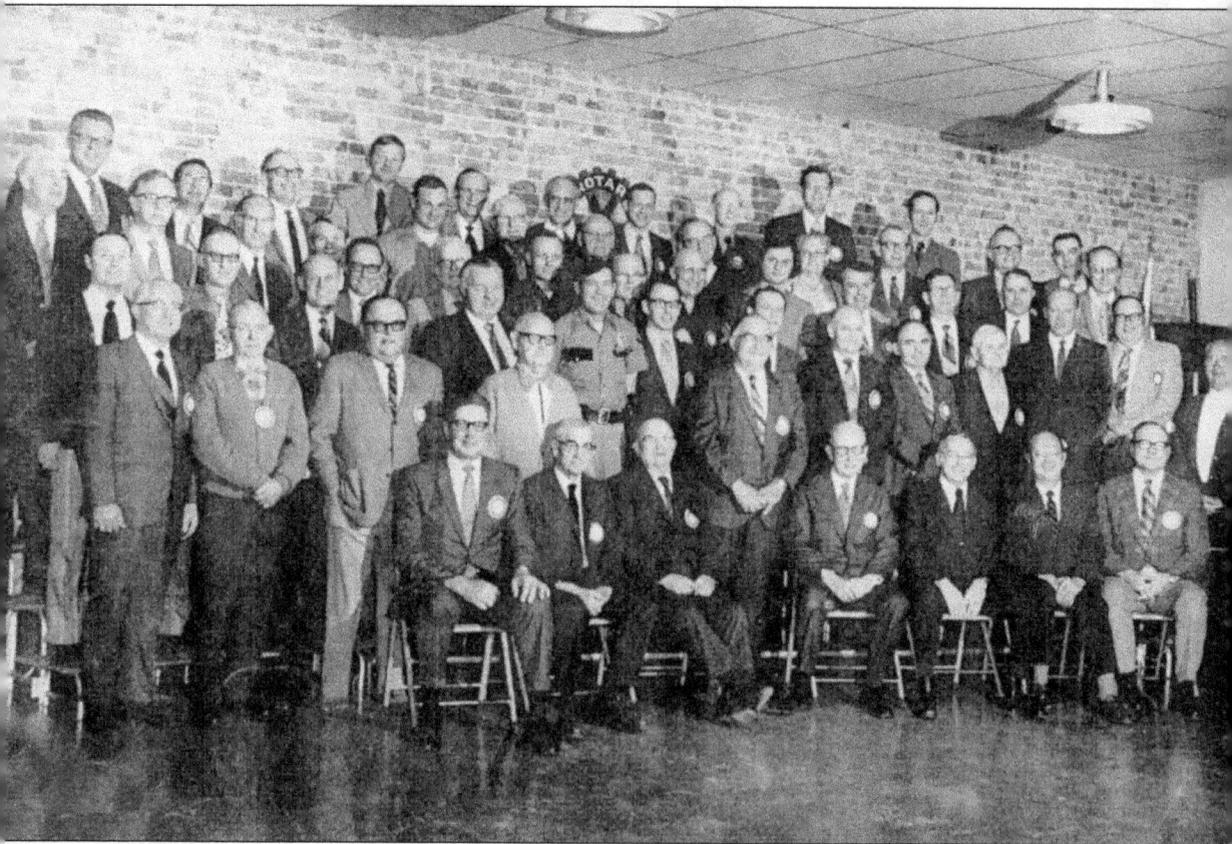

The Rotary Club was organized in 1922. They are still an active and vital part of the community. The above picture was taken in the early 1960s.

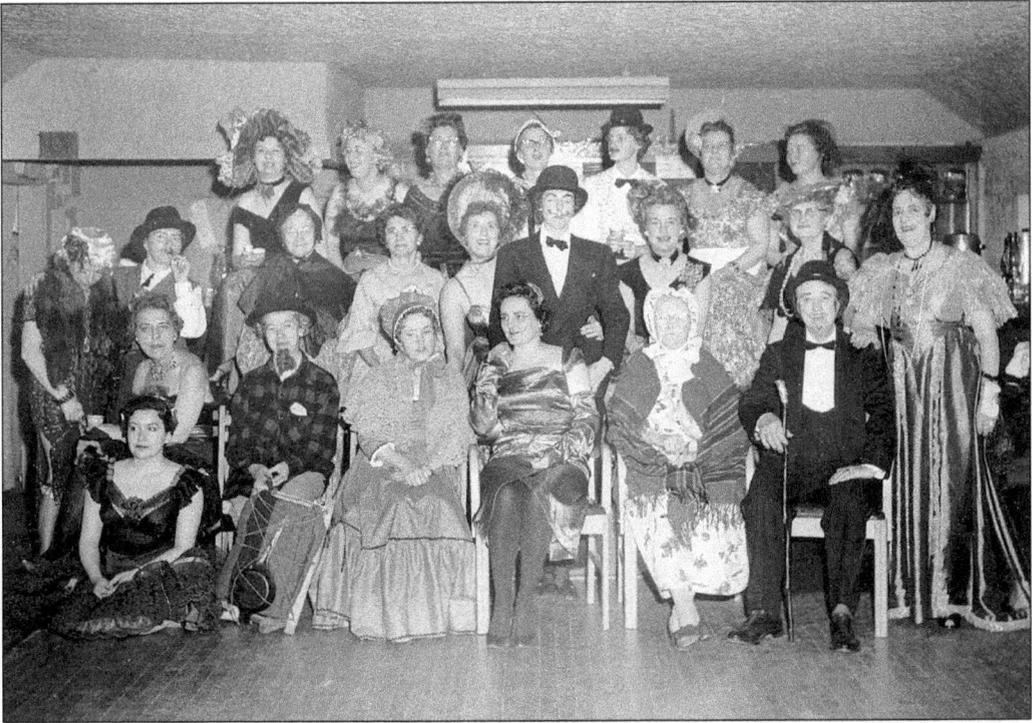

The Soroptomist was chartered in 1949. The above picture is of a skit they preformed.

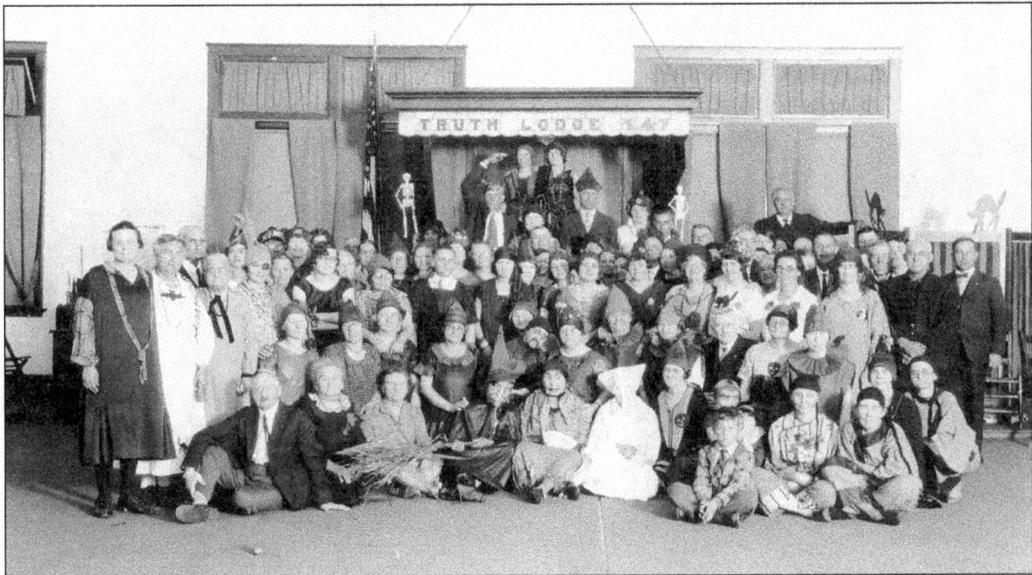

The Success Rebekah Lodge #74 was organized in 1895. The above picture is of a Halloween party they had in 1920.

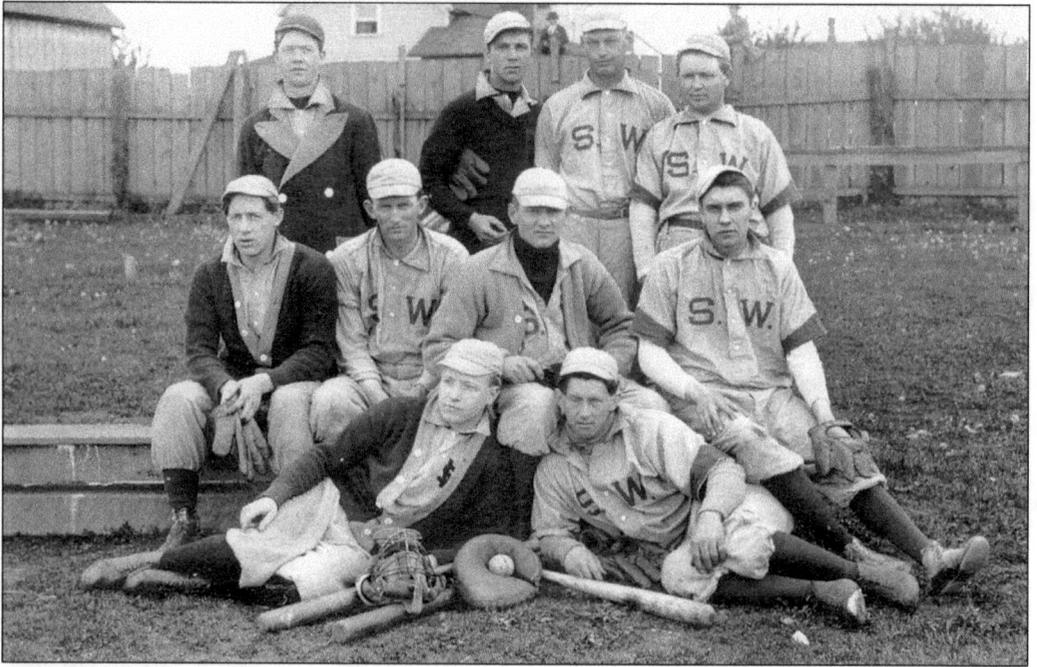

Sedro-Woolley's home-town baseball team is pictured here 1911.

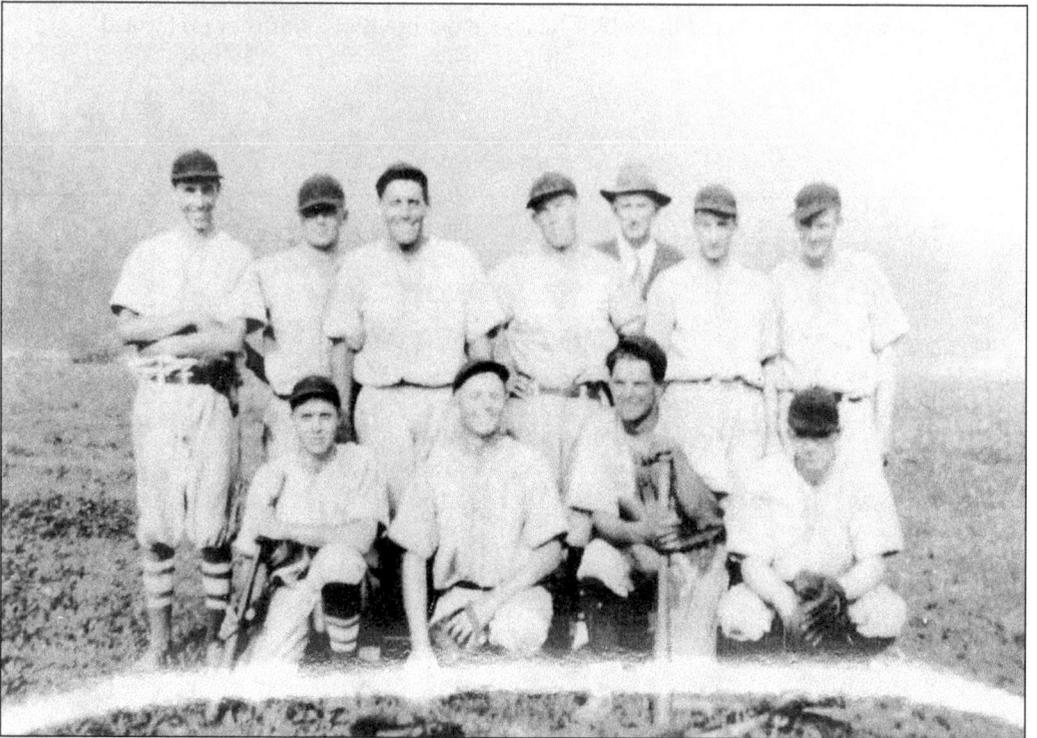

The Skagit Valley Grange baseball team, 1933-1935, was, from left to right: (front row) Dorsey Marchant, Stanley Coultus, Eddie Parsons, and John Stephson; (back row) Frank Marchant, Clarence Tennis, George Nichols, Vincent Johnson, Fred Jarvis, Bob Parsons, and Ed Jarvis.

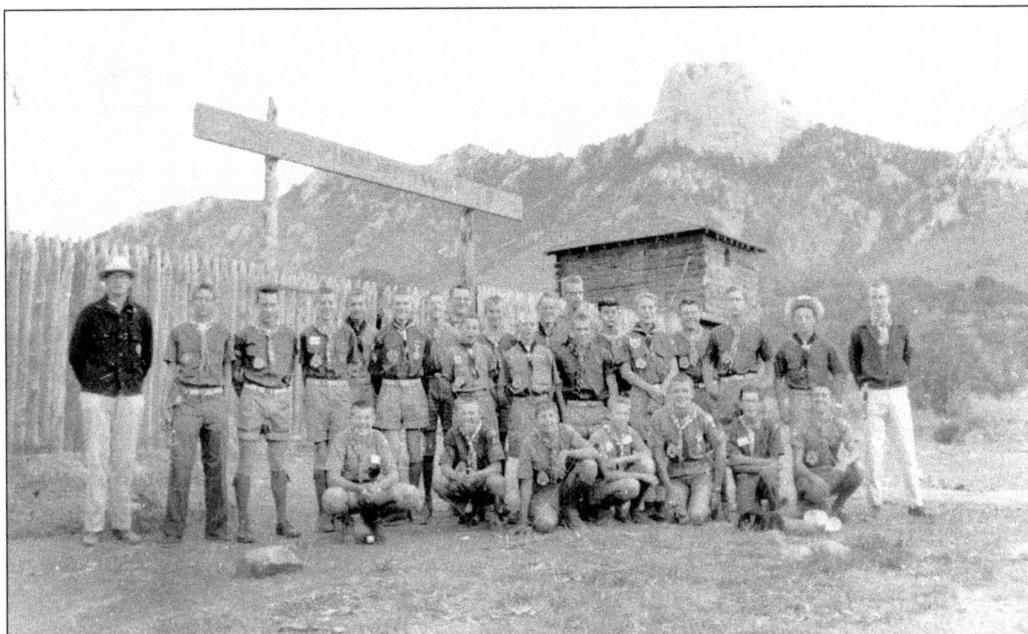

The Sedro-Woolley Boy Scouts are camping at Camp Philmont, New Mexico, in 1959.

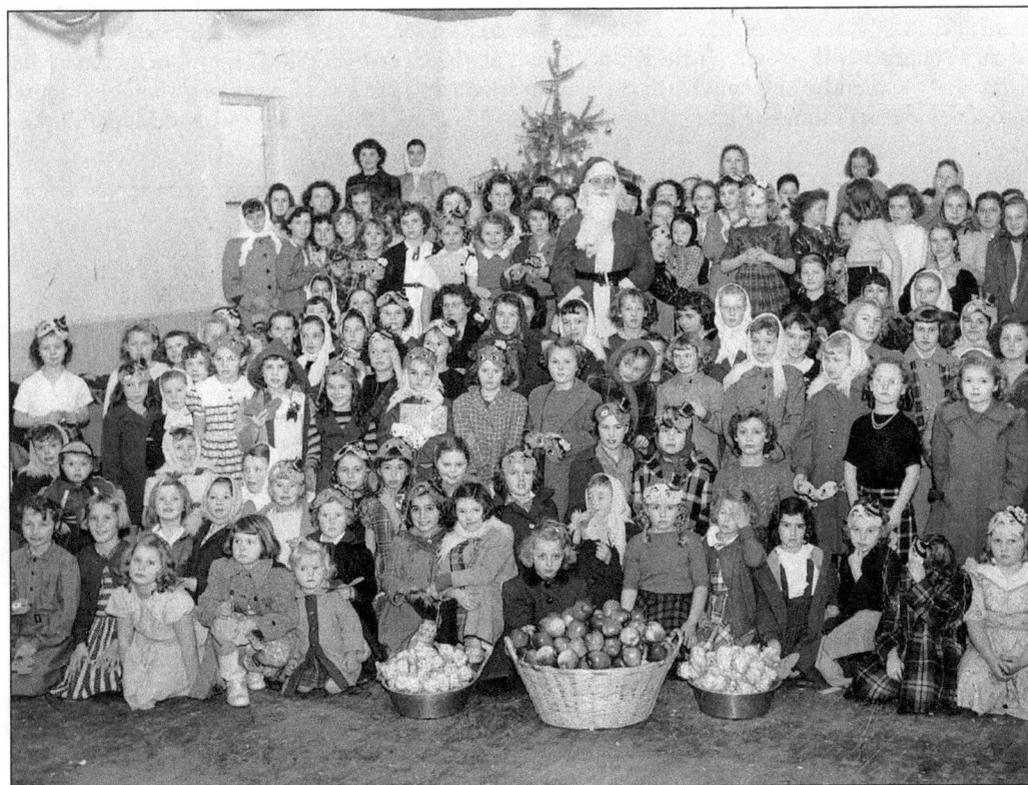

The Sedro-Woolley Girl Scouts are shown at a Christmas Party held in the IOOF hall, *c.* 1950.

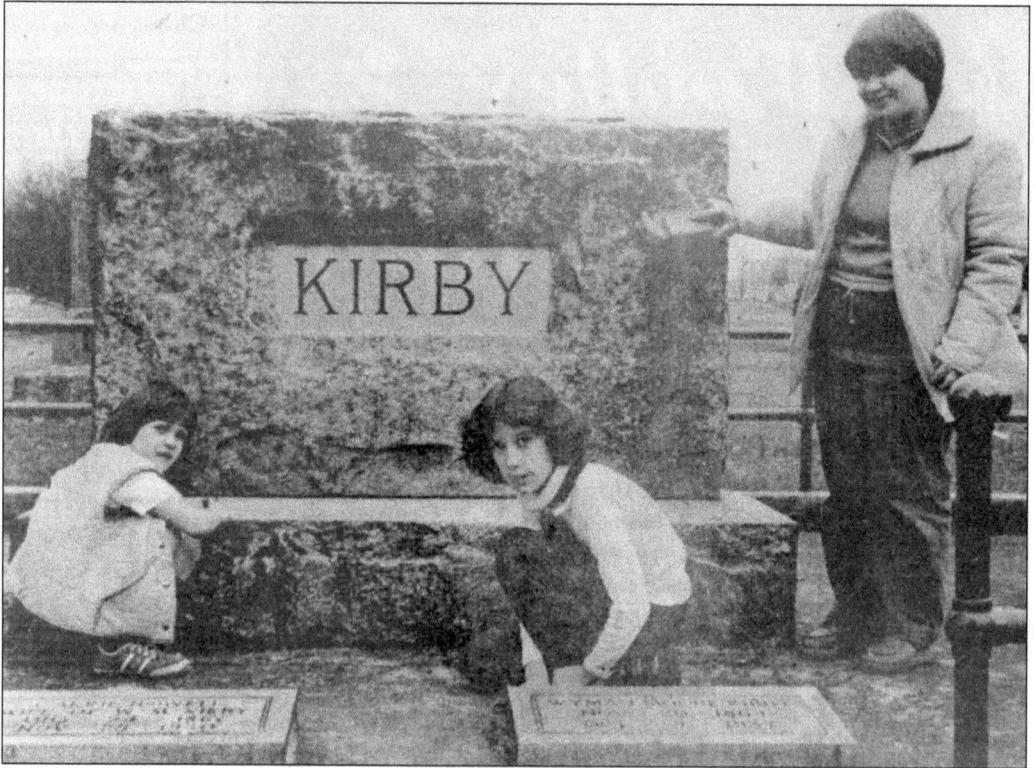

Local Campfire Girls clean Carrie Kirby's grave at the Sedro-Woolley Union Cemetery. Mrs. Kirby was the founder of Camp Kirby on Samish Island and the local Campfire girls. The original campfire lodge still stands. Pictured above are Julie Freeman, Christy Bigelow, and Margo Burke.

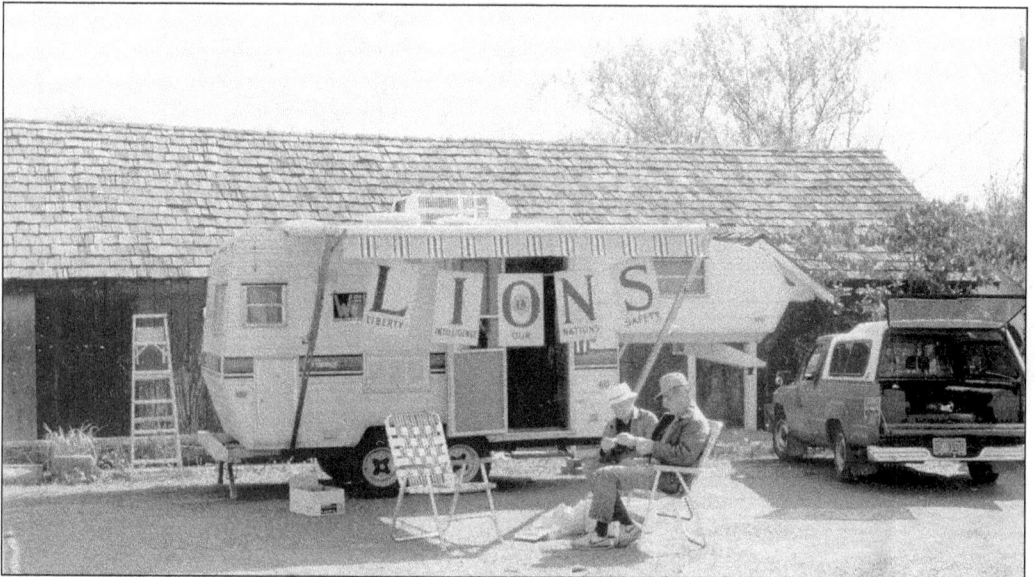

The local Lion's Club was organized in 1937. Picture above are Glenn Hall (white hat) and Gus Suryan, manning a check point for the March of Dimes Walk America.

Ten

CELEBRATIONS
AND EVENTS

Richard Baxter said "An ounce of mirth is worth a pound of sorrow." The social life of the pioneers may have been small, even dull by today's standards, but very important. The life of the pioneers was hard so any opportunity to gather with others for a picnic or celebration was an event.

Ethel Van Fleet Harris, an early pioneer, described Sedro's first Fourth of July celebration. This excerpt illustrates to what length people would go to celebrate:

"The little town of Sedro staged its first Fourth of July celebration in 1886. A spot near Benson creek was chosen as the scene of the festivities.

The tables decorated . . . the ladies came with well-filled baskets and all sat down to a bountiful meal.

After dinner came the program, David Batey read the Declaration of Independence . . . Eva Van Fleet . . . spoke *The Burial of Sir John Moore*, and log rolling in the mouth of the creek . . .

People came from far and near. A large canoe came from Sterling. Mr.& Mrs. Dave Moore and baby came from what is now the McRae district. Fred Hall brought Fannie Kollorh . . . down from Prairie, a distance of six or seven miles. They walked all the way over a blazed trail, crossing Reed's slough (at the foot of Duke's Hill) on a foot log.

In the evening there was a big dance at old Sterling in the hall over the new store, so after the picnic as many people got into the big canoe as it would hold and drifted down the river to Sterling.

The canoe was so loaded; they did not dare use the paddles except to steer it. Many other people walked down, danced most of the night and then walked home.

The people who walked from Prairie to Benson creek and then on to Sterling and back home would have covered about 20 miles or more besides the energy expended at the picnic and on the Sterling dance floor."

The pictures featured in this chapter cover some of the mirth and merriment celebrated over the years by the citizens of Sedro-Woolley.

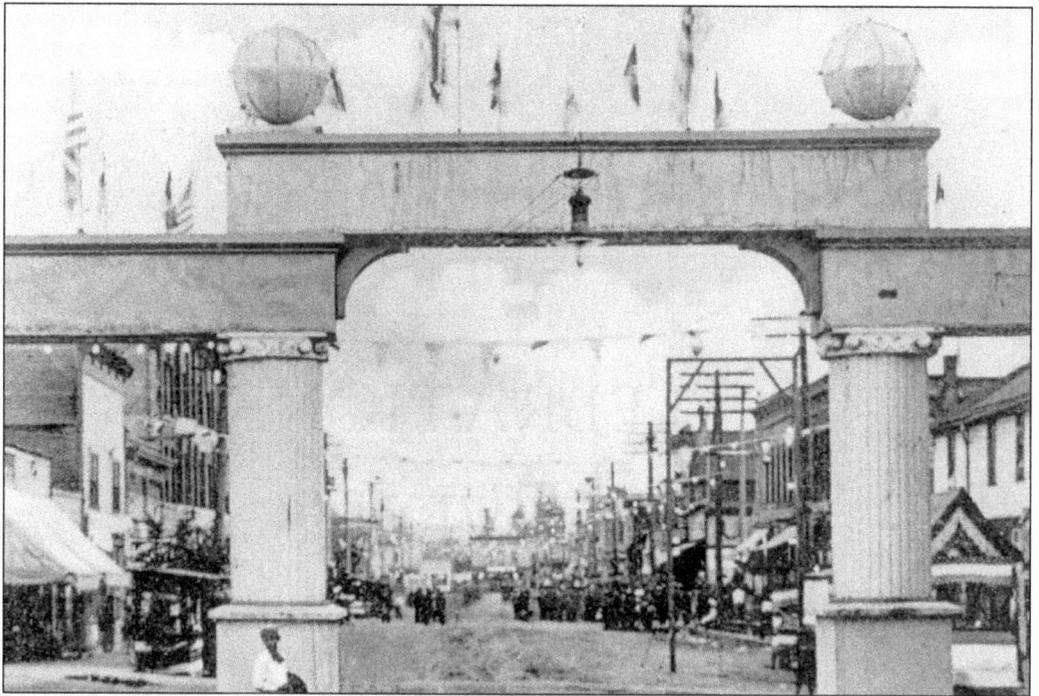

This parade arch was used only during the 4th of July celebrations in Sedro-Woolley in the early years. They would place an arch at each end of town. Note the early streetlight hanging in the center. The 4th of July celebration in Sedro-Woolley is the oldest in the state. This picture is looking south, c. 1910.

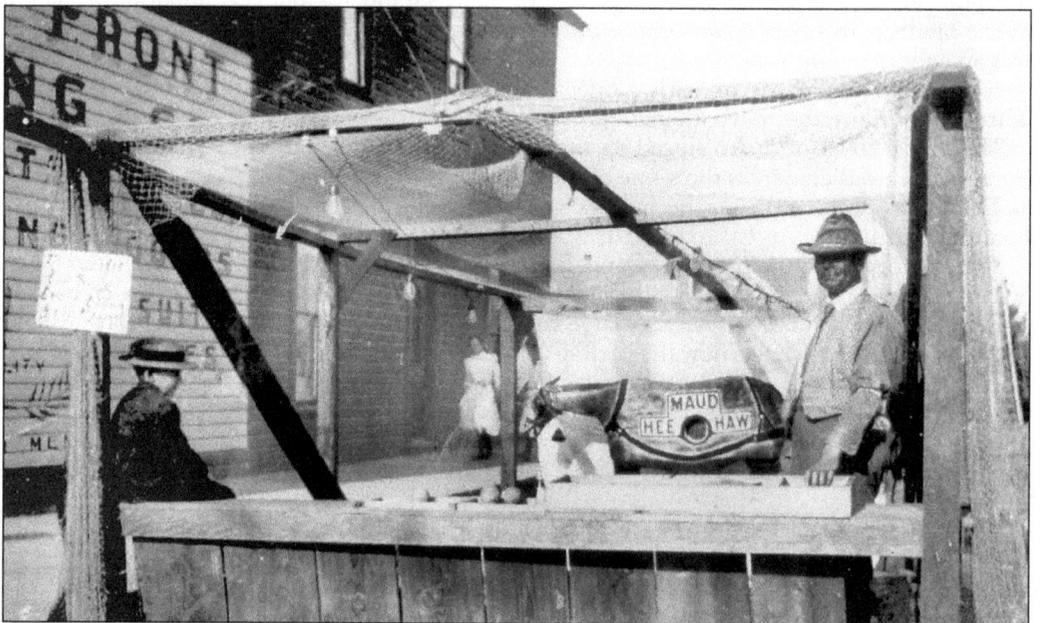

This Hee Haw game booth was set up during the 4th of July celebration and photographed about 1910 before the 1911 fire. The picture is from Woodworth Street behind where Cascadian Farms is today.

Two unidentified boys prepare for the 4th of July celebration.

Ethel Van Fleet Harris and Susie Batey Taylor pose in their costumes, ready for the 1939 4th of July parade. They were part of the Territorial Daughter's entry: "Fifty Years of Statehood." They won first place.

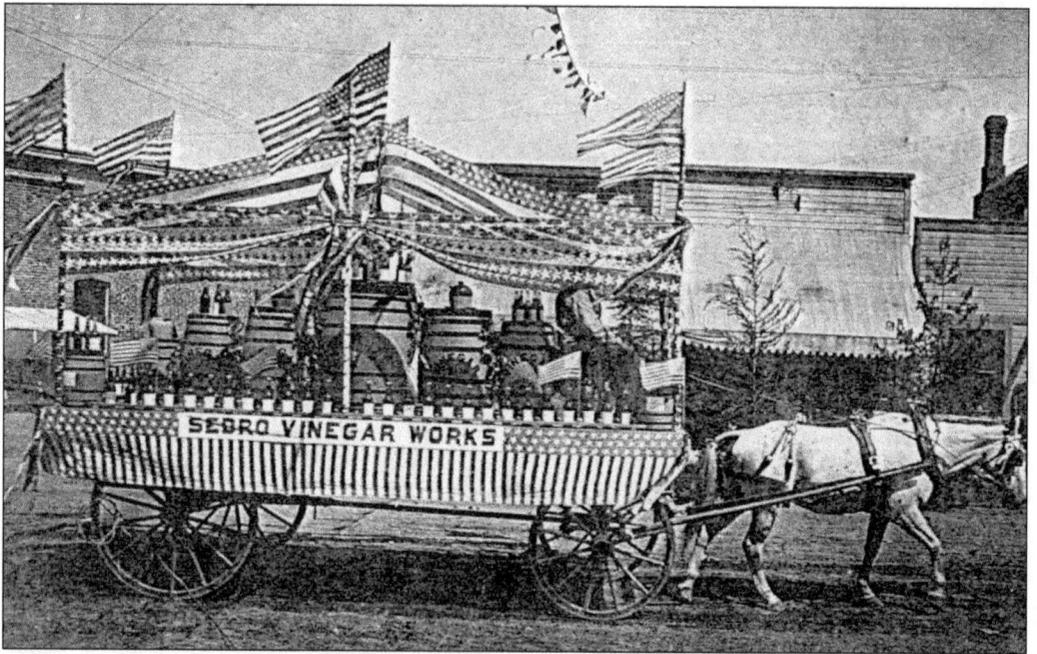

This is the Sedro Vinegar Works 4th of July float on Metcalf St, *c.* 1910. Sedro Vinegar Works was owned and operated by David Batey and located on W. Jameson Street.

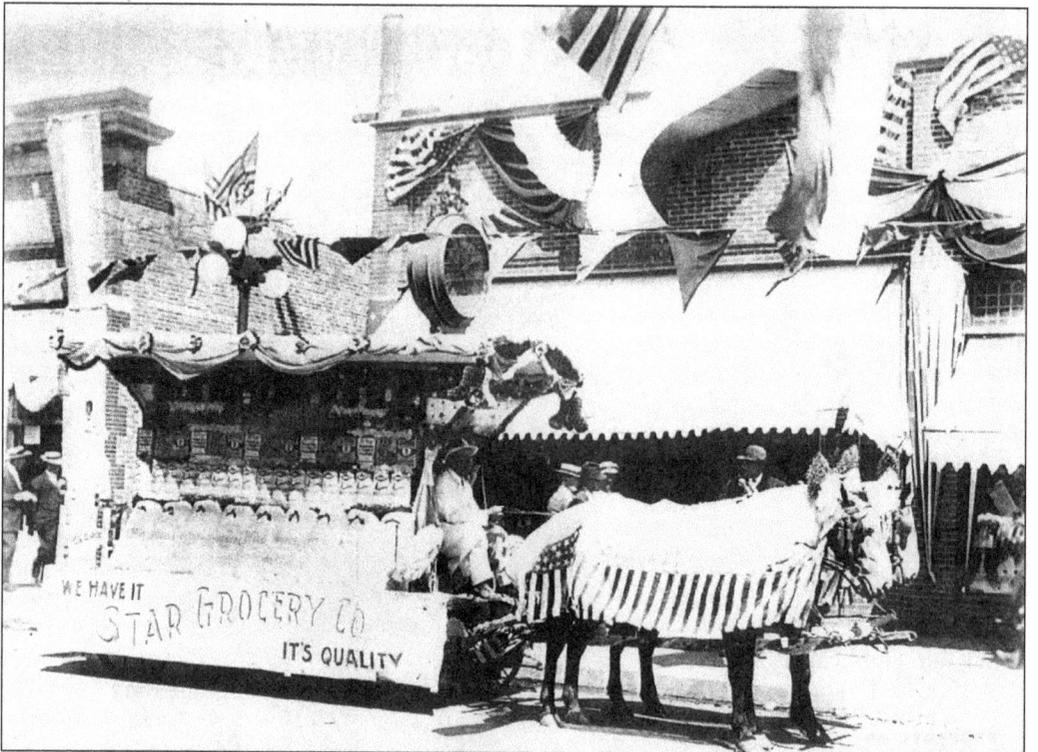

The Star Grocery Company also entered a float in the 4th of July parade. We estimate this photo was taken about 1914.

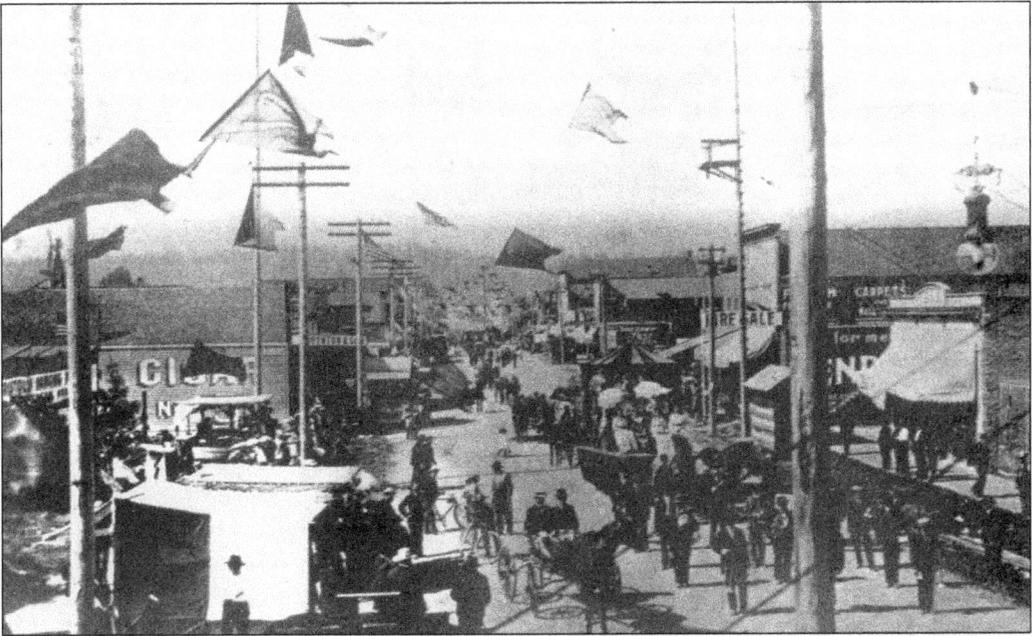

This photo is of the 1909 4th of July celebration, looking north on Metcalf Street. Note the streetlight to the far right and the chair-like structure to the right of center. This is a fire-watch observation platform.

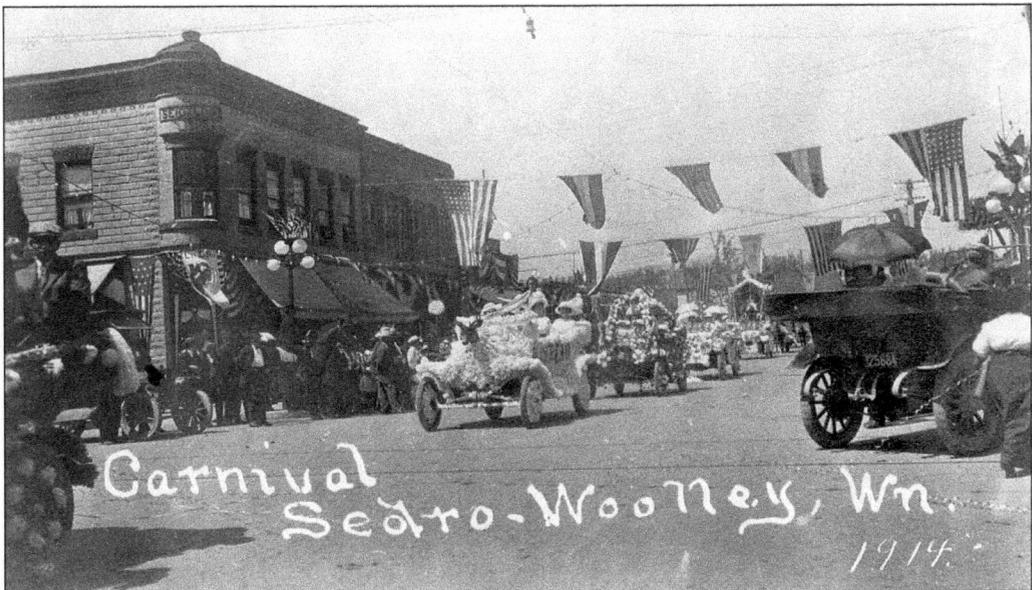

This is the Carnival scene and 4th of July parade in 1914.

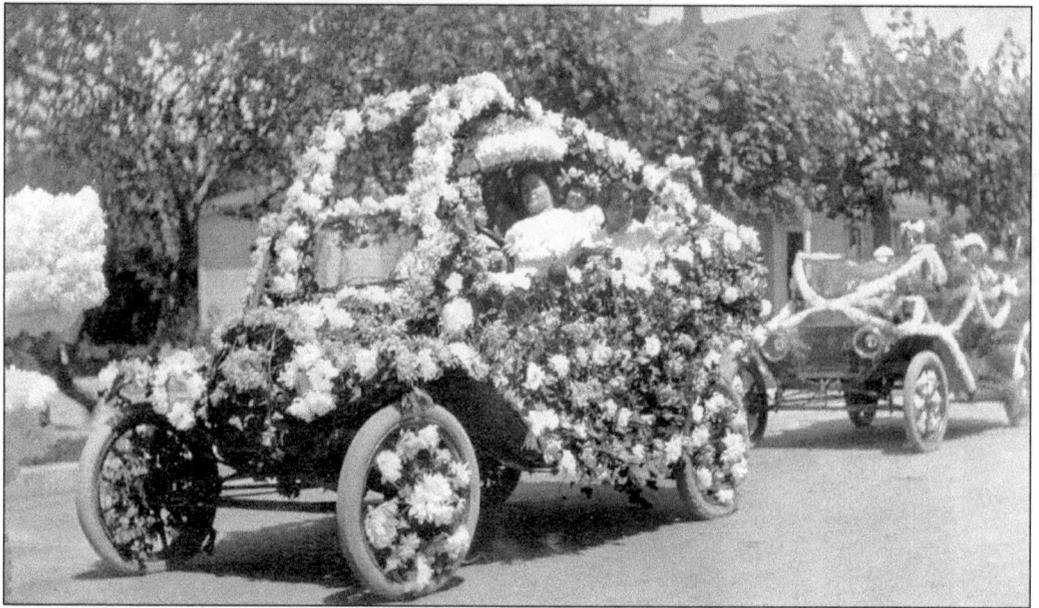
Mrs. George Clark's car was decorated for the 4th of July parade, 1914.

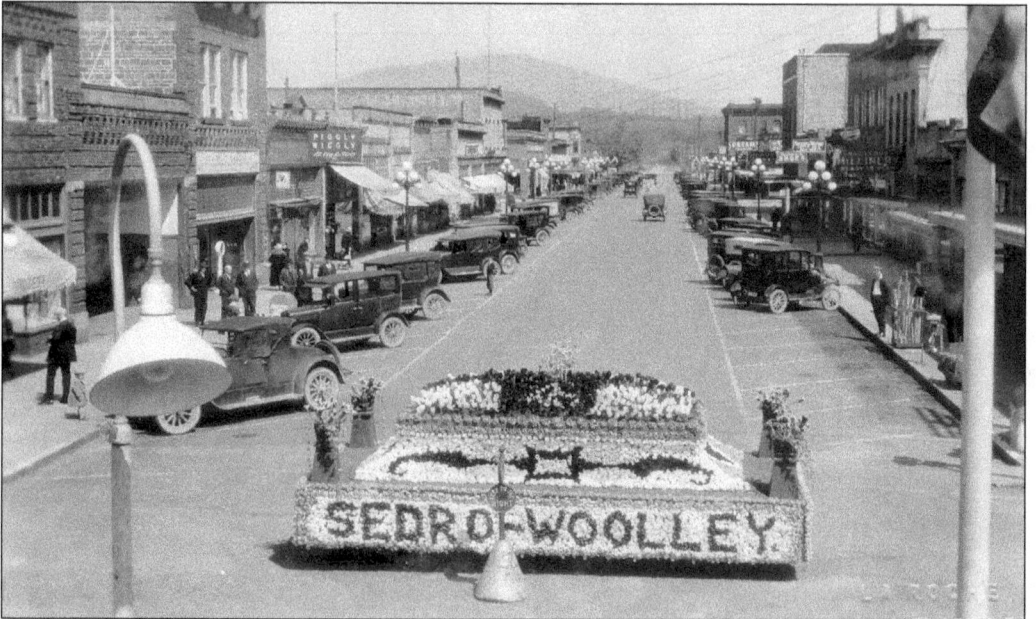
Sedro-Woolley's community float was photographed on Metcalf Street in the 1920s.

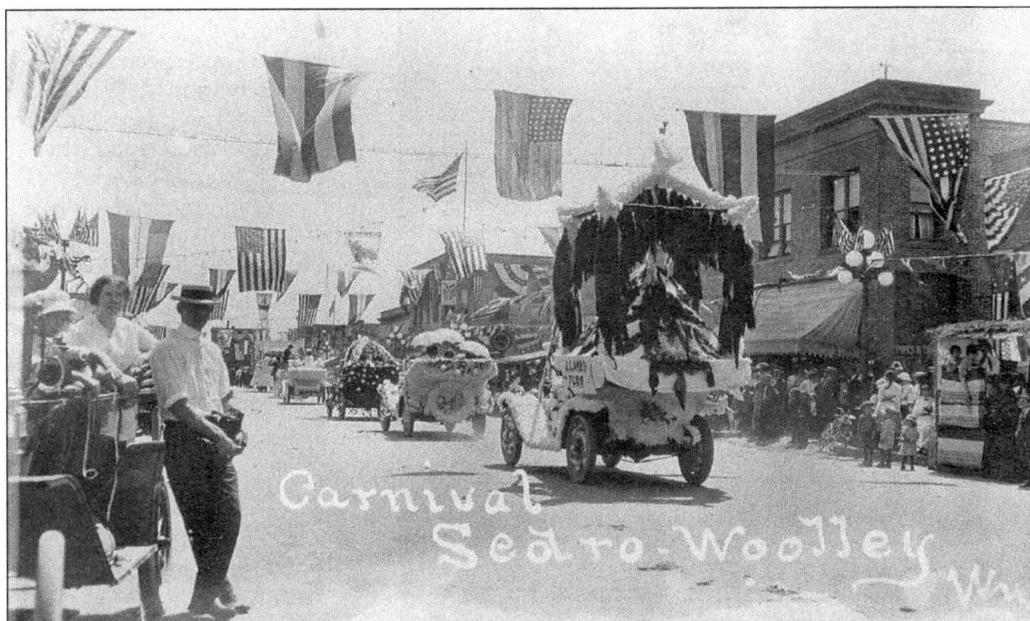

The 4th of July parade in downtown Sedro-Woolley was photographed in 1914.

Here are the Beards and Garb festivities of June 27, 1935. Sedro-Woolley's 4th of July celebration included a beard contest; also if you were caught without a beard, "A Paleface," you were thrown into a public jail and had to be bailed out. This proved to be a good fundraiser.

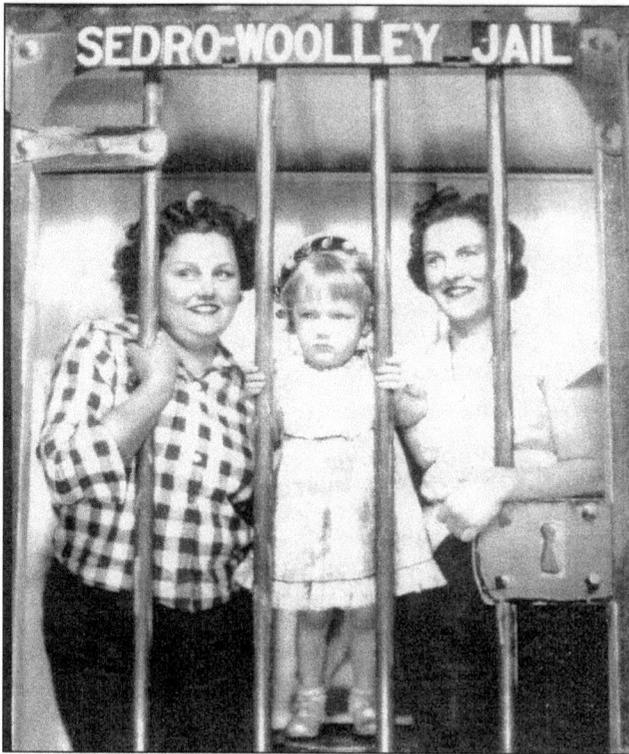

The public jail was used during the Loggerodeo's 4th of July celebration, *c.* 1950. Pictured are Torchy Downey, Carolyn Anderson, and Esther Anderson. Note: The 4th of July celebration started out as a parade, carnival and log show, then in the 1930s they added the rodeo and in 1948 changed the name to Loggerodeo.

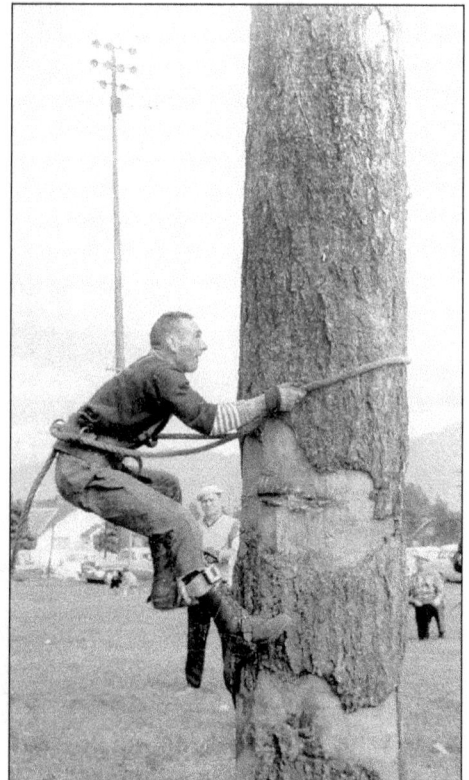

The Loggerodeo celebration always included a loggers' competition. This picture depicts a logger climbing a tree. The first to the top won.

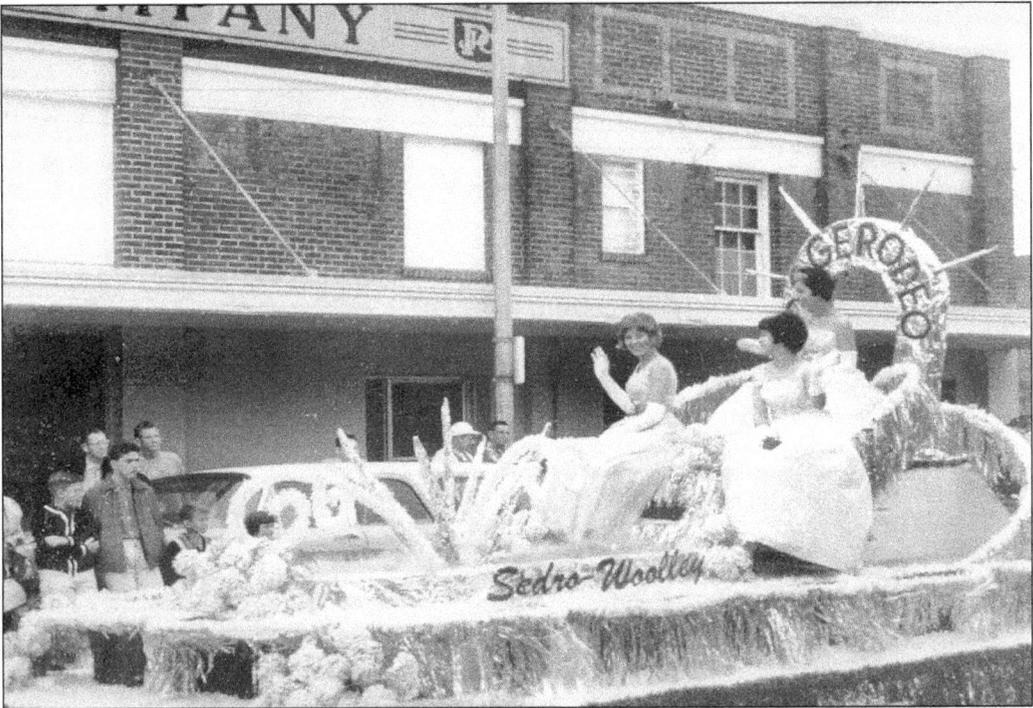

The City of Sedro-Woolley's Queen float in 1964. The Loggerodeo Queen was Carol Franulovich, the 1st princess was Cheryl Tresner, and the 2nd princess was Judy Walker.

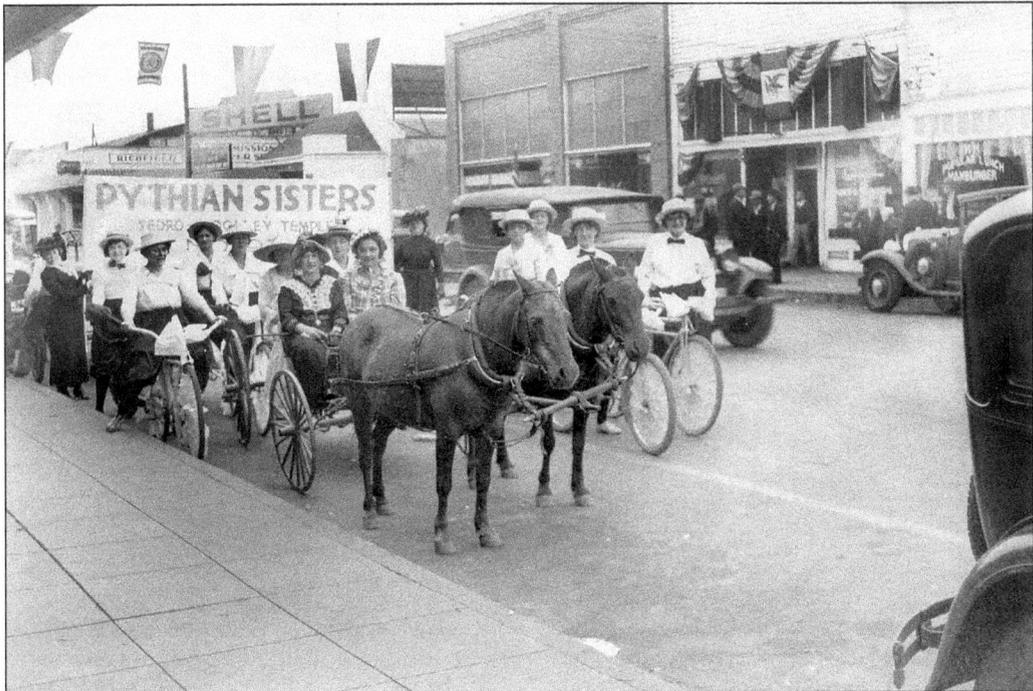

Here is the Pythian Sister's entry in the 4th of July parade, c. 1930.

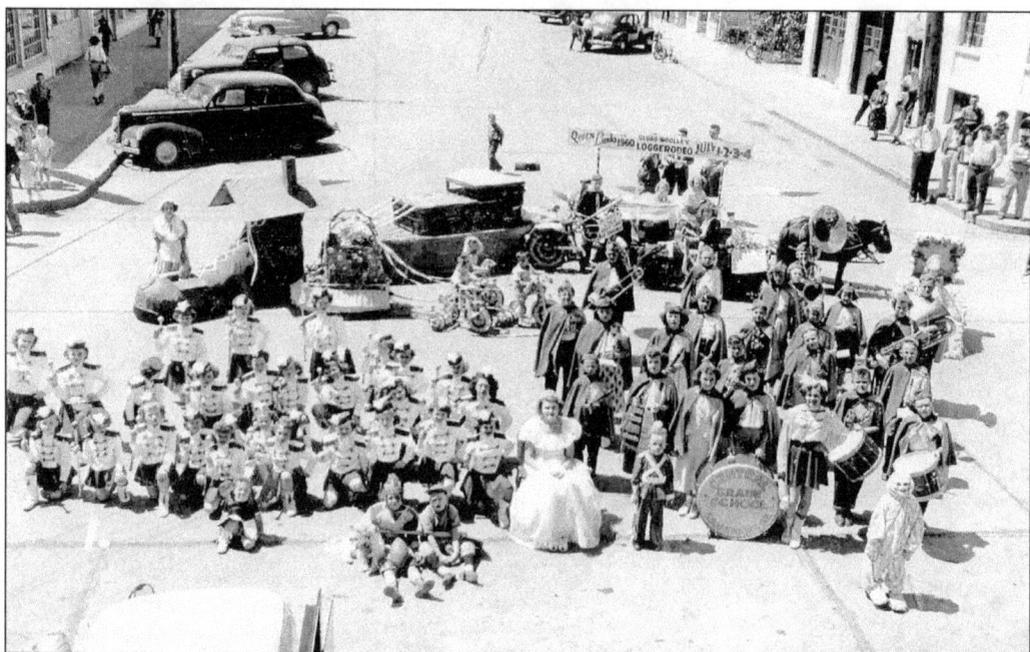

This 4th of July kids parade was photographed *c.* 1949. This photo was taken in front of what now houses the Sedro-Woolley Museum.

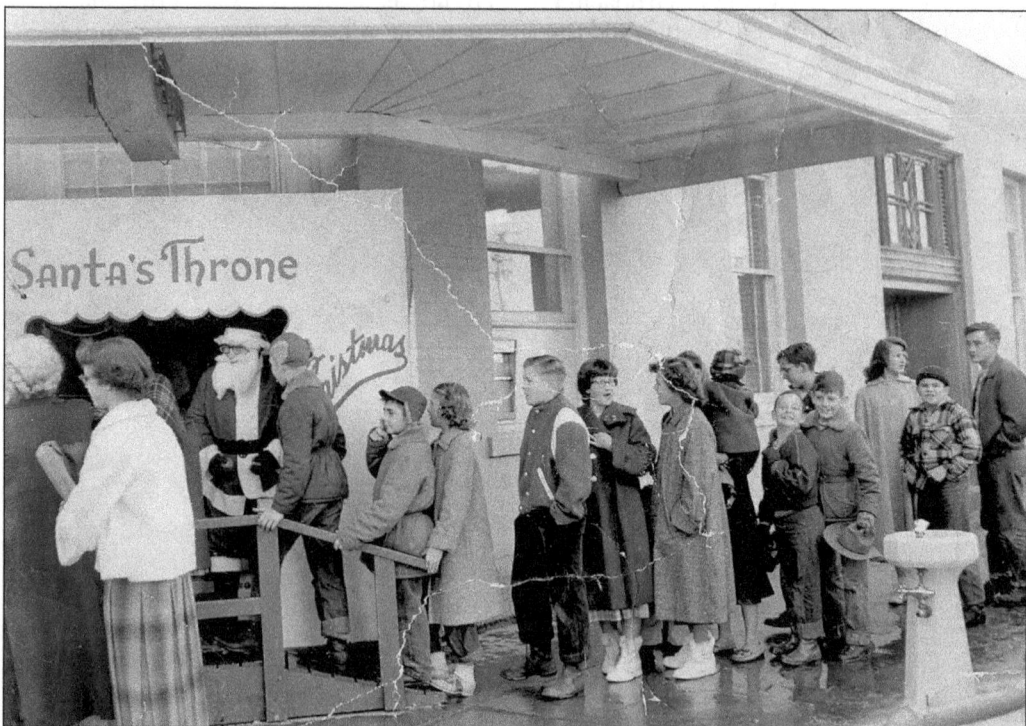

Sedro-Woolley's Christmas celebration always included Santa. Santa's throne was set up in front of the Bingham bank. Visiting Santa, fourth from left, is George Fair, Carolyn Hill, and Rita Fladabo, *c.* 1956.

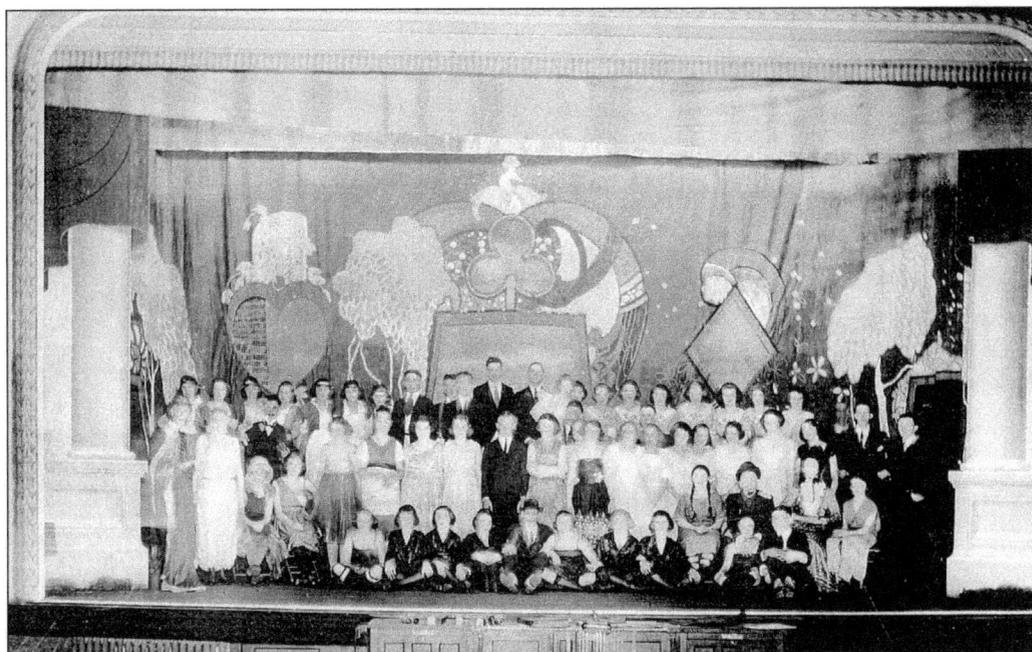

Another event in early Sedro-Woolley was the different organizations performing skits, plays, or talent shows. This picture was the Rotary Club's skit on the stage of the Dream Theatre.

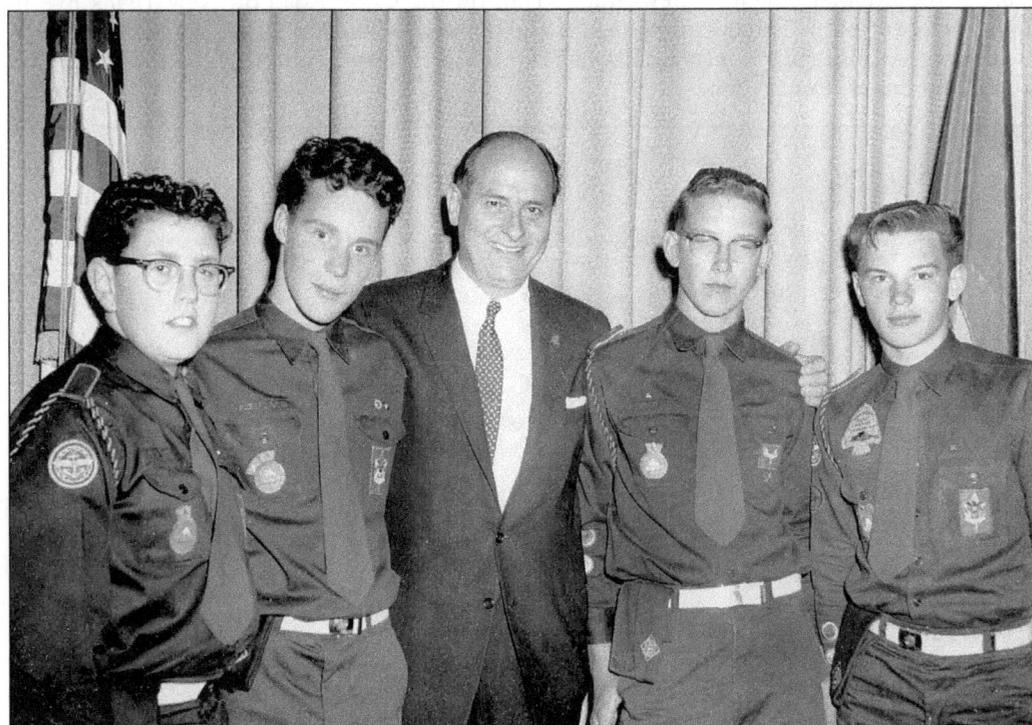

A big event in Sedro-Woolley was when Governor Albert Rosellini visited: local boy scouts acted as honor guard. From left to right are Mike Hamel, Kerry Freeman, Jerry Correon, and Mike Williams, *c.* 1958.

Here is the original Skagit Valley Grange Hall on the Cook Road on New Year's Eve in 1944, before it burned that same year. At the piano is Mrs. Don Lowe; accordion, LeRoy Anderson; vocalist, Jeanie (?); trombone, Hank Morris; bass, Bill Allen; saxophone, Don Lowe; and drums, Doc. Allen.

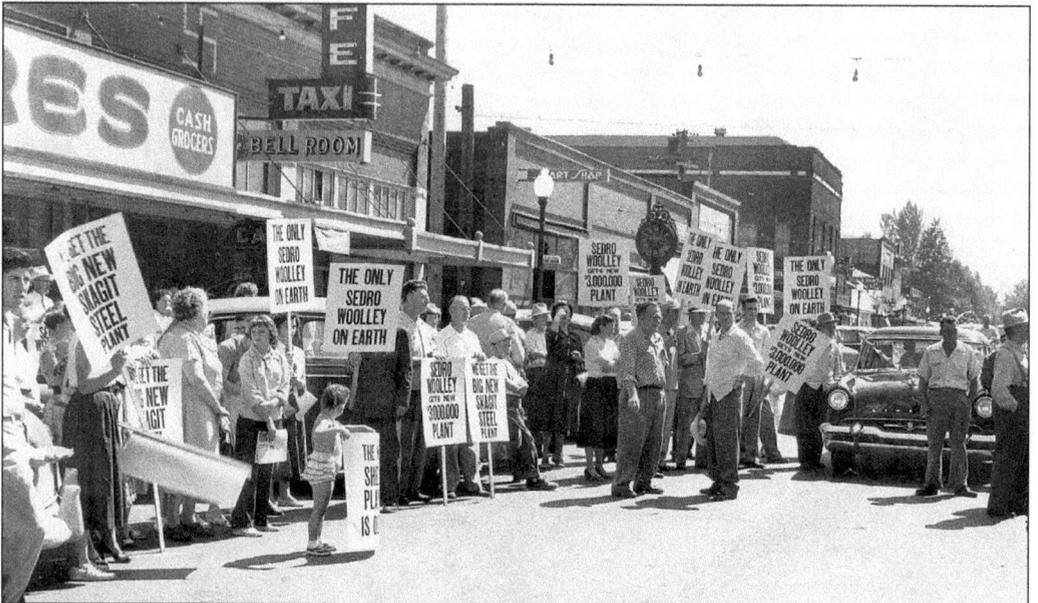

One of the biggest events in Sedro-Woolley happened when the community got together to raise $300,000 to get a new ammunition plant as part of Skagit Steel. This photo was taken in the summer of 1953.

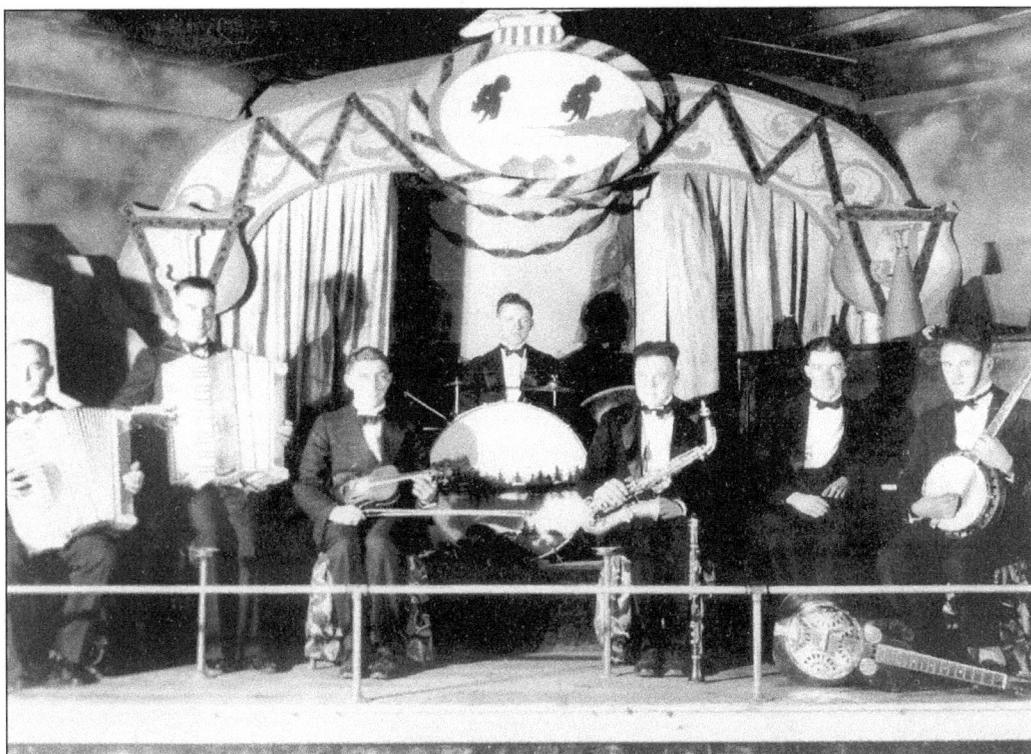

Big bands played for many occasions. This picture was taken in the Eagle's Hall, where the bowling alley is now located, c. 1930. From left to right are Harold Knox, Holger Johnson, Floyd Maxwell, Cliff Williams, Bill Johnstone, Perry Manley, and Bob Hemphill.

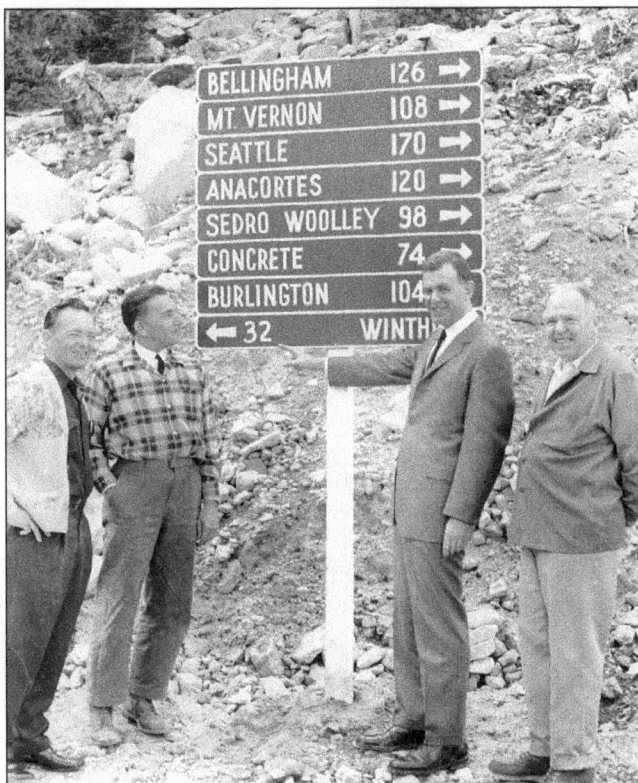

Pictured is the opening of the North Cascade Highway in 1972. From left to right are State Senator Lowell Peterson, State Director of Highways Charles Prahl, U.S. Congressman Tom Foley, and the Department of Highways Commissioner, Harold Walsh.

Acknowledgments

Rusty Robertson

Bill and Mildred Holtcamp

The Van Fleet family

The Dreyer family

George McRae and the Skagit Valley Grange

Joan (Jenkens) Crawford

Lemley Funeral Chapel

The Museum Book Committee:
Roger Peterson
Dean and Rosalie Schanzenbach
Kerry and Carolyn Freeman

www.ingramcontent.com/pod-product-compliance
Lightning Source LLC
Chambersburg PA
CBHW050552110426

42813CB00008B/2334